Advance Praise for Kid Quixotes

"Cervantes would be proud that his 400-year-old novel is helping these extraordinary schoolkids and their impressive teacher make sense of their lives; face their fears; and tell their stories with courage, imagination, and song."
—Salman Rushdie, author of *Quichotte*

"Haff paints a picture of what education in America could and perhaps should be. His story is passionately honest, profoundly open-minded, and suffused with optimism, and his writing is crisp and clear and persuasive."
—Andrew Solomon, National Book Award–winning author of *The Noonday Demon: An Atlas of Depression*

"In my years of experience as a writer and as a college professor, I have never seen anything like this: the love for language, the passion for discussion, clarity of mind, and humility of heart. Stephen Haff invents impossible projects and makes them possible."
—Valeria Luiselli, author of *Lost Children Archive*

"The story of the Kid Quixotes is gritty, moving, and inspirational. It is a potent reminder of how powerful gentleness is, how important respectful, sincere attention is—an urgently needed reminder in our time. Stephen Haff is a great teacher who has allowed himself to be taught. This beautiful book shows the reader, among other things, how to learn and to keep learning through careful, gentle attention to people, words, and ideas."
—Mary Gaitskill, author of *Bad Behavior*

"*Kid Quixotes* is alive with humor and heartbreak. It is a great reminder of the resilience of children in the face of adversity. Goliath may have become ruler of the land by spewing hatred toward immigrants, but, true to their namesake, the Kid Quixotes refuse to stand by idle in the face of injustice. Their stories weave into powerful songs echoing with optimism and purpose and resounding with a love that refuses to be silenced."

—**Maria Venegas, author of** *Bulletproof Vest*

"Behind a storefront in Bushwick, Stephen Haff is doing the work of angels. The story of his evolution into a teacher making a huge difference in the lives and education of immigrant children is inspiring enough, and the stories of the children themselves are a fascinating tapestry; but the message throughout—that we listen to one another, and respect study and expression—overrides it all. It should be woven into all systems of education. You cannot read this book and go a page without being thoroughly inspired."

—**Susan Minot, author of** *Monkeys* **and** *Evening*

"In a Bushwick storefront classroom, Stephen Haff and his mostly immigrant Kid Quixotes have created a community of joyful learning, resilience, courage, astounding creativity, generosity, and love. Haff is a humble genius and visionary, and this book brings you into that enchanting, truly revolutionary classroom."

—**Francisco Goldman, author of** *Say Her Name*

"A remarkable demonstration of the actual miracles that can be performed with no resources beyond the determination of an individual and the community that rallies to support him. It's the most inspiring book I've read in a long, long time."

—**Michael Cunningham, author of** *The Hours*,
winner of the Pulitzer Prize

"*Kid Quixotes* is an adventure of the human spirit, a glimpse into the genius of immigrant children who overcome circumstances few readers can imagine with courage, heroism, and the love and dedication of a visionary teacher. . . . A riveting, inspiring, and ultimately triumphant ode to the power of education and indomitability of the imagination."

—**William Egginton, Johns Hopkins University,**
author of *The Man Who Invented Fiction:*
How Cervantes Ushered in the Modern World

"*Kid Quixotes* is one of the most achingly poignant and genuinely inspiring books I have ever read. Steve Haff's clarion call for diversity and inclusion, his emphasis on empathetic listening, and his conviction that classic literature can be urgently relevant to our lives today make his a peerless pedagogy. The story of his brave, creative, and resilient students will win your heart completely; the story of his school should galvanize reforms of our educational system and political policies and remind everyone that any true education must be founded on love."

—**Priscilla Gilman, author of** *The Anti-Romantic Child:*
A Memoir of Unexpected Joy

"The one rule at Still Waters in a Storm, the beautiful school at the heart of this beautiful book, is 'everyone listens to everyone.' I listened to the many voices telling this necessary story, and I was moved and changed by them."

—**Jonathan Safran Foer,** *New York Times* **bestselling**
author of *Everything is Illuminated*

"In *Kid Quixotes*, the children of Latino migrants in Bushwick, Brooklyn, carry on Don Quixote's mission to bring literature to life and rescue the world in the process. Stephen Haff reveals

the power of words to heal oneself and a country simultaneously formed by migrants and suspicious of them. Cervantes couldn't be any prouder."
　　　—Rogelio Miñana, author of *La verosimilitud en el Siglo de Oro*, head of the Department of Global Studies and Modern Languages, Drexel University

"A necessary antidote to despair and reminder of the immensity of what can be accomplished in a single neighborhood, in a single classroom, and how that can improve us all."
　　　—Phil Klay, National Book Award–winning author of *Redeployment*

"In lively dialogue both funny and heartbreaking, and a multiplicity of narrative voices, *Kid Quixotes* allows its characters to tell their own deeply moving stories. This is a book that listens."
　　　—George F. Walker, author of *Love and Anger*, winner of the Governor General's Award for Drama

"I wept and cheered all through this extraordinary book. There is magic in these pages just as surely as Stephen Haff and his students prove there is magic in the act of telling and, importantly, in the act of listening. Everyone everywhere needs to read this book."
　　　—Cristina Henríquez, author of *The Book of Unknown Americans*

Kid
Quixotes

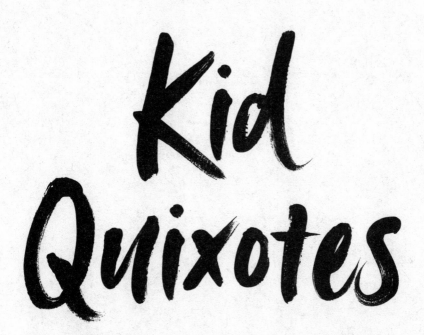

Kid Quixotes

A Group of Students, Their Teacher, and the
One-Room School Where Everything Is Possible

Stephen Haff

HarperOne
An Imprint of HarperCollinsPublishers

HarperOne

KID QUIXOTES. Copyright © 2020 by Stephen Haff. All rights reserved.
Printed in the United States of America. No part of this book may be used
or reproduced in any manner whatsoever without written permission except
in the case of brief quotations embodied in critical articles and reviews. For
information, address HarperCollins Publishers, 195 Broadway, New York, NY
10007.

HarperCollins books may be purchased for educational, business, or sales
promotional use. For information, please email the Special Markets Department
at SPsales@harpercollins.com.

FIRST EDITION

Designed by SBI Book Arts, LLC

Library of Congress Cataloging-in-Publication Data has been applied for.

ISBN 978-0-06-293406-2

20 21 22 23 24 LSC 10 9 8 7 6 5 4 3 2 1

For Bushwick

It is the history of our kindnesses that alone makes this world tolerable. If it were not for that, for the effect of kind words, kind looks, kind letters, multiplying, spreading, making one happy through another and bringing forth benefits, some thirty, some fifty, some a thousandfold, I should be tempted to think our life a practical jest in the worst possible spirit.

—Robert Louis Stevenson, *Letters*

Contents

Introduction

"That's a big book," says Felicity. Her eyes are impossibly wide, made for seeing everything around her.

"Yes," I answer.

"We're going to read this?" she asks. At eight years old, she has never seen a book this big aside from the Bible in church. She is tiny and barely reaches my elbow as we sit side by side.

"Yes, and we're going to translate the whole thing. It's going to take five years."

"Whoa."

"Open it up."

All of the kids open their copies. There are twenty-five students, aged six to fifteen, all sitting around the same table, facing each other.

"What are these words?" asks Felicity. "Is this Spanish?"

"Yes. Four-hundred-year-old Spanish."

"I can't read Spanish."

"How many people here can read Spanish?" I ask the group.

Hands go up: about half the kids, mostly the teenagers. Percy, barely seven years old, also raises his hand, as does Rebecca, aged eleven.

"Don't worry, Felicity. See? All of these people can help

you. Plus, you know how to speak and understand spoken Spanish at home with your family just like everyone here except me, so you have an advantage."

"Do you know how to read Spanish?" she asks me.

"I know the words that your parents are teaching me, and I can use my knowledge of Latin to guess. As you know, Latin is the mother of Spanish. I'm excited to learn more, right beside you."

"Why are we doing this?" asks Rebecca, a little suspicious.

"For pleasure," I say. "To fill our lives with beauty and adventure. And because it's funny."

Each kid has a copy of *Don Quixote de la Mancha* by Miguel de Cervantes, about one thousand pages bound by a red cover illustrated with a knight's helmet blossoming with elaborate, endless swirls—a garden of imaginings gone wild.

"Go ahead and write your name in your copy. The book belongs to you."

They write their names in the book.

"What's it about?" asks Rebecca.

Percy has already read the first ten pages, right here in class. "It's about an old man in Spain who reads all the time," he says, "all day and all night, and he starts to believe that the adventure stories he reads are real. Then he loses his mind and believes that he is a knight from those stories, and he decides to go on the road to start rescuing people."

"Thank you, Percy. That's a good summary. It's also a story of two opposites who become friends. The man who reads is Don Quixote, and his neighbor who goes on adventures with him—and who can't read—is a farmer named Sancho Panza."

That name makes the kids laugh because *panza* means "belly" in Spanish.

One girl is not laughing. Her name is Talia, and she is six. Her face is rearranging itself for tears.

"What's wrong, Talia?" I ask. She's sitting directly across the table from me.

"I can't read," she answers, her voice squeezed by the struggle not to cry.

"That's okay," I say.

"No, it's not okay," she answers.

"Maybe you could have the job of reading an English translation, so you can help us in case we get stuck."

"I can't read at all."

Tears push their way out of her eyes and her hands can't push them back inside.

Lily and Alex, two teenage girls, stand up, walk around the table to Talia and put their arms around her. Everyone waits while she sobs.

At long last, the sobbing subsides and Talia breathes normally. Rebecca brings her a cup of water.

"We're all going to read this together," I tell the class. "I'll read the story out loud while you follow along. Anyone can help me pronounce the Spanish properly at any time, and readers of Spanish can take over from me whenever they're ready."

Joshua, our lone teenage boy, is sitting next to Talia. "Talia," he says, gently, "I can point at the words while the person is reading so you can see what they look like while you hear what they sound like."

"That's very kind, Joshua," I say, "and smart. Reading is like recognizing people's faces and names. I'll show you."

Shielding a piece of paper from view with my arms, I write eight random letters on one side. Then I say to the kids, "I'm going to show you this paper, with eight letters on it, for two seconds. Then I'm going to test you to see how many letters you remember."

"No, please don't test us!" says Felicity. "It's too stressful!"

"It's not a test like at school. It's a scientific experiment."

After I show them the paper for two seconds, the kids start shouting out letters. The most anyone can remember is four.

"Now," I say, "I'm going to write down *eleven* letters, show them to you for only *one* second, and I bet you right now that you will remember every letter."

The kids make sounds that indicate their amazement and doubt.

I write the letters, again shielding them from view, then raise the paper and display it for one second before putting it out of sight.

"New York City!" they shout in unison with big smiles, including Talia.

They are easily able to name every one of those eleven letters.

"Why?" I ask. "How can you remember all eleven letters when before you could remember only four out of eight?"

"Because they're words," says Talia.

"Yes!" I say. "Bravo, Talia! There is structure! The letters are organized into words! The more words you see, the more words you recognize, and the easier it is to read. It's just like recognizing the people in this room and knowing their names. Joshua is going to help you with that."

"Thank you, Joshua," says Talia. She takes one deep breath, in and out, and her face relaxes.

Dylan, one of the soccer players in the group, places a yellow card in front of me.

"A penalty? For me? What did I do?"

"It's for making Talia cry."

"No he didn't," says Talia. "It's just I get in trouble at school when I can't read."

"You *can* read," I say. "You're learning how. You're always learning."

"Wait," says Felicity, rerouting the conversation. "What does an old man have to do with us?"

"A lot. You'll see."

Not everyone speaks that first day of *Don Quixote* class. Nor do they need to speak—not until they're ready.

Wendy, aged eight, has the smile of someone who agrees with life. I have never seen her angry or worried or bothered by anything. Her teenaged sister, Ruth, sits next to her, paralyzed by anxiety, her default state. Neither sister says anything.

One girl, Sarah, who at age six in the spring joined the little school—la escuelita, as the families call it—is now seven. As always she is silent; her eyes track everything that happens in the room and her face reveals nothing of what she thinks. She is also drawing with her pencil inside her copy of *Don Quixote*. I almost ask her not to, but I stop myself. The book belongs to her.

"All right," I say, "Let's read!"

———

Kid Quixotes weaves together three main narratives: the story of Sarah, a shy little Mexican girl, and her family living in

Bushwick, Brooklyn; the story of Stephen (me), a former public school teacher recovering from bipolar depression; and the story of Still Waters in a Storm, the one-room schoolhouse where Sarah and her peers and I translate *Don Quixote*, adapt it as a bilingual touring musical show, and—in the process—rescue each other. Running through this weave is the secret world of Sarah's imagination, drawn by her in the margins of the novel, in which she is a superhero battling monsters and defending the defenseless.

Sarah's story, representing those of her classmates, is one of coming out of hiding—as is mine—and the story of Still Waters is the story of our shared sanctuary, a place where everyone is safe. Our show, *The Traveling Serialized Adventures of Kid Quixote*, takes us on the road, outside the safety of our little school, with purpose.

The kids and I meet in Bushwick, our Brooklyn neighborhood, five times per week: Monday through Thursday after the kids are released from their day schools, and on Saturday. All classes are free, there is always food (provided by me or by the families), and there is no admissions process. Whoever appears is part of the group. The name "Still Waters in a Storm" was composed by a student of mine at Bushwick High School, a young poet named Angelo who, before and after naming the school, has spent a number of years in jail. He said that the group, wherever we met, was a place of peace in his stormy life.

The one rule at Still Waters is "Everyone listens to everyone." It's a simple maxim that produces beautiful, complex results.

Everything we do—whether Spanish, English, Latin, or

music—is based on the same ritual of reading a text, discussing it together, writing a response, and taking turns reading our responses to the group. There are no tests, homework, or grades, no punishments or rewards—just reverential listening to each and every person in the room.

The Still Waters practice of careful, reciprocal attention is inspired by Alcoholics Anonymous, Quaker prayer meetings, and psychotherapy, and it creates deep trust among all people in the group across a wide range of ages. Years ago, when I had my breakdown, I didn't know what I know now: this cross-generational group, this random family, was what I was missing.

———

The pedagogy of attention at Still Waters came to me in part through Denise, one of my high school students, who was also an alcoholic. At least twice a week she would drink so much she would black out, often waking to find herself in jail (one time for attacking a police officer). When she wasn't drunk, she was a brilliant poet.

Denise would call me often to read me a new poem over the phone, and the conversation would always turn to alcohol. More than once I was able to talk her into pouring a bottle of vodka—her favorite because it was hard for other people to detect on her breath—out of her third-floor apartment window. She held her phone out the window, too, so that I could hear the poisonous liquid splashing on the sidewalk.

Growing up in Canada, I learned that if we were playing hockey on the frozen lake and somebody fell through the ice, we were *not* to go to the hole to help them: the ice is weakest

at the edge of the hole, so we would fall in, too. Instead, we were to go to shore, and from solid ground, throw a rope or a extend a tree branch for the swimming person to grab.

Likewise, there was no way I could sustain the rescue operation for Denise on my own, so I brought her to her first Alcoholics Anonymous meeting nearby her home. It was very simple: everyone took a turn speaking while the whole group listened. This basic ritual was a solid footing for relationships that had a chance of pulling people up from drowning. Why, I wondered, is this practice only for alcoholics?

Around that same time, after reading about the Religious Society of Friends (Quakers), I visited their Brooklyn location to experience the ritual myself. The meeting room was unadorned and full of light. There was no order of worship. Everyone sat in silence, heads bowed, until one person rose and spoke. When a Friend was moved to speak or sing or recite poetry, everyone else continued to sit and listen to that person. Time passed before the next person spoke, although nobody was obliged to say anything. There are variations on the ritual, but this is the heart of the practice: the silence, the occasional speaking, and the constant listening—and the idea that anyone can supply ideas for the group to contemplate, for each person is divine.

The single classroom at Still Waters in a Storm is a storefront with a large, transparent window and a glass door. Those inside

can see the neighborhood go by and the neighborhood can see into the classroom, our neighborhood within the neighborhood. The sirens of ambulances, fire trucks, and police cars, the music blasting from nearby buildings, and the shouts and laughter of pedestrians often make the room noisy.

There is nothing spectacular about the interior, just a collection of ordinary household wooden tables and chairs and an array of very full bookshelves of varying sizes hugging the walls. We have a piano and a couch, and a half dozen floor lamps light the room. One wall is a chalkboard that displays kid graffiti and the conjugation of the Latin verb amare, "to love." All year round a string of multicolored Christmas lights runs across two walls, and one wall is filled by a scale map of Bushwick—hand-drawn—with children's writing inside the blocks where they live.

Yet visitors often gasp and smile and gaze slowly around the room when they enter for the first time. They expect a classroom with rock-hard institutional desks arranged in rows and humming fluorescent lighting from above. What they see—a living room, a home—surprises them. They feel welcome; they belong here.

The real miracles—from the Latin for "objects of wonder"— are the children. People may smile at the room when they enter, but they leave in awe of the children and the relationships among them.

My job is to make sure that our mutual listening is practiced with devotion. I am often passionately reminding everyone that most of us don't have a place to go where other people will simply listen to our stories and accept us: if we want to

speak to the group, we need to raise our hands to be acknowledged, so that the conversation isn't dominated by the fastest or loudest among us.

I have a certain experience and expertise in literature and theater, but the kids, too, each have their own experience and expertise. We are all experts on our own thoughts and feelings; nobody, no matter how young, is an empty vessel; no one knows better than we ourselves what lives in our minds and hearts. When listening to each other, as in the Quaker meetings, there is no need for an authority to negotiate for us. Our reverence is for each other.

We listen to each other in a sacred hush, even as the streets of Bushwick holler all around.

Psychotherapy taught me that devoted, mutual listening can save people from despair. After giving me the diagnosis of bipolar depression, my psychiatrist told me that I would eventually recover, with a combination of medication and talk. I imagined that *talk* meant advice—someone telling me what to do—but it turned out to be a process of storytelling and revision. My therapist would ask me to tell the story of my suffering, and she would answer by reflecting back to me what she heard. Often the story and the reflection sounded different to me. There was a gap between what I said and what she received, so I would try harder, over the course of years, to articulate what I was thinking, to close that gap, to understand myself and to be understood.

Our other discipline is reading and writing. One influence in this academic arena was the writing workshop that ran all the way through my three years at the Yale School of Drama. Every week, one writer in the small group, which usually was composed of one professor and five students, submitted an essay for the group to read. During class, the professor would read the essay aloud while everyone else followed along on their copies. After reading the whole essay, the professor would start reading again at the beginning, and this time the group was allowed to speak: to analyze and criticize the writing, sentence by sentence.

This process—the relentless ripping apart of every phrase, delivered in a tone that said the writer should have known better and needed to be shamed—knocked out all of my belief in my ability to write and thereby ruined my belief in myself and the value of what I had to say. My classmates suffered the same abuse, and all of us would later confess that, after our first session or two, we had to run to the restroom to weep.

There *was* a stated purpose to this activity, though the rationale often went unfulfilled. The goal of our writing, said the professors, was exactitude; the corresponding goal of reading these essays was to locate failure of exactitude. The professors did not want us to summarize someone else's thoughts or to quote another writer or to stray from the heart of the matter. They wanted our ideas in our own precise words. The standard was high, and deviation was derided, but I am grateful that— after I survived multiple harsh critiques—I had learned the necessary courage and resolve to speak for myself.

At Still Waters, we aspire to hear each other's true thoughts, but without the threat of shame. Instead of attacking or policing

standards of expression, we ask kindhearted questions in order to better understand what the writer is saying.

———

Still Waters in a Storm began in the spring of 2008 as a small gathering in my apartment on Saturday afternoons, an opportunity for me to stay in touch with my students after I had resigned from teaching for the New York City Department of Education. Despite the violence and desperation of Bushwick High, I loved the kids and I wanted to continue teaching, but in an environment that truly encouraged empathy and learning.

The key, I would discover, was reciprocal listening among all members of the group across a range of ages.

As a teacher at the high school, I represented the institutional power against which my students rebelled. Their presence in the room was compulsory, and they were required to obey my orders. They competed for the attention of the only surrogate parent: namely, me. There were ways I tried to let them know that I was a person who cared about them as individuals, despite the impossible 150-to-1 student-to-teacher ratio across my five classes. They wrote in journals, and I wrote back to them in private ungraded, uncritical correspondence every night, but it wasn't until Still Waters that I discovered that the need for attention didn't always and totally have to be answered by me. The group could take care of its own.

After that discovery, classroom management was a breeze.

At Bushwick High, where I first heard the term "classroom management"—a skill much different from teaching—I often lost my temper, raised my voice, even threw chalk against the

board where it exploded into dust. Once I hurled a book up into the dropped ceiling of the classroom—it never came back down—and overturned an empty chair. I resorted to threats of poor report cards, or I called parents who applied their own kind of discipline at home. This phone call was the action that the kids feared most.

———

As the group grew in number—from two to six to twelve to fifteen, and the kids brought their own kids, siblings, cousins and friends—across the passing of two years we moved from my living room to a local pizzeria to our own dedicated storefront classroom in the neighborhood, rented for us by benefactors who believed in the work we were doing together. Friends and family and social assistance kept me fed and housed until I began applying for and receiving grants.

That spring of 2010 we started to meet in our new home on weekdays as well as Saturdays. Parents walked by the classroom, saw kids inside and asked what was happening. I told them we were practicing reading and writing. They asked if I could help their kids with homework and I said, "Sure!" and held open the door.

My old high school students—those who were now in college—became volunteer tutors for the younger ones. Not only would they help with homework, they would also read aloud to their little partners and talk about what they were reading, what it reminded them of, and how it made them feel. The kids began leaping up reading levels at school, and their mothers told more mothers what was happening. I put the word out to friends I'd made from my thirty years in town, and

to college students via professor friends, that kids in Bushwick needed homework help, and many came to volunteer.

Alas, weekday homework help started to distress me. Saturdays were still reserved for the ritual of reading, writing, and listening, but on weekdays I was essentially back in the public school system. The problem was that homework help was the prize parents valued, the reason the room was filling up with kids.

So, for the sake of joy, I began in 2011 to offer classes each day, Monday through Thursday, after homework time: reading literature on Mondays and Tuesdays, Latin on Wednesdays, and small group mentoring on Thursdays. Volunteers who helped with homework also stayed to work with the kids in class. About twenty-five kids regularly came to weekday classes, along with a staff of five or more volunteers. On Saturdays we could rely on an average of fifteen volunteers to work with upwards of fifty kids. I just kept saying "Yes!" to anyone who asked to come in.

Mondays and Tuesdays we read out loud, wrote about, and discussed classics of children's literature including *The Call of the Wild*, *The Jungle Book*, *A Wrinkle in Time*, and *Alice in Wonderland*, one book per year, taking our time to understand each sentence. There was no real deadline—our lives were already busy and structured enough. This reading was for pleasure. In 2015, we sailed into *Paradise Lost*, the seventeenth-century epic poem by John Milton that baffles college students. We collectively translated it from the original intricate verse and antiquated English into our present-day vernacular as we read, writing and speaking about the ways in which it is still relevant to our lives.

We teamed up on Wednesdays with the Paideia Institute, a nonprofit advocate for the study and conversational use of Latin, who supplied a rotating roster of fifty passionate classicist volunteers including high school students, college and graduate students, teachers, and professors.

The Thursday mentoring groups, each with two or three kids—as many as twenty groups on any given day—were guided by volunteers from all walks of life. There were college professors and their students of writing, science, mathematics, economics, literature, religion, language, and history. Tradespeople from a wide range of professions, such as an electrician, a nurse, a doctor, a detective, a lawyer, a politician, an architect, a social worker, visual artists, actors, musicians, songwriters, photographers—all came to volunteer. My former high school students, honored to be thought worthy of such responsibility, were especially kind and devoted to the little ones. Many volunteers found Still Waters by reading about us in social media or were referred by their friends and acquaintances, grown-ups who would read and write and talk about daily life together with the Still Waters students, and, in the process, provide examples of the variety of lives that are available to the kids as they grow.

Saturday afternoons we welcomed accomplished authors who would read to the kids and participate in our ritual by listening as the children read their own work in return. This exchange began when a dear friend of mine who happened to be a world-renowned writer visited us on a Saturday in the early days of Still Waters and was moved by the reciprocity he found. He was accustomed to reading his work in public— always for grown-ups—with a moderator, who would introduce

the reading, have a conversation with the author, and perhaps elicit two or three questions from the audience, who themselves had come to the event because they knew his work. The Still Waters kids, by contrast, had no idea who he was apart from the fact that he had written the book he read that day. They were polite, but not at all in awe. Their written responses to his work, spoken aloud, balanced his own reading, and the process created a partnership he hadn't experienced before in his long and celebrated career. In that space, the children's voices mattered as much as his.

Rapidly and for years to come, he reached out to friends of his and pushed them to visit Still Waters, telling them that a day with these kids would "lift up your heart." "You will be beloved," he wrote, "rather than admired." The writers came and in turn recruited their own friends to come, with the same promise that had been made to them before their first visit.

This relay radiated swiftly, and soon we counted more than one hundred writers as our friends. Every time these writers gave their full, respectful attention to the kids, the kids received the message that their words mattered, not only inside the room but beyond, in a world where they could one day belong.

———

Just as important as practicing the culture of listening is choosing the right puzzle for the group to work on. The kids at Still Waters love the puzzle of translating Latin and the puzzle of reading *Paradise Lost*. Classroom management here needs no strategy: the puzzle is the strategy, the curriculum, and the goal.

The Traveling Serialized Adventures of Kid Quixote project began at Still Waters early in the fall of 2016, in the school's ninth year and just two months before an election that would release a plague of fear among vulnerable people, humans in need of asylum and a second chance.

For our reading class I chose *Don Quixote de la Mancha* by Miguel de Cervantes (originally published in two parts in 1605 and 1615) because that book is everything human—it is funny and tragic and beautiful and disgusting and smart and stupid—and because it was written in Spanish, the native language of my students and their families. This time we would not only be reading together out loud, we would also be translating the novel collectively, by speaking and writing, from Spanish into English, and for five years instead of one. Later we would also decide to adapt our translation as a series of bilingual, musical "Adventure Plays," reimagining the story of a delusional old man in Spain of the early 1600s as the story of a group of Spanish-speaking immigrant children living in Brooklyn today.

By reading one book across a period of five years, the Kid Quixotes (as they call themselves) are reclaiming the patient practice of reading itself—the play opens with Sarah as the titular Kid Quixote sitting on the floor and reading in silence, and it ends with the words, "Let's read!" sung by the whole group. In three years, our group has only read the first twenty-two chapters of *Don Quixote* (234 pages), an average of about seven chapters (78 pages) per year.

By reading slowly, we make sure that everyone in the group understands the story in depth. There's also pleasure to be had in thinking, and we don't want to hurry pleasure. As we read

aloud we often stop to talk, to debate choices in translation, and to relate the reading to our own lives, which is how the work of adapting begins. These conversations help us to know each other and ourselves and to discover common ground between Cervantes and our group, a process that takes time and can't be coerced any more than the growth of a flower can be accelerated by yelling at it or pulling it out of the ground.

Slowing down is a rebellion. Students struggle with deadlines in their day schools for homework and tests. If they don't understand the material they've been studying by the deadline, they are said to have failed. Taking five years to read one book states that the experience of reading, not the time frame, is what matters most.

———

"What do we call this show?" I ask the group in rehearsal the night before our first performance at a private home in Manhattan. "People will want to know what it's called."

Nobody answers. They're all thinking.

"Well," I ask, "What are the important words to describe the show, so people have some idea of what they're going to see?"

"Quixote," says Felicity, who will end up not performing on the tour because she and her mother are afraid of what could happen to her away from home. "And kids."

"Adventure," shouts Percy, who is vibrating with anticipation.

"Funny," says Sarah.

"Also sad," Rebecca says.

"*The Sad, Funny Adventure of Quixote, by Kids*?" I offer.

Lily, aged sixteen at the time, objects. "I think we need to let the audience decide if they find it funny or sad. We can't tell them what to think or feel."

Everyone nods and says yes, that's right, respect the audience. I revise the title: "*The Adventure of Quixote, by Kids.*"

"It's not just *by* kids, it *is* kids." This is Joshua. "How about *The Adventure of the Quixote Kids?*"

"There's more than one adventure in the play," says Rebecca. "We could say, *The Adventures of the Quixote Kids.*"

"But just like Quixote in the book," says Lily, "*We* are also having adventures on the road by doing the play in many different places. It's a traveling show, like a carnival. We need to say that."

"*The Traveling Adventures of the Quixote Kids?*" asks Ruth.

"Yes!" says Lily, her face opening and closing in reflexive self-doubt.

"That makes it sound like there's more than one Quixote," says Rebecca, Lily's younger sister, a middle child who is as tenacious as a badger. "Or like Quixote is our father and we are all his babies."

The group laughs at the idea.

"There is a way," I say, "that all of you are Quixotes. You're bravely going out into the world with your story, every one of you."

"But people will be confused because in the show there's only one Quixote," says little Talia, who wept two years ago about not being able to read.

Alex, our beloved, mysterious adolescent, raises her hand. Everyone goes quiet. This is what Alex does; she waits, she listens, and then she puts things together.

"*The Traveling Adventures of Kid Quixote.*"

"I love that!" says Joshua. "It's like the name of a superhero: 'Kid Quixote!' Sarah, you will need a cape!"

Everyone laughs.

"I'd like to add one more word," I say. "'Serialized.'"

"That sounds like 'cereal,'" says Percy. "It makes me think of Captain Crunch."

The kids all laugh.

"It means 'in a series,'" I explain. "Like a TV series, where you keep adding stories. That's what we're doing, and when people read that word they will know that more adventures are coming."

"'Tune in next time,'" says Percy, to the delight of his adoring crowd.

"So," says Lily, "We have *The Traveling Serialized Adventures of Kid Quixote*. Raise your hand if you agree."

The agreement is unanimous.

The families of Still Waters in a Storm have left their native soil for the promise of prosperity and peace, only to run into the hard reality of the Bushwick barrio, just as Quixote leaves his village in order to live out his fantasy of heroism and discovers that the road can be hostile to dreams. His persistence despite the wide and heavy obstacles in his path runs parallel to the undeniable determination of these families, the parents who risked everything to come to this country, and now parallel to their children who are remaking classic Spanish literature as a bilingual vessel for their own stories and the stories of their people and traveling together in defiance of biases.

The word *translate* comes from the Latin, meaning "carry across." Translation, across languages and borders and cultures and identities and generations, is a fundamental experience of these children and their families. They live in two worlds and must always move between the two, the children often helping their parents, for whom the duality of the immigrant life is especially difficult, by negotiating between Spanish and English at school, the doctor's office, or in court. The multiple ways *The Traveling Serialized Adventures of Kid Quixote* crosses art forms, history, geography, gender, fiction, and reality in addition to language widen the very idea of translation.

After three of a projected five years devoted to this project, the kids continue all of these crossings—while also teaching me how to speak Spanish—as a group, negotiating every word of dialogue, every lyric and note, until they reach consensus. They perform their ever-growing work in non-theatrical settings, such as private homes of the rich and poor, college classrooms, and government offices (including City Hall), places where friends of Still Waters have invited us.

This is their brave, public response to the nationwide scapegoating and persecution of their people, fueled by a government trading in xenophobia and hate: the kids manufacture a cooperative belonging. Having all ages sit around the same table recreates our ancestral tribe, an extended family where the big ones care for the little ones and the little ones, in return, with naïve gratitude and silliness, lift up their hearts. Seeing through each other's eyes, benefiting from multiple visions and a variety of truths that widen our understanding of everyone, we all feel loved and necessary.

Collective storytelling and choral singing are ways of

making a community in class, in rehearsal, and—with the consent of the audience—in performance. These compositions and presentations are emotional, imaginative art and deliberate social action. The children are showing that they belong, in our group, in Spanish and in English, in all neighborhoods, and in the worlds of literature, higher education, and civic power.

They belong in this country, and this project will carry on—beyond five years if necessary—until the whole country agrees.

- 1 -

The Rescuing Song

A girl is born. A sweet and goofy girl.

She is born to throw thunderbolts at those who trample down the tenderness of things.

She learns to speak Spanish and English.

She contains multitudes.

This girl lives in a Brooklyn barrio, where her father teaches her how to defend herself on the streets, and she carries inside her Mexico, the countryside where her mother as a child daily dug up potatoes and harvested corn—corn that was blue, red, white, and yellow. She crushed the corn between two rocks, making flour for the tortillas cooked on a flat stone above a fire out in the field. After dark, all nine children and two parents slept on a dirt floor in a one-room wooden shack. They had no electricity and rarely a candle. In the fields the children would tie a rope to a tree branch to make a swing and play pretend that rocks were cars. They were poor, and most days a total

of two tortillas was all each person was allowed to eat, but no one ever got sick.

The girl carries inside her the violence of her mother's father, a man who would drink alcohol and beat his wife and daughter, whipping them with ropes and hitting them with the fallen branches of trees. He told them they were not allowed to go to school because they couldn't afford a pencil, and school was a waste of time when there was food to be gathered in the fields. His wife found a discarded pencil in the village and hid it at home so that her daughter could practice writing in secret.

That daughter, the girl's mother, would eventually walk for more than two weeks across the burning desert sand, carrying nothing, avoiding snakes and going days without water, to climb over a wall into the promised land.

The girl's mother has stopped the legacy of violence. She has never raised a hand in anger, except once, when she held up a leather belt as a warning to her misbehaving children and the girl asked, "Are you going to do what your father did?"

The girl never speaks an unkind word to anyone. When asked what she would say to Immigration and Customs Enforcement (ICE) agents, she says, "Please stop doing what you're doing." She would not insult them, but suggests that they might try living in a cage or walking across the desert— not as revenge or punishment, but to better understand what migrant people are suffering. Empathy can bring understanding and wisdom.

"Their hearts need to grow, like flowers," she says. "Flowers need water and dirt and sunshine to grow. The hearts of ICE need to be loved; they need the enjoying of something, or

hanging out with friends; they need the celebrating of themselves, and beauty and nature."

This kindness is her thunderbolt.

The girl has learned from her mother, who learned in turn from her mother, always to say, "Please" and "Thank you." These are not just superficial manners. She approaches everyone with genuine respect and gratitude.

Her heart beats at twice the normal rate for children her age, her mother says.

Her name is Sarah, she is seven years old, and she is Kid Quixote.

At Still Waters in a Storm, the day after the 2016 United States federal election, about a dozen of my students and I sit around our table—which really is four tables pushed together, surrounded by chairs—ready to continue our ongoing collective translation of *Don Quixote de la Mancha* from Spanish into English. The surface is stacked with copies of the novel in Spanish, Spanish-English dictionaries, a Latin dictionary, an etymological dictionary of English, books of synonyms in Spanish and in English, and a big coffee cup full of sharpened pencils.

But we can't begin, because no one can speak. The silence is alive and monstrous. Goliath has been chosen ruler by riding a wave of racist hatred against immigrants, a rolling, roaring fire that burns but gives no light. The lives of my students and their families have been plunged into fresh horror. We use the names Goliath and ruler to remind us that such horrors have risen before, and to seek solace and resolve in the patterns of myth and history. Giants have come and gone.

Early in 2017, after the swearing in of the new ruler, The Legal Aid Society distributes a flyer to schools and community centers in New York—in Spanish and in English—warning migrants, in all-capital and boldface letters, not to open the door. Migrants are being hunted by officers of ICE, and while New York is officially a "Sanctuary City" where the immigration status of residents is supposed to be protected, nothing is sacred anymore. I post a copy of the warning on our bulletin board and give a copy to each of the families I work with. They trust me with their children's safety every weekday after regular school is over and all of Saturday afternoon.

In class we speak about the very real danger the children face, the danger of separation from their parents. We talk about the "Cold Room" where ICE agents confine refugees, a room held at a very low temperature, where the asylum-seekers are fed frozen peanut butter sandwiches.

The children in their fear remind me of sparrows: tiny birds who gather in bushes and chirp to each other before a coming storm. Sparrows never seem able to relax. Even when they're not hopping or flying, their heads keep moving, turning swiftly, rotating in at least a dozen directions in quick glances of precise panic, scanning the sky for falling doom.

"Why do they hate us?" asks Miriam, a guarded eleven-year-old girl who brings her pet birds to class in a box with a hole in the top and lets them fly around in the bathroom. "They don't even know us."

"That's why," says Joshua, the tallest person in the room, a gentle adolescent boy adored by the younger ones for his kindness and patience. He dresses daily in a black vest decorated

with a red carnation. And every day they tease him when he walks in the door, calling out, "Oh, no!" and he smiles, because he recognizes love. Joshua is fourteen years old and has been coming here since he was seven—half of his life.

"What can we do?" asks Felicity, who struggled with reading until it was discovered that she needed glasses; then she could see the words.

"Do you remember what you said in September?" I ask her. "When I gave you your copy of *Don Quixote* and I told you that we were going to translate the book?"

"I said, 'That's impossible. That book is too big and heavy.'"

"That's what we do," I say. "We do what seems impossible."

"Why impossible?"

"We're practicing slaying the giant, destroying the idea of impossible, so we know that when the time comes, we can bring down any Goliath."

"With a book?!" she asks in baffled disbelief.

Percy, the next child to speak, has eyes so bright and dancing they remind me of a young coyote I met once at an animal rehabilitation center. The abandoned, injured pup could not be released back into the wild because she had become attached to the humans who worked at the center. I had never seen eyes so fully alive.

Percy wears blue goggle-style unbreakable plastic glasses, the kind supplied by schools to kids whose families can't afford to buy glasses. He is always reading, all throughout class, but not always the book he is *supposed* to be reading. He loves *Calvin and Hobbes* comics—illustrated stories of the adventures of a little boy and his tiger who may or may not be real—and

holds a volume on his lap, just under the edge of the table. Percy has frequent outbursts. All of the kids get excited and have trouble waiting for their turn to speak, but Percy seems completely unable to comply with our egalitarian system.

Now he shouts, "We could hit him on the head with the book and knock him out!" Everyone laughs.

"That's not enough, to just do something impossible," says Rebecca, an eleven-year-old girl whose intellect is always sending out sparks. She used to walk with heavy steps, as if gravity paid special attention to her. After taking a dance class, she has learned to walk with grace, with air beneath her feet.

"Outside this room, nobody knows what we're doing. It's a secret."

"All right, then," I ask. "What else can we do?"

Alex, fourteen at this time, a girl who almost never speaks—and when she does we all need to lean in to hear, her voice like breath itself—now says, "We need to sing to people."

Sarah's eyes and mouth pop open in a cartoon-like but genuine expression of surprise.

The room goes quiet.

Over my three decades of teaching—in New York, Vermont, and Canada, at the elementary, middle school, high school, and university levels—there are two actions that most students have said they can't perform: drawing and singing. They can draw and sing in private, or maybe with a trusted friend, but in public the vulnerability is too wide open, like falling in love. You show your drawing or sing your song, or say, "I love you" and, with your heart slamming and your vision distorted, you ask to be accepted.

I know the kids are afraid to sing.

"If you want to sing, we'll do it together," I say. "You won't be alone."

"Why did you choose *this* book?" asks Felicity, who always asks about what she wants to know, regardless of the topic we're discussing.

"I chose this book for us because it's our story. The crazy old man could be me, trying to help people, but he's also you: he has the heart of a kid and he believes in what his imagination shows him, like kids do. He keeps getting beaten and knocked down, but he also keeps standing back up. That's you and your families. You never give up. And listen to what you're saying right now! You're asking what we can do when evil rises against us. You want to fight back!"

Felicity says, "This is a civil war!"

"Yes!" I shout as I jump up out of my chair. "It *is* a civil war! And we need to win!"

Years before, at Bushwick High School, I had tried to dissuade a student of mine, Lucy, from fighting after school. I saw her in the hallway getting ready: tying back her hair, removing her earrings, and putting Vaseline on her face so that her opponent couldn't grasp her. Lucy was short and dark-skinned, and the whites of her eyes shone through her face like daylight piercing the rainforest heights.

"Just walk away," I told her. "Come to rehearsal; I got sandwiches." Food always brought kids to rehearsal.

"Mister Haff," she said, "You don't understand how it goes. If I don't fight this bitch right now she's going to make my whole life hell. I can't back down."

I had a lot to learn about reality in the neighborhood.

Lucy was a fighter in multiple ways, both in taking on bullies on her block and in the lunchroom at Bushwick High and in swearing to carry on despite the loss of her sister Beatriz to asthma, though she daily blasted God with her blameful grief.

"If God is good," she asked me once, "why would he let Beatriz die like that? She never hurt anyone. She was even polite to all the boys who followed her around, and they didn't deserve that. There is no God. You want proof?" She looked up at the sky, framed her crotch with her hands and yelled, "Suck it, motherfucker!" Then, with a smile, she asked, "See?"

———

"How do we win?" asks Dylan, another eight-year-old. He loves the New York City subway system and knows every train line and station and when there are delays because of track repairs or accidents. When the kids play soccer on the sidewalk in front of Still Waters, Dylan is the referee. He blows a whistle and pulls out yellow or red penalty cards from an official referee's wallet.

Felicity replies, "We win by making people know us, by reading this book to them."

"But how will they know it's our story?" Dylan asks.

Alex raises her hand and I call on her. Everyone leans in towards her, listening.

"We could act it out," she says. "And sing it out. Then they would know it's us in the story because they can see us in the story right in front of them."

"The book is a boat we're all rowing into war!" shouts Percy.

"But I don't want to act," says Felicity. "I'm scared. Can I just do the writing part?"

———

While translating one scene from the original Spanish into English, the group disagrees for nearly an hour about the precise meaning of the Spanish word *desfacer*, an antiquated verb that wasn't in our Spanish-English dictionary; we had to call a friend, a professor of Spanish literature, to get the basic definition.

Quixote, an old man who believes himself to be a knight errant placed on Earth to rescue the needy and defend the defenseless, hears the cries of a shepherd boy who is being whipped by a landowner—which the kids translate as "landlord" in keeping with their own experience with owners of property—for carelessness in losing sheep on his watch. High on horseback and brandishing a spear, Quixote stops the whipping, unties the boy from a tree, and commands the landlord to pay the boy his wages, which have been withheld as further punishment. The hero departs, trusting that he has rescued the boy and undone a great injustice; but the boy is quickly bound again and the whipping resumes, until the landlord grows tired and unties the boy, leaving him for dead, fallen on the ground.

When the landlord immediately resumes whipping the child after the hero's departure, he says that "you'll see how Quixote 'no desface' this injustice." Some kids argue for "won't undo (this injustice)," others vote for "can't undo."

"'Won't,'" says Lily, "implies a lack of will on Quixote's part, a choice not to help."

"That's good!" exclaims Joshua. "The landlord wants to make the boy lose heart and feel hopeless."

"But there is no way that my character would believe that Quixote would choose not to help," says Rebecca. "I would know it's a lie."

"Exactly!" shouts Lily, and then, moderating her voice, "'Can't undo' is more accurate; to say that Quixote *can't* help means that the injustice is fundamentally beyond his power to change it."

"No matter what he wants," agrees Joshua, finishing the thought and nodding his head.

Rebecca, seeing the logic, concludes, "And that is truly hopeless."

"I don't know," says Joshua. "Maybe we're making too much of the 'won't' connection to human will. Maybe it's just the way English grammar works."

"'Won't' could also mean that Quixote fails to undo the injustice for some other reason," I say. "He might be distracted or get lost on the road. That wouldn't mean he's powerless, just that the event doesn't happen in the future."

We are pushing each other to consider every possibility packed inside these two words.

This classroom scene will become part of the play. The story stops as the group reenacts the debate, improvised every time. They finally hold a vote, including the audience. The majority decides which translation to use—"won't" or "can't"—the scene reverts to the start of the second part of the whipping and carries on, revised, from there.

There is no right or wrong answer, only a choice to be made.

"Let's ask ourselves," I ask the group in class, "do we have the will to undo injustice?"

The whole group shouts, "Yes!"

"*Can* we undo injustice?"

They stop to think.

———

The next week, we start working with composer Kim Sherman, whom I've known since our days at the Yale University School of Drama in the early to mid-1990s. The group is beginning to write lyrics for our first *Traveling Adventures* song, "The Rescuing Song," based on two passages in *Don Quixote*. The first passage is the scene where the landlord whips the shepherd. It is at this moment, specifically after the landlord has told the boy to keep his mouth shut, that the kids decide the boy has to sing.

This is how they will choose the adventures to include in our play: whenever they feel strongly as we read that there desperately needs to be a song. Kim has told us that songs happen when words alone are not enough, when the feelings are so strong that there is an emergency need for transcendent or deep-diving expression.

"Why does he need to sing here? What does he want?" she asks the group.

"To be understood," says Lily, sister of Rebecca. Two years later she will become the first kid from this group—and the first among her ancestors—to graduate high school and attend college.

"The landlord is telling the boy not to speak," Lily continues, "So he sings. That's the boy's way of fighting back against the power of the landlord. If people in the audience hear the song and understand him, they might want to help."

"How does he begin? What does he say first, to get their attention?" I ask.

"Please understand me?" offers Lily, a shadow of uncertainty crossing her face—as always—immediately after she speaks.

"It needs to be more desperate," says Joshua. "He's trying to save his own life."

"'I *beg* you to understand me,'" says Rebecca, and she looks out the window to the street. She rarely makes eye contact with the group.

Then she adds, "'Please listen to my voice.'"

She suddenly turns to look at me with eyes full of purpose. "Can I be the boy?"

———

The first step in writing "The Rescuing Song"—named by the kids for the desperation of the historical moment in which we are writing it ("We all need rescuing," says Rebecca)—is to make a list of who and what we want to rescue.

Sarah writes, "Poor people, immigrants, kids in cages, little kids that came here by their self, girls, hungry people, people getting bullied, humble people, my neighborhood, my family and the Earth." While she doesn't say so directly, it seems she might be trying to rescue herself, reaching in as well as reaching out.

Lily, at age sixteen nearing the threshold of being adult, says, "We need to rescue our childhood!" This idea eventually

becomes a lyric near the end of the song: "Hold my hand, please, and save my childhood."

The group then speaks about what this could mean, to save childhood, and the word *safe* comes up repeatedly. The words *save* and *safe* have the same Latin root: "to save" means "to make safe."

I realize that during my own childhood, safety was a given, not something to pray for.

The kids read aloud from written lists of words that they associate with the idea of saving childhood, asking to be protected from drugs, alcohol, violence, and "bad words," which they say is verbal violence. Give us safe streets, they write, safe schools and safe homes. Return us to paradise, to nature, to grass and trees and clean air and clean water, and make room for us to play and to imagine. Towards the end of the song, this conversation becomes the lyrics:

Together let's go play
Let's pretend that we are heroes
We are here to save the day.

Some of the kids know abuse directly, and all of them feel beaten by the vicious, anti-immigrant rhetoric they hear on TV.

One day in rehearsal, Rebecca, who is playing the part of the shepherd boy as she requested, says, "This scene is too depressing. It makes me want to jump off a bridge."

Her sister Lily agrees, perhaps protecting her. "The great power of kids is that they love to laugh. They always find

what's funny at the most depressing time. Once, when I was younger, I had to leave a funeral because I couldn't stop laughing. I don't even know what was funny."

(Two years later a story will appear in the news about children incarcerated in a former Walmart store, separated from their parents at the border between Mexico and the United States. The children are, of course, afraid and depressed, but at night, after they've all been ordered into bed, one child starts mooing like a cow. The moo is echoed by another child, and another and another, until the whole makeshift prison is resounding with the voices of cows.)

I tell the kids that a writer named Nabokov said that to bring down a tyrant, you need to make him appear to be ridiculous. "How can we make the landlord ridiculous?"

"You could be the landlord," says Joshua.

"Thanks a lot!"

"No, wait! You're not ridiculous, but you're a white man, and white men have the power in this country. White men are abusing brown kids. And they don't pay immigrants enough for the work they do taking care of white men's property."

"That's true. I'll do it. But what about the funny part? What's funny about me?"

"The way you speak Spanish," says Percy.

I never studied Spanish in school, but I did learn her sibling language French and mother language Latin, so I have a linguistic structure to build on as we read *Don Quixote* and when the kids and their parents patiently help me to communicate with them. I'm forever using what I do know to guess what I don't know. I want to show the kids my own desire to learn and my willingness to make mistakes and ask for help; I want

to be brave for them. When I first began teaching at Bush-wick High School in 1998, I thought I already had to know everything and avoid what I didn't know in order to hang on to authority in the room. The power struggle was stressful and demoralizing; I resorted to yelling and throwing things. Since then I've gradually surrendered to the truth of how very much I do *not* know.

"All right," I agree, "so the landlord struggles to speak Spanish. Why does he try?"

"He tries to seem like he's humble in front of Quixote, as if he respects him," says Lily.

"And my character could help you," says Rebecca to me. "Because that's what we do."

Around the table, as our script grows by spoken improvisation, my character, justifying to Quixote his abuse of the boy, confuses *oveja*, the Spanish word for "sheep," with *abeja*, the word for "bee." This does not happen in the original book; the kids are mimicking my real-life attempts to remember Spanish vocabulary. Rebecca's character, visibly exasperated but never giving up, holds up her drawing of a sheep alternating with her drawing of a bee (both of which will become stuffed animal toys in the show) and asks me to repeat *oveja* and *abeja* again and again in turn, and when I still don't understand, she slaps her own forehead in frustration.

The dialogue runs according to the rhythm typical of my trying-to-be-bilingual exchanges with the kids and their parents:

LANDLORD: Señor—cowboy?

BOY: *Caballero.*

LANDLORD: Caballero. Gracias! This boy—muchacho?—careless?

BOY: *Descuidado.*

LANDLORD: Muchacho descuidado who I am punishing is one of my—mi—trabajos?

BOY: *Trabajadores.*

LANDLORD: Trabajadores. His job is to protect a flock of—abejas?—and no es responsible!

BOY: *Responsable.*

LANDLORD: Responsable.

BOY: Y la palabra es *ovejas,* no *abejas.* [And the word is *sheep,* not *bees.*]

The kids laugh at the back-and-forth as they write down what Rebecca is inventing: the shepherd boy, the victim of abuse, is now running the scene.

Nonetheless, when the whipping is complete and Rebecca is left alone, the scene still ends in darkest despair. The abuser wins.

The kids will not allow this to be. "We have to make this part funny, too," says Rebecca.

"But abuse isn't funny," Lily objects. "We have to respect that."

"Respect abuse? Never!"

"Respect the suffering. The suffering is really happening. It's not a joke!"

"Yes, we're living in fear!" says Joshua.

Again we strain to hear Alex as she says, "But we don't want to live in fear!"

"Wait!" I say. "'We don't want to live in fear' is a great lyric for the 'Rescuing Song!' I'm going to write that down!"

"Anyway," continues Alex, a little louder this time. "We have to fight back! And we don't have money and we can't vote so we have to refuse the despair. We can't give up."

"Ok, so she's down on the ground and she's in pain," I say. "She needs to stand up. The ground is for surrender."

Rebecca says she needs to work for resurrection. "If I get up right away that makes it look like the beating wasn't real."

"She could pretend it doesn't hurt," says Percy, as though this idea might come from his own personal experience.

"She could tell him it doesn't hurt and tell him that he can never break her heart," says Miriam. Her father only ever appears in her life once per month to give her the required parental support money, and Miriam never wants to meet him, but she does on her mother's behalf.

"'You call that a whipping?!'" hollers Rebecca, in character. "'It felt like a butterfly!'"

Everybody laughs.

"Now she stands up?" asks Felicity.

"Not yet. One joke isn't enough." Percy is a connoisseur and collector of jokes.

"The audience won't feel how strong she is until they see how hard she has to work to stand up," I say.

"I could cry," Rebecca suggests.

"And put your head down," adds her sister. "Then you have to lift your head up, too, before you can stand up."

"What makes her lift her head up?" I ask.

"Maybe a friend comes?" says Felicity, unsure.

"She doesn't have any friends. She got kidnapped by the landlord. She doesn't have a family anymore." Rebecca knows her role.

"But she has sheep!" shouts Percy, with perfect comic timing.

Everybody laughs.

"A sheep could tell her jokes!" Felicity is very excited about this development.

"Does anyone here know any sheep jokes?" I ask.

Nobody does.

"Time's up for today. Do your research. Come in tomorrow, each of you, with a sheep joke."

After everyone else has gone, Sarah remains. Her mother usually comes to collect her about half an hour late. Sarah is drawing in her copy of *Don Quixote* with a pencil, as she has been all day.

I approach her and ask her, "May I see?"

She nods her head yes.

All class, every day, Sarah is quiet. She looks at each person who speaks, her eyes as dark as the origin of everything, her long, black hair woven into two intricate French braids, one on each side of her head, pulling at the roots. There are thoughts in those eyes, and stories in her braids.

I sit down next to her. Inside the book, in the margins, I see a drawing of bulky, square characters.

"Who are they?" I ask.

"The Ice People," she answers.

"Are those ice cubes?"

She nods yes.

"I don't see eyes."

"They're blind."

"How big are they?"

"As big as a house."

"What are they wearing?"

"Underwear. That's all they wear."

I laugh.

"What language do they speak?"

"They beat their chest like a gorilla."

Sarah's mother Maggie (short for Magdalena), arrives. "Disculpa," she says, asking me to forgive her for being late.

"No hay problema," I answer, a statement I make often, as the grateful parents are always apologizing to me for something.

"Gracias!" she says, and nudges Sarah with her elbow.

Sarah says, "Thank you."

"Con gusto!" I reply. This phrase, meaning "With pleasure," is always my response, ever since I heard one of the mothers use it. I like it better than "De nada"—"It's nothing."

"By the way, Sarah, you can keep drawing in class. I want to know more."

She looks at me and nods.

———

The next day in class we have more sheep jokes than we can use. The three favorite jokes, by consensus, are:

"What do you call a cross between an angry sheep and a gloomy cow?

"An animal in a baa-aa-ad moooood!"

And:

"Why did the police give the female sheep a ticket?"

"Because she made an illegal *ewe* turn!"

And finally:

"What do Spanish-speaking sheep sing at Christmas time?"

"*Fleece* Navidad!"

This last joke eventually turns into the song, "Feliz [now 'Fleece'] Navidad," sung by the rest of the kids, who are wearing woolly hoods and representing the rest of the flock of sheep but also making a statement of compassionate solidarity among children. When we come to stage this scene, they will surround Rebecca, lift her up, and dance with her.

After everyone laughs, the conversation turns to who will tell the jokes. Will a kid pretend to be a sheep, crawling on all fours? We try that, right there in the middle of the room. It's not obvious enough that Dylan, the kid pretending to be a sheep, is actually supposed to *be* a sheep. Will someone hold up the plush toy sheep from earlier in the scene and make it appear to tell the jokes? We try that, too, using a stuffed toy

sheep I borrowed from my daughters the night before. Nobody is satisfied. "It looks like Dylan is just waving around a toy, and its mouth doesn't move," says Felicity.

"Make the sheep a puppet," says Percy, not looking up from *Calvin and Hobbes*. To make his idea very clear, and while continuing to read, he then holds up his hand as if it were a puppet and makes it say "Hello!" to the class. Everybody laughs.

When Percy says "puppet," I am transported back to the mid-1990s when I was making a living writing about theater for *The Village Voice*. The *Voice* had assigned me to report on the International Festival of Puppetry at the Public Theater.

At the festival I saw a performance by Stuffed Puppet Theater of the Netherlands. A large man was training a hand puppet—a flimsy, melancholy dog—to jump through a hoop. The man was cruel. He would whip the dog with a leather strap until it jumped. The audience vocalized their sympathy for the dog, groaning and gasping in unison at each blow and even yelling, "Stop!" The dog, trembling and glaring at the man, encouraged by the crowd, finally refused to jump anymore. The people cheered.

The man then tried to make the dog catch a ball in its mouth and spit it back to him on command. The dog did this a couple of times before stopping, glaring at the man, and spitting the ball on the floor. The two stared at each other. Finally, the man bent to the floor and retrieved the ball. The crowd cheered again.

I tell this story to the kids and ask them, "Who won that fight?"

"The DOG!" they shout.

"But wait" says Lily. "The dog is on the trainer's hand. That's the only way the puppet can be alive."

"But the people believe in the dog," says Joshua. "That's the important part."

Percy has one of his sudden, loud outbursts: "That's like *Calvin and Hobbes*! Calvin believes that Hobbes is a real tiger, so he *is* real!"

"Like God," says Miriam. "All that matters is what you believe."

"But what if you believe something and other people don't believe what you believe? Who is right?" asks Lily.

"What do you mean by 'right'?" I ask.

"I mean what is real and what is not real?"

"Reality is in your brain," I tell them. "Your eyes just let the light in—your brain makes the pictures."

Lily is not content with this answer. In fact, the group relies on her not being content with answers. "But why do we believe something even when we know it's fake—like the puppet? We can see that it's just a puppet, and we can see the person's arm going up inside!"

"Maybe we believe because we want to believe," says Alex, barely audible.

Joshua drops his head onto the table in histrionic mock distress. Thud.

"Ok," says Rebecca. "So, if the shepherd boy wears the sheep puppet on his hand—or *her* hand, because it's me—what are we saying?"

"We're saying she has the power to cheer herself up!" says Felicity. "Kids have Laughing Power!"

"And Imagining Power!" Dylan adds.

"Only kids have that power?" I ask.

"Yes. Grown-ups know what is really real and that's why they're sad." This is Percy, stunning us all with truth.

I want to keep the door open to other possible answers, so I say, "I don't think we're *saying* anything, necessarily. I think we're *asking* what is real. And who has the greater power, the abusive landlord or the laughing child?"

Everyone goes quiet, thinking.

———

After class, as yesterday, Sarah is sitting and drawing with her pencil inside her copy of *Don Quixote*. I ask her if I may see what she has drawn.

"Are those doors?" I ask.

"Yes, the desert is full of doors," she answers.

"Doors to what?"

"Doors to nothing."

"Standing on the sand?"

"Yes."

"Why," I ask, "are there doors in the desert?"

"They are traps. You open the door and the Ice People grab you from below. They pull you down into their underworld."

"Why do they live below the desert?"

"Otherwise they would melt. Their world is a refrigerator, a giant refrigerator as big as the desert, under the desert. That's where they keep the children."

I point to a large rectangle. "Is this the refrigerator?"

"Yes."

There is silence.

"I went there," she tells me.

"You went to the giant refrigerator?"

"Yes."

"When?"

"Last night."

"How?"

"I can go places when I pray."

"How does that work?"

"I light a candle for la Virgen de Guadalupe, I go on my knees and I ask her, 'Thanks for giving us food and classes to learn stuff, because in the future it's going to be tough and people might try to conquer our world and we need to be ready. And please let my mommy stay with me. And I always want to be young, even when I'm old, please.' Then I say, 'I pray to go to somewhere,' and I go. I went to Bethlehem and saw the baby named Jesus in a barn. I also shrank myself and talked to insects. Last night Guadalupe let me visit the kids in the giant refrigerator under the desert."

"Wow! What happened?"

Maggie arrives.

"I'll tell you tomorrow," says Sarah, and waves good-bye.

"The Rescuing Song" is also based on an early scene in the novel where Quixote, having been viciously beaten by a traveling bully, lies bruised on the dusty desert road, unable to stand. A neighbor passes by and stops to help. After washing the dust off of Quixote's face, the neighbor carries the old man home, but first waits until the dark of night can protect the fallen hero from the unsympathetic eyes of the gossiping village.

The kids are in awe of this anonymous, unconditional, unrewarded kindness. "It's like my mom," says Percy. "She is patient with my tantrums and she always brings me books."

To prepare for lyric writing, we all write in silence for

fifteen minutes, telling stories from our own lives related to the neighbor's actions. Then we take turns reading our stories out loud as the group listens. All of the kids write about their mothers. Their mothers wash for them, cook for them, put them to bed with a gentle hand and a soft voice, stay awake on nights when the children are sick, placing a cold wash-cloth on a hot forehead and whispering "Shhhhh"—the sound the child first hears inside the mother's body, the swishing of warm amniotic fluid in the unborn ears—and the mothers hug and hug and hug away the fear and the anger and the falling. No mother is paid for doing all of this; no mother is famous for being a mother.

The only child not to read is Sarah. For the first two months of the *Traveling Adventures* project, she has been quiet during class. When asked to read her writing to the group she has shaken her head, "No." Sarah has been coming to the Still Waters writing class on Saturdays since the spring, but she has yet to read aloud her own work, always asking a volunteer or another kid to read for her and to protect her privacy by not revealing her name. The Quixote group is about half the size of the big writing class, and there's nowhere for her to hide anymore, so she simply refuses.

Then one day in private, during a break, Sarah informs me that at her school, "They're kind of rough on people. Everything you say is only right or wrong." She tells me that she sits at her desk in class, never moves, and never says any-thing. The school sent a social worker to inspect the house and interview her parents. The social worker asked if there is violence at home, but there isn't any. Sarah is just hid-ing, holding her mother's leg when faced with a stranger, or

hanging onto her desk in class. At school, she doesn't know what is coming next, play is not allowed, a vague threat of punishment for being "wrong" fills the air like humidity, and, in her innocence, she is afraid.

How do I help Sarah to be brave? I don't want to force her to read to the group; that could inflict trauma.

I remember a story my paternal grandfather, "Papa," once told me, a story that guides my teaching and illuminates this problem. At age ten, in 1917, he had won a bamboo fishing pole in a small-town raffle, way up in the mountains of northern Idaho. His father told him he would need to wrap the pole in thread, an intricate procedure requiring great patience. His father said that he himself needed to rewrap his own pole, too. So they sat side by side on the porch and wound thread around their bamboo poles. My grandfather added, at the end of the story, that, looking back, he suspected that his father didn't really need to rewrap his own fishing pole.

Today, remembering Papa's side-by-side education, and my father's tendency, as long as I can remember, to read whatever book I happened to be reading so we could think side by side, I sit next to Sarah as we write and, when it's my turn, I read to the group, showing her the way by making myself vulnerable.

"There was a time," I say, looking down at my paper, "when I thought nobody loved me. I called the city's phone number for depression. A woman answered and said her name was Sarah."

Our little Sarah at Still Waters looks up and there is that face again, eyes and mouth wide open at the coincidence of names.

"She asked how she could help me and I began to cry—my mother had raised me to cry, telling me that whenever I needed

to I could let the tears fall and keep going until whatever was stopping me was washed away—and I couldn't stop crying for a long, long time. I cried so hard I choked and coughed and boogers came out of my nose—" the word *boogers* makes the kids laugh "—but Sarah did not hang up the phone. I kept repeating, 'Nobody loves me.'

"Two hours of conversation later, after telling that grown-up Sarah that I had not left my apartment for days, eating only boiled eggs and saltine crackers and food left outside my door by friends I would not allow to enter, I agreed to go to the hospital.

"At the hospital, the psychiatrist, Heather, after listening to me for a long time—" I don't tell the kids about the bandage on my wrist "—told me she would rather have two broken legs than have what I had inside me. She promised me that I would feel better, but I would need to work very hard for a long time, with the help of a therapist, to understand my story. And she was right. The more I told my story the better I understood myself, and the more peaceful I felt in my heart."

I want the kids, especially the reticent Sarah sitting beside me, to know that here, in this room, in our sanctuary, it is safe to be vulnerable—Latin for "able to be wounded"—because here, nobody will wound you. Here, you can breathe. No one will drop from the sky and carry you away.

After weeks of refusing and listening and watching with those bottomless black eyes as other children and grown-ups read their stories, on this one day, this day of vulnerability, Sarah, daring beyond daring, raises her hand, is called on, and begins to read: "My mommy rode across the desert on the back of a tiger. That's how she came here from Mexico."

At first nobody speaks. Then they can't stop asking questions. These questions are born not from doubt, but a love of adventure.

"Really?"

"Yes, really. She told me in Spanish at bedtime."

"How long did it take them to get across the desert?"

"Two weeks."

"How did they cross the border?"

"They came to a very high wall. It went as far away as they could see to the left and to the right. The tiger said, 'I can't jump over the wall. You need to carry on alone now.'

"My mommy said, 'I know you can do it. You have very strong legs.'

"My mommy held on to the fur of the tiger's neck. The tiger moved its head up and down, and crouched and wiggled its butt—" the kids all laugh; every time they hear the word "butt" or "but" they need to laugh "—then it jumped over the wall. My mommy almost touched the moon.

"The tiger said, 'I did it!'

"My mommy said, 'Yes, you did it for sure!'"

I say, "My cat moves her head up and down before she jumps up onto the refrigerator."

"Wow!" says Sarah. "That's high up!"

The kids have more questions. The room is jumping.

"How did they eat?"

"The tiger knew where to find water and rabbits and cactus fruit and how to step away from snakes that were hiding under the sand."

"How did they get to Brooklyn?"

"They walked all the way to Brooklyn, through the desert

and the forest and the the fields and the ghost towns and the swamps." Sarah speaks faster and louder as she goes, releasing a horizontal avalanche of words.

"Nobody tried to stop them?"

"No. When they reached the City, they stayed on dark streets with not a lot of people. The shadows protected them."

"Nobody saw the tiger?"

"Yes, strangers noticed the tiger and they were afraid, so they called Animal Control. The tiger fought back," she says, rising up a little bit from her chair, "with its mighty paws and long, sharp teeth, but there were too many Animal Control humans with nets and ropes and a dart that made the tiger sleep.

"My mommy said, 'Bye,' and she cried. Her tears made lines on her dusty face."

Sarah is now speaking in tongues, possessed and transported by the visions she has inherited from her mother.

"My mommy was sad for the tiger and sad for herself. She missed Mexico out in the fields. She missed the dirt between her toes and the wide-open heavens above, more full of stars than darkness. Here, in Brooklyn, the buildings blocked most of the sky, the electric lights erased the stars, and her feet, still bare, were punished by the unforgiving concrete.

"The tiger cried, too, quietly, as it was falling asleep, and said, 'Good-bye.' Animal Control took the beast away in a cage inside a truck."

There is an awestruck silence in the room.

"What language did the tiger speak?" asks Lily.

"Spanish. My mom didn't know English then."

"Time's up for today," I say. "Thank you, Sarah. Good job, everyone. See you next time."

As the kids walk out the door they look stunned, as if they had just met God.

—

The group could choose a teenager to play the role of Kid Quixote, someone who can more readily handle the often antiquated and sophisticated language of Cervantes.

"No," says Lily the day we begin to speak about casting that role, more than a year into the project. "Teenagers are too ironic."

"What is ironic?" asks Felicity.

"It means acting like you're cool," says Lily. "Quixote isn't trying to be cool."

"You could do it," says Felicity, turning to me.

"But I'm already the landlord."

"You could switch parts."

"Why me?"

"You're his same age and you like to help people. And you have problems with your mind."

"That's all true," I say.

I have bipolar depression and have survived dizzying grandiosity—the belief that I, from a mountaintop or even from the moon, was meant to rescue everyone in need—and the great fall that followed.

"As much as I would love the attention," says Joshua, and everyone laughs, "I think our Quixote needs to be a little kid."

Lily agrees. "Quixote is innocent. He has the heart of a child."

"And," adds Alex, carrying us to our destiny, "He believes that the stories he reads are real, the way little kids believe in Santa Claus and the Easter Bunny."

"What do you mean?" asks Sarah, suddenly alarmed.

"Exactly my point," says Alex. "When people grow up, they stop believing."

Rebecca declares, "Sarah would be perfect."

I ask why.

"She's little and it would be funny for her to rescue me from a grown-up."

The image of tiny Sarah stepping between me and Rebecca to stop the whipping, looking up at me, the big bully, and bringing me to my knees with her boldness is unlikely and very brave. It's an icon to rally around, inspired by her real-life courage in coming out of hiding and reading a story to the class.

"I've also noticed," I say, "that Sarah is an excellent listener in class. She never interrupts anyone and her eyes follow the speaker. The look on her face, the way it changes depending on what the person is saying, tells me she's giving all of her attention. When you're acting you need to listen to your partners onstage."

"And," says Rebecca, with her usual assertiveness, "she's a girl. Girl power!"

There is another reason Sarah is playing Kid Quixote and leading us. After a writing session earlier in the second year, the kids were taking turns reading their stories aloud, stories about what is beautiful and what is difficult about being a girl, while everyone listened. When it was Sarah's turn, she read a brief story about how she hates wearing dresses. Then Miriam, the eleven-year-old girl sitting next to her—usually a kind and sheltering person—told the class that Sarah had also written another story that day. Sarah didn't want to read the other story to everyone. Rebecca, also out of character, grabbed the

unread story and prepared to read it to the group. I stopped her and told her to give back the paper and apologize. Each girl said, "I'm sorry, Sarah," in turn.

Sarah sat very still and silent. She was visibly hurt and didn't know where to rest her eyes. The other students bowed their heads.

Her vulnerability, based on her belief in people's basic goodness and her trust in her neighbors, is what makes Sarah a great leader and our Kid Quixote. She would never tell anyone what to do, but with her humility she guides the class. I had read to the kids what Lao Tzu says, from 2,500 years ago, in verse 66 of the Tao Te Ching, "The reason the sea can govern a hundred rivers is that it has mastered being lower." Regardless of their ages, the children and grown-ups flow down toward Sarah like rivers to the sea.

She plays Kid Quixote, a character obsessed with the novel by Cervantes and believes herself a hero destined to rescue the victims of injustice and defend the defenseless. She repeatedly falls down, and she always gets back up. She's just a kid, but she never surrenders. This is, in Sarah's innocence, funny. Who she is, her unwavering belief in her mission—"To rescue the world," as she says in the very first scene—despite its impossible odds, and her loyalty to adventure and to what is right and good—all of this delights audiences, and their laughter encourages her to keep going.

This is the how the uprising begins.

———

The parents of my students believe that the Still Waters process can help the kids in their weekday schools, whose promise,

in turn, is the ultimate salvation of attending college. Many of the kids have leapt up reading levels within weeks of joining the group, and their parents are passionately thankful for this progress, the desire for which inspired them to journey through hardship to come to a country where school can bring prosperity.

But success in school is only a by-product of what happens in the room. The kids come weekdays after six to eight hours in their day schools followed by one or two hours of homework—and all Saturday afternoon—not for their education, but for the other kids. A little boy named Terangel, a name meaning "Earth Angel," only eight years old, once braved a brutal thunderstorm that turned his umbrella inside out and swept it away from him, just to come to Still Waters—by himself—over the protests of his understandably protective mother. Sarah wept one day when her family's car broke down and she had to miss class, and many of the kids have insisted on coming despite their being sick, even with a fever. "Everyone listens to everyone" gives us a specific way to enact "Love your neighbor," and the children feel that love. As do I.

At Bushwick High School, where I taught for seven years before opening Still Waters, the public address (PA) loudspeaker, positioned directly below the clock and above the chalkboard, drove me and my students crazy. We were trying to practice what I would eventually try again years later at Still Waters: reciprocal listening. Our class session would frequently be interrupted by announcements from the principal—asking teachers to withhold all bathroom passes until further notice,

or to confiscate all hats, or to teach "bell to bell"—with no rest for the students. The general message was clear, that the principal's authority was valued above our own relationships, and that students were—above all—to be controlled.

One day as we were writing in class I heard an announcement—the principal's voice—but the sound was coming from the hallway speaker, not from the one in the classroom. I opened the door, just in case the announcement was important. After the principal had stopped talking, I turned to my students.

"That's weird," I said. "I wonder what happened to our PA speaker."

The kids were strangely still, and they were all staring at me.

"Nobody here knows anything," said a boy named Jason. "Nobody."

I reported the broken speaker to the head of building maintenance and it was repaired. To this day I like to think that this sabotage, however they did it, was the kids' way of taking back control of their education.

The huge red brick building with cages on the windows looked from the outside like a prison or a fortress or a mental hospital. The student desks were in rows facing the front of the room and they were bolted to the floor. I chose to teach there because, as part of my interview, I was allowed to observe classes, and I admired and enjoyed the way the students used humor to rebel against the systemic restrictions on their thought and behavior. In one room, as the teacher was writing instructions for essay writing on the chalkboard, the kids held a "Your Mama" joke battle behind his back.

"Your mama's so fat she jumped in the air and got stuck!"

"Oh, yeah? Well your mama's so skinny she has to run around in the shower to get wet!"

The whole class whooped and clapped as the warriors struck blows round after round.

After I began teaching at Bushwick High, I quickly learned that every day there were also physical fights. A number of times I had to use my body to block the classroom door and stop kids from running into the halls to join a fight, and inside my own classroom two girls once clawed each other's faces and ripped out each other's hair. I had to call the school police (for legal reasons of liability, teachers were forbidden to intervene in fights between students).

One day I walked by the lunchroom and heard screams like no screams I had heard before. Dozens of kids had assembled in a delirious, noisy crowd around two girls, one of whom, my dear Lucy, was bashing the other's bloody head into the floor. Soon, the group would descend on the fallen one and finish the fight in a hail of punches and kicks, interrupted only by the arrival of police officers who pushed their way through the crowd to seize Lucy and separate the girls. The defeated girl was a renowned bully.

Often, between classes, when the corridors were jammed with kids traveling from one room to another, someone would light the bulletin boards on fire.

The physical violence was accompanied by emotional and mental assault. The kids had to walk through metal detectors and x-ray scanners to enter the building and the hallways were patrolled by armed police with bulletproof vests. Several times a day the principal would announce on the loudspeakers that the officers were to conduct a "sweep."

"What do you sweep," asked one of my students, "except garbage?"

———

Sarah's mother's story of the escape on the tiger is simple like a parable, includes an element of the supernatural like the *1001 Nights*, and opens itself to moral contemplation and interpretation.

I know from speaking with Maggie that there was no tiger. She crossed the desert with the paid help of human traffickers, also known as "coyotes." Changing the traffickers into a tiger changes the toxic anxiety of living without faith in other humans into a story of courage and magic, a fairy tale where a talking animal of mythic ferocity becomes a friend. The two characters, Maggie and the tiger, can be thought of as one being, both fierce and kind, attributes that Sarah will need as she travels from childhood to adulthood. The image of her mother riding on the back of the tiger and jumping the wall of impossibility is a gift that Sarah carries everywhere she goes.

The turning point for the pair is the moment of doubt at the wall. The tiger says he can't jump over, and the mother-to-be insists that he has the power. The success of the jump is an answer passed between two generations, belief responding to doubt: "Yes, you can."

As Maggie and the tiger transcend the wall, Maggie *almost* touches the moon. She could say that she *did* touch the moon, but the yearning is an important legacy—a process, a way, like a cathedral spire stretching up to the sky, or the path of the Tao that needs not reach a destination.

At first, the group wanted to put the tiger in the "Rescuing Song," but Kim, our composer, has guided the group away

from that path because it would require too much context for the audience to understand. We need to focus on the story we are telling, she says, which is difficult when that one story contains a multitude of stories.

The lyrics that survive from the tiger narrative are:

> I came here to seek protection
> I traveled through the night
> Adios, preciosa patria
> Found myself in burning light
> Burning, burning desert light.

Although there is no mention of the beast anymore, every time the kids sing the song, in rehearsal and in performance, they remember the tiger and the leap of faith.

——

As the *Traveling Adventures* group continues to write the "Rescuing Song," we need a rhyme for the lyric "Ignorance built this wall," reshaped by the group from Percy's brainstorming sentence "The wall is stupid and ignorant," which refers not only to a border wall between the United States and Mexico— the real, partial wall and the imagined complete wall, all the way along the border—but also, Percy says, to any obstacle built by ignorance. In the case of this song, the wall is whatever is blocking the mutual understanding of immigrants and citizens, which the song tries to break through or jump over.

"Rhyme," I tell the group, "can join what has been separated."

The kids love to search for rhymes in our rhyming dictionaries and compile a catalogue of possible word choices.

They rhyme *wall* with *tall, small, ball, hall, call, sprawl, stall, fall, all,* and *igual,* Spanish for "equal." The challenge then becomes building a sentence that ends with one of these words and follows logically from the line before—"I don't want to live in fear"—which follows the rhyming line "Ignorance built this wall," which in turn has followed "Por favor, entiéndanme" (Spanish for "Please hear me" or "Please understand me"). The kids come up with, "It is impossibly tall and I am impossibly small," "I am blocked like the end of a hall," "For ever and ever I see it sprawl," "Somos todos iguales" (meaning, "We are all equal"), and, "If I go to the top I hope I don't fall."

Then Sarah, seven years old at the time, reads, "My family is my best of all."

We know from the quiet in the room that something meaningful has happened. The line rhymes according to the pattern we've established, it identifies the nature of the "fear" in the line before, the fear of separation of a family by deportation of the parents, and it is spoken in the voice of a child, "my best of all." The image is vivid: a child on one side of a wall, parents on the other. They all sing, and rhyme brings them together.

"Wait," says Lily. "If we change 'My family' to 'Mi familia,' then we have everything. The two languages come together, like they do in our families. The kids speak English and Spanish and our parents speak Spanish. We translate for them, just like the lyric travels from Spanish to English. Our parents came across the border for us, or for the idea of us, and we bring our parents across the languages."

Everyone agrees.

"What's this?" I ask, looking at new drawings inside Sarah's copy of *Don Quixote* after a long Saturday of working on "The Rescuing Song." Sarah continues telling me the story of her prayer-voyage to visit the kids in the giant refrigerator under the desert, pointing to the drawings as she speaks.

"I brought ten suitcases full of things that are cozy and warm and soft. The Ice People took those things away.

"Then the Ice People gave us frozen peanut butter sandwiches to eat and cold water with a layer of ice on top. The kids were crying all the time and their tears froze on their faces, like a sparkly mask. The Ice People punished them for crying by whipping them with cold wind. That didn't help. The kids kept crying.

"At bedtime, the Ice People told the children a scary story that the other kids thought was true, about a kid picking up berries in the forest with his family and his family told him it was a haunted forest, so stay close. But the boy didn't believe them so he kept picking up berries. Then his sister suddenly disappeared. Later his father disappeared. The boy was scared. He stayed close to his mommy and his little brother, and the little brother thought he saw his father so he went to him but it was a tree. The little brother disappeared. The boy heard a rustle in the bushes. It was midnight and he tried to go home but his mommy disappeared. The boy ran in the dark forest and a man caught him and put him in a cage with his family all together. The man took them back to his house and put them all in a huge oven and cooked them to eat.

"The kids were really very scared. I told the kids that what the Ice People were telling them wasn't true. 'Don't worry,' I said. 'I'll save you.' The kids trusted me. I taught them math

and history and English and Right Now—the truth from out-
side the refrigerator. Then the ones who learned from me told
other kids, and they told more kids, and more and more. The
kids were not allowed to touch each other, not even to hug a
little girl who is scared and misses her mommy.

"Then the Ice People tucked the kids into bed, covered
them with blankets made of snow and gave them all a bedtime
hug. The hug was so cold it froze the kids and they couldn't
move. Being frozen isn't the same as being asleep."

I interrupt. "If the Ice People speak by beating their chests,
how did the children understand the story?"

"Kids are good at understanding. I like to repeat what
strangers say in other languages."

"Me, too! Please keep going."

"When I woke up in the morning I looked all around. I ob-
served and I studied the place. The walls and floor and ceiling
were all white and covered with twinkly frost. It was hard to
see where the corners were. The ceiling was very very high
up, so nobody except the giant Ice People could reach the trap
doors.

"A little boy told me that the Ice People know where the
kids are in the refrigerator by using their feet. The frost is their
nervous system and they can feel anyone taking a step.

"I noticed that the frost under my body was melted from
sleeping on it. I stood up on the melted area and none of the
Ice People noticed. A few seconds later the shape of my body
turned back into frost and blended in with the rest of the floor.
I had an idea. It was dangerous, but it just might work!"

Maggie arrives.

"Thank you!" says Sarah as she walks out the door.

"Gracias!" says Maggie, as she follows her daughter.

"Con gusto!" I say, and I turn out the lights and go home, carrying the story with me, wanting to know what comes next.

———

For the kids in overcrowded public schools such as Bushwick High School, there is a constant problem of not getting enough attention. One teacher standing in front of thirty students, five times a day, five days a week, cannot possibly give each student enough attention to feel truly loved and cared for, so the kids compete against each other for what they need. And because they are physically segregated by age, kept in a room with only kids as old as they are, they are all in competition for that one developmental category of attention from a single "parent." Teachers are responsible for the kids *in loco parentis*, Latin for "in place of the parent." "See me, hear me, feed me, protect me, know me" is the unspoken plea that mostly goes unanswered.

I tried to address this problem at Bushwick High, in what I called our "Ongoing Correspondence." My students could, every day, write to me to say what they didn't have a chance to say or were scared to say in class. Being openly vulnerable wasn't possible there. That's why meditation didn't work: I tried to help my students compose their attention around their breathing, focusing on the air traveling in and out of their nostrils, cool on the way in and warm on the way out, a reprieve from the noise and chaos of the corridors—but the kids were afraid someone could hurt or rob them when their eyes were closed, or even half-closed, or whenever their attention went to their

own breath. They even wore their winter coats in class because of the very real threat that classmates would steal them.

Students at Bushwick High always had to appear self-sufficient when they were really still children inside. I used to ask them, "Who here is independent?" Most hands would go up. I would say to one kid who had raised a hand, "Those are nice sneakers. Did you buy them?" If the kid said, "Yes," I would ask, "Where did you get the money?" If the kid had earned the money, I would say that he or she relied on being paid by the boss. If there was no boss, I would ask if the kid had made the sneakers. There was always at least one dependency in every story.

Sometimes in their Ongoing Correspondence my students would write things that alarmed me, such as, "Mr. Haff, my dad hates me. He doesn't care if I live or die," or, "All we eat is ketchup on toast but somehow my mom has enough money to get high," or, "I think I might be gay but if I tell my parents I'll get a beat-down."

Midway through the school year a girl named Lydia, who told me she belonged to a gang, wrote to me in her journal, "Mr. Haff, may I call you Dad?"

I wrote back, "Yes. I'm honored. But I don't know if I can live up to that."

"It's ok," she said. "You're way better than nothing."

That spring, I had recently returned from visiting my ninety-five-year-old grandfather, Lent—my Papa, the one who learned from his father how to wrap a fishing pole with thread high in the mountains of Idaho. He was dying in a San Francisco hospital, my father was suffering, and my grief must have been apparent.

"Dear Mr. Haff," wrote Lydia, "Please try to be happy because you are my happiness in school. Even though you are always smiling I can see. I know what it is like to lose someone. One day they are there, then they are not. My aunt who passed away comes back at night to bother me but it's okay. Please feel better. Eat more fruits!"

All I could produce as an answer was, "Thank you, Lydia," a woefully inadequate response.

Other kids would conceal their stories behind clues, the same way they would turn their faces into masks of menace and disinterest to cover a self that was, in secret, sweet.

"Hi, Mr. Haff," wrote a boy named Sebastian. "All I really care about is anime, the Japanese cartoons. That's all. I have nothing else to say."

Sebastian was tall and wide and heavy and he narrowed his eyes to make himself look like a hardened soldier, a veteran of war with a thousand-yard stare. I wrote back, saying, "I'm interested in learning more about anime. Do you have a favorite character?"

"Yes, I do. His name is Goku," he wrote below my question.

"I don't know him. Can you please describe him for me?"

"Sure. He has fire for hair and he has a tail."

"Does he have special powers?"

"Yes, he does! He has superhuman strength because he was born on a different planet and he comes from a race of warriors. He protects his new home, Earth, mostly with energy attacks. He can devastate people with blasts of blue energy from his hands, but he also has a kind heart and he forgives his enemies."

"I have a favorite character, too. His name is SpongeBob SquarePants. Do you know him?"

"Yes, I do. But he is not anime. He's for little kids. And he's annoying because he is always hyperactive."

"That may be true, but he has one power that makes him invincible. Can you guess what that power is?"

"No, because SpongeBob has no powers. He's just a sponge."

"Ah, but what can sponges do?"

"They can soak up water."

"Yes! SpongeBob is a sponge and sponges ABSORB! Always remember that. Anything Goku does to SpongeBob, SpongeBob can absorb. In this way, he can vanquish Goku."

This correspondence took place over the course of weeks, often in class, during study time, and also after hours when I carried home my students' journals and spent the evenings responding to their writing. Sebastian finally wrote a full essay in which he logically and passionately made what he felt was an irrefutable case for Goku's ability to defeat and destroy SpongeBob SquarePants. The essay was well written, strictly argued, supported by ample, relevant evidence to back up his claims, and I praised him for the writing and the thought. Then I added, at the end of my response, "But remember, SpongeBob is a sponge, and sponges *absorb*." As this exchange progressed, Sebastian's eyes relaxed and opened. He began to smile and he even started to lose weight. Years later he would join Still Waters as a tutor; the little kids would trust him and he would listen to them.

During class and at home after school, every night I would write back to each of my students at Bushwick High, a total of 150 kids per day, just to say, in various ways, "I hear you." This was before I fell apart, and before I had children of my own.

The design of Still Waters allows the kids to give each other

this same message. They share in this way of teaching, this reciprocal attention, so that I am not solely and impossibly responsible for giving each of them what they need. They are reassured by their peers of all ages, by their neighborhood, by their tribe, reassured that they are understood and needed. "We hear you," they say to each other—and to me.

Grounding this practice in the natural world I knew in my boyhood, I tell the Still Waters kids often of a family trip to New Mexico when I was a student in high school. We went to see petroglyphs, symbols scratched into rocks in the middle of the desert. I was enchanted by the ancient writing whose messages I could not understand, and I brushed my fingers across the scratches, trying to feel something across time and language.

Then, as the sun went down, the coyotes began to sing. I couldn't see them, but their yipping and howling, back and forth, from one side of the valley to the other, bounced around the barren land. It sounded to me as if one group called out, "We are here," and the other answered, "You are there, and we are here." Eventually they went quiet, and I made my best coyote howl into the silence and waited. After a few seconds, my call—I like to believe—was answered. "You, too, are there," they sang.

After I tell this story, I ask the kids to yip and howl to each other, reenacting the nightly song of the coyotes. The little ones especially love this, and the teenagers join in for their sake. "This is what we do here; we acknowledge each other. Remember the coyotes when you write and speak and listen."

One of my favorite practices, at home and in school, is reading out loud to kids. At home, this reading is a ritual, a transition for my daughters from the multiplicity of the day's demands to a state of peace and rest, the same spell cast by Scheherazade in the *1001 Nights* as she rescues herself night after night by telling tales.

In my Bushwick High School classroom, years before my daughters were born, I deployed the power of reading aloud as one way of keeping the students in order. I had also read that one of the most important predictors of success in school is parents reading to their children. About 75 percent of my ninth grade students, I discovered in a classroom survey, had never had anyone read to them at home.

My reading aloud was meant to model the mysterious internal intellectual process of reading itself. It's not always obvious to beginning readers what happens when we read. I would change voices when speaking for different characters and I would use my body to act out scenes, standing on my desk to be a giant, sitting on the floor to be a child, and kids in classrooms at the other end of the hall or on the floor above or below reported being able to hear my roaring vocalizations. By the end of the reading I would be sweaty and breathless, having worked very hard to communicate the idea that books are alive.

And I would stop often to tell a related story or to ask my students to do the same. Their favorite book was *Matilda* by Roald Dahl, which is about a quiet little girl who loves to read and whose powerful mind pulls down oppressive grown-ups, including her father, who has disallowed her reading in favor of TV, and her school principal who says her idea of a perfect school is one with no children.

"When the principal says that," I said, pausing the story, "It reminds me of how our security guards do 'sweeps' of the hallways to clear them of kids."

"Yeah," said Sebastian, "to make us disappear."

"They just don't want us in the halls," objected Elijah, a dutiful student who took great pains always to be on the right side of the law. "That doesn't mean they want us to disappear."

"They want to control us, though," replied Sebastian, getting excited about speaking dangerous thoughts. "And the ultimate control is to banish us. No kids, no problems."

Another boy, Angelo, said, "Without kids, they don't have a school. We have more power than you think."

A girl named Clara, who moved and spoke with calm grace, as if none of the hurry and strife in the building could reach her wherever her mind resided, said, "I feel the same way Matilda does at home. We have a TV in every room and they are always on and they are always loud. I can't think, so I go out and sit on the fire escape and close the window behind me."

"Noise is the enemy of thought," said Hercules, who would later go on to a prosperous career writing rap music. "Noise is disorganized."

By articulating their associations with the book we were reading together, the students learned that reading was a social activity, as it would later become at Still Waters—a trading of story for story. This reading and group conversation surrounding a book was their favorite part of the day, and every day at the end of the half hour devoted to this process they would ask me to read just one more page.

Hercules stood up one day for what mattered to him. Normally he was very quiet, but he always showed that he

was participating with his eyes—eyes that followed me as I stomped and leaped around the room shouting or whispering a story, eyes that also focused on every classmate who spoke. Hercules's parents were both murdered when he was in elementary school. He had an aura around him, a spirit of steadfast integrity and maturity, and he received universal respect. None of the kids would mess with him. He sat front and center in the classroom.

Another boy in that class, Demetrius, used to sit in the back corner and talk and talk, making silly remarks—saying, for example, that the drawing of Miss Honey, Matilda's kindly teacher, looked "hot"—that nobody found funny. Day in, day out, Demetrius's loud mouth could not be stopped.

One day, though, as Demetrius made his usual daily noise, Hercules stood up, pushed back his chair, turned around and, into the sudden hush said, in a low and steady voice, "Shut the fuck up. We're trying to learn something here." For the rest of the year, Demetrius was silent.

Years later, after I had resigned from teaching at the high school, I ran into Hercules on Knickerbocker Avenue in Bushwick and I thanked him for that long ago day. He told me that I was the first teacher really to listen to him, in our "Ongoing Correspondence," and he thanked me in return.

"By the way, whatever happened to Demetrius?" I asked.

"He got shot in the head."

"Oh my God."

"Running his mouth in the 'hood."

Angelo, who had told the students in my class they had power, eventually was part of a theater group we organized at Bushwick High. He was as thin as an empty shirt hanging on a hook, and his wide eyes seemed to look out the sides of his head like the eyes of an ever-wary deer scanning for predators. He was also a verbal virtuoso who stood on street corners with friends and spoke spontaneous rhymes as easy as breathing. There were two of him: the Angelo I knew, the one who, as he said, would "crumple inside" when faced with the suffering of others—as if he had no skin, no barrier, and everything that hurt them hurt him—and the crook, the one I knew only by the stories he and others told me.

As we walked around the neighborhood, which we often did before and after I came back to Bushwick from my recovery in Canada, he generated rhyme after rhyme about what he saw and what it meant to him, verses about a skeletal man he called his "fiend"—the desperate one who volunteered to taste the quality of the cocaine sold on the street—and verses about blocks where he wasn't allowed to go because of wrongs he had done there, such as stealing another boy's girlfriend or swiping jewelry from a home where he had been welcomed and trusted as a friend: "Swiping ice that don't melt / like a heart that never felt / true love."

Real People Theater began when I realized that I was failing at teaching my students Shakespeare by teaching them the way I had been taught—by simply reading the play from beginning to end, discussing patterns of imagery, and committing soliloquies to memory. Desperate for any relevance to my students' lives, I assigned them to rewrite scenes from

Hamlet as they would speak them on the streets. They later asked me if they could perform the results of this exercise in public. It was Angelo who came up with our name, explaining that "We are not actors, we are real people telling our stories in our own way."

Real People would go on to perform at renowned professional and university theaters all around New York City and in Vermont, Chicago, Los Angeles, Toronto, Nova Scotia, and Europe. The group included the loyal core of Angelo, Lucy, Julius, and Ezekiel, plus a dozen others who came and went, and for seven years we would remake Shakespeare and Milton as a combination of the original verse, Spanish, and street slang. Angelo, who was in that tenth-grade English class because he had failed it two years before, was especially adept at making these translations, with his sensitive ear for spoken verbal rhythm and the sounds and flavors of words. This is what he gave me on the first day of the class translation exercise:

> To be or not to be—that is the motherfucking question.
> Do I hang on in the storm of poverty,
> Face the cops, fail outta school, rob niggas on the train,
> Bring smack for my Moms so she could forget
> She's a ho fucking strangers to survive,
> Just keep going day by day,
> I can't go on but I do go on,
> Or do I let go and let the wind blow me off this ship
> Into the dark and deadly sea and end
> The heartache and the thousand natural shocks
> That pound my body and my brain?

Fearless, Angelo had ripped the soliloquy open and pushed his way out.

———

After a day when the *Traveling Adventures* group has spoken at length about our government separating refugee families at the border with Mexico, I see that Sarah has returned to drawing stories in the margins of her copy of *Don Quixote*. The daily news, when it crosses the threshold of her mind, is transformed into something a little less hopeless. I ask her to tell me, please, what the drawings are saying.

"This is the outline of my body when the frost melted in the giant refrigerator when I slept on it. Remember?"

"Yes, I remember. And this, these swirling lines?"

"That is my breath coming out of my mouth and melting the frost. I have noticed that when I breathe in and the air crosses the opening in my nose it feels cold, but when I breathe out the air on the edge of my nose feels warm. I can breathe out with my mouth because it's bigger than my nose and I can make an empty melted spot to step on and I can keep doing that again and again until I reach one of the other kids, and the Ice People can't feel me walking on the frost."

"That's smart. What will you do when you reach the first kid?"

"I don't know yet. Maybe give her a hug."

I tell Sarah that in the courage of her fantasies and her genuine desire to go where she is needed she reminds me of a story told to me by my Papa about his boyhood village of Wallace, Idaho. It was 1918 and the first World War had just ended and given way to the global pandemic of Spanish Influenza, which

would kill more than fifty million people in one year, as far apart as the Arctic and the South Pacific. The disease even climbed the mountains and reached into Wallace and struck down the young and old, the strong and the frail, without discerning any differences.

On the outer edge of the village stood a small, wooden shack, called the Pest House because it housed victims of the pestilence, burning with fever until they died from respiratory collapse. While almost everyone in Wallace stayed away from the Pest House, there were a dozen or so women—always women—who chose to go there to comfort the dying, washing them with clean water and battling their fever with a cold cloth placed on each blazing face. They would also often hold the victims' hands. These women, my grandfather told me and I tell Sarah, were as brave as any soldier in a war. They could not hope to save anyone, but they were willing to cross that threshold, to stand up to the invisible demon inside that dark room, and to risk their own lives carrying mercy to the fallen.

Sarah looks directly at me and says, "That's how I want to be."

One day, during my career at Bushwick High, I got word that Ezekiel (also known as "Easy") and another of the *Hamlet* students, Julius, had been locked up at the local police precinct. I never asked what they had done, I just brought them sandwiches and asked the officer who was watching them, a white man named O'Neill, if I could go inside their cell and have lunch with the boys. He let me in and locked the door behind

me, and while we were sitting on a bench and eating in the cell I told the officer that the boys were acting in *Hamlet* and I needed them for rehearsal that day. He asked them to recite their lines for him and they did, Easy as Hamlet and Julius as his friend Horatio, wisely choosing to use the original Shakespeare instead of what they called their "Ghetto Version."

"If thou hast any sound or use of voice," spoke Julius to Officer O'Neill, "Speak to me. If there be any good thing to be done / that may to thee do ease and grace to me, / Speak to me."

Easy recited that the world was "An unweeded garden / that grows to seed."

It turned out that officer O'Neill adored Shakespeare and had acted in *Hamlet* in college—as Hamlet. He then recited the "To be or not to be" soliloquy verbatim, appearing to tear up when he spoke of "The heartache, and the thousand natural shocks / that flesh is heir to," and we all clapped our approval. Then he opened a drawer in his desk and lifted out a heavily worn copy of Shakespeare's complete works. Before an hour had passed, the boys were set free.

Sarah is narrating more drawings in the margins of the novel. She continues from where she left off the story, as she is crawling across the frost on the floor of the great refrigerator, breathing on the frost to melt it and create another place to step undetected by the Ice People, until she can reach another incarcerated child.

"I see the empty, melted places, but what's happening here?" I ask.

"One Ice Person is blocking my way."

"How were you discovered?"

"By accident he stepped on a melted place and his feet got confused by what they felt."

"What's he doing?"

"Beating his chest like a gorilla."

"What is he saying to you?"

"He says, 'Stay in your place.'"

"What do you say?"

"I also beat on my chest to ask, 'Why can't I walk around?'

"'Stay in your place.'

"'Ok, but why?'

"'Because you are dangerous.'

"'But I am only a little girl and you are a giant as big as a house.'

"'I am afraid.'

"'What are you afraid of?'

"'I don't know. I am just afraid.'

"'Why are you here?'

"'All my life the penguins were walking on me, back and forth, all the way to the sea and back again, stepping on me and stepping and stepping. I don't like penguins, so I took this job and now I get to punish them.'

"'But I am not a penguin; I'm a human girl.'

"'I don't believe you.'

"'I am speaking your language. Could a penguin do that?'

"'Maybe.'

"'I would never step on you, ever. I promise.'"

"What's this here?" I ask Sarah, pointing at a group of little marks at the Ice Person's feet.

"Those are drops of water," she answers. "The Ice Person is beginning to melt."

———

As I was living in the basement of my boyhood home during 2005 and 2006, the two years of my recovery from suicidal depression between the days of Real People Theater and those of Still Waters in a Storm, my psychotherapy was based on understanding the nature of boundaries between people, accepting responsibility for my choices, and studying my feelings against evidence that supported or contradicted those feelings. To summarize, the process was a search for truth—an attempt to see things as they really are. What it felt like was an invisible brawl between reality and belief: two cats, claws out, attacking each other while trapped inside my skull.

I practiced repeating the basic ideas that no one else was to blame for my state, that I was not in charge of anyone else's state, that all of us live our own separate lives making our own choices, and that absolute assessments such as "Nobody loves me" or "I am a total failure" or "Everybody else knows how to live the right way" were not accurate, no matter how intensely real they felt. My dark beliefs, that I was an unlovable victim and a sinner in charge of other people's happiness, battled back against the light of day, day after day after day.

"Where's the evidence?" asked Vicky, my therapist in Canada.

"It's not the kind of thing there's evidence for."

"How did you come to the hospital today?"

"My dad drove me."

"What does that tell you?"

"That he loves me," I answered with resignation.

"What did you eat this morning?"

"Oatmeal and bananas."

"Did you make it yourself?"

I knew what was coming. "No, my mom did. She always does."

"Why does she always feed you?"

"Because she loves me. I know. But they only love me because they're generous people. I'm a disappointment to them; forty years old and living back at home. I'm a loser. I've wasted everything they've ever done for me."

"What were you doing before you came back to them?"

"You know this already. Why do I need to repeat myself?"

"Because we're studying you, and proper study requires repetition."

"Like for a test in school? You're testing me?

"No, it's more like we're writing a new script for you to rehearse, so you can go back and play your part, the part that's right for you."

"Who says I'm going back?"

"What were you doing before you returned to Canada?"

"Teaching."

"Where were you teaching?"

"In Brooklyn."

"What part of Brooklyn?"

"Bushwick."

"What kind of neighborhood is Bushwick?"

"A ghetto."

"What does that mean?"

"You don't know what the word *ghetto* means?"

"I want to know what it means to you."

"A neighborhood that is separated from the rest of the city."

"Separated by what?"

"Race or money, usually."

"What's the most important lesson your parents have taught you?"

"To love my neighbors."

"Were you doing that in Bushwick?

"Yes. I really did love those kids."

"So did you really waste everything your parents gave to you?"

"No. But I quit. I abandoned the kids."

"Before you left you helped the kids. That's not a total waste."

"My parents never gave up on me."

"Who says you've given up?"

"I left Bushwick."

"Why did you leave?"

"They turned on me. My mentor at Bushwick High School warned me they would turn on me. He said, 'Don't be surprised when they turn on you.' And he was right. They did."

"How, exactly, did they turn on you?"

"I had resigned from my job at the high school, sacrificing the best wages I'd ever made, plus my health insurance and pension, to devote myself completely to Real People Theater. I had won us a grant and I was renting an old curtain factory as a theater and we had just finished our first season of shows, including a tour to Los Angeles, Chicago, Toronto, and Europe, and newspapers were writing about us and I was trying to raise money to keep it going. It all felt like bubble gum about to burst.

"Summer came and we began work on adapting the *1001 Nights*. Julius and Ezekiel and Angelo missed a week of rehearsal and when they came back they were wearing fancy new shirts; they had been out selling drugs. Then Lucy came two hours late for a three-hour rehearsal and when I asked her what happened she told me she had been at the Yankees baseball game, in a tone that said, 'I dare you to do anything about it.' The kids had been working in two separate groups, four kids in each, and Lucy joined one of the groups. When everyone came back together around the table to show each other what they had done with the same story, Lucy's team said they no longer wanted to work on this project. I asked them what was going on. Lucy shrugged and repeated what she often said to explain their collective self-destruction: "hood stays with 'hood,' meaning that the neighborhood is always loyal to the neighborhood. I got up, left, and never returned. They tried reaching me by phone and by doorbell for two weeks, but I didn't answer their calls. One night, I made sure they weren't there outside my door and I snuck out and boarded an airplane for Canada, carrying in my backpack everything I owned and, in a pet carrier, my cat, that same neighborhood cat called Robin Hood who had been adopted and then abused by the kids—punched, and kicked and left alone in the theater in the dark, before I took him home."

"This was the fall of 2004?"

"Yes."

"Just after you broke your way out of your stuck bathroom door?"

"Yes, like Jesus risen from the cave."

"You said they turned on you. How did they turn on you?"

"I just told you! That whole story!"

"I'm trying to understand precisely what you mean."

"They missed rehearsals to sell drugs and go to a baseball game, and they rejected the work we were doing."

"Had they never missed rehearsals before?"

"Yes. A lot. Usually the first time we were able to run an entire play together was at the opening. We had to rehearse in small, separated pieces and patch it all together at the last moment, with whoever actually showed up. The girl who played Hamlet's mother just didn't show up for a performance at a famous theater in Manhattan, so a friend of hers went onstage after rehearsing her scenes just once in the hour before the show began."

"Were you surprised, then, when they skipped rehearsal for the *1001 Nights*?"

"Not surprised, but hurt and angry."

"More so than usual?"

"Yes."

"Why? What was different that time?"

"I had sacrificed everything."

"Sacrificed what?"

"I told you! I quit my job! Plus I had broken up with my girlfriend."

"The abusive girlfriend?"

"No, this one was nice, but she was jealous of the kids."

"Did the kids ask you to break up with her?"

"No."

"Did the kids ask you to quit your job?"

"No."

"Did they promise never more to sell drugs or miss rehearsal?"

"No."

"Were they allowed to disagree with you?"

"Yes."

"In what sense, then, did they turn on you?"

"They didn't appreciate my sacrifices."

"The sacrifices you chose to make?"

"Argh!"

"What does that sound signify?"

"You don't understand! You can't understand."

"I'm trying to understand. I'm asking and I'm listening."

Every day, all week, month after month, for two years, the same conversation repeated itself.

Meanwhile, I was also working with a psychiatrist down the hall to arrive at the right medication or combination of medications at the right dosages. There was no way of knowing in the beginning what would work for me; every person is a special case. After each new pill was introduced we had to wait and I had to report on anything that felt different from before. If there was no change, that could mean either the medication wasn't helpful or the dosage wasn't right, so we tested a higher dosage and waited yet again. It was hard to know when to give up on one pill and switch to another, and when the switch was to be made we had to wait long enough for the failed medicine to leave my body first, to avoid any crossover confusion of the two different guesses. The round of guessing and waiting and looking inward repeated and repeated and continues to this day. Twelve years later and twelve different medications after the beginning of treatment, I am mostly stable, but adjustments remain necessary.

These twin therapeutic processes, in their attention to detail, demand for patience, and acceptance of revision, prepared me for the *Traveling Adventures* project: five years of reading and rereading, writing and rewriting, making and, ultimately, remaking.

———

One day, as we are translating the whipping scene and writing the "Rescuing Song," I bring to class copies of George Herbert's seventeenth-century religious poem "The Flower," a verse I carry with me always, and the Kid Quixotes read the first stanza aloud together:

> How fresh, oh Lord, how sweet and clean
> Are thy returns! Even as the flowers in spring;
> To which, besides their own demean,
> The late-past frosts tributes of pleasure bring.
> Grief melts away
> Like snow in May,
> As if there were no such cold thing.

We all write for ten minutes about what the flower represents for us, then we read our writings aloud to the group.

Leading the way to encourage bravery, I tell the kids that Herbert's use of the flower in spring has, for me, represented the return of my sanity after the melting of the cold thing called depression.

"What is depression?" Sarah asks me in class.

"It's hard to describe."

I circle around the idea, trying to get close to a description

that she can feel. I don't tell her about the repeating pressure of my mental images urging me to step in front of a train. Instead, I say:

"The word *depression* comes from the Latin for 'pushing down.' It's like that, like you're being pushed down all the time and you can't get up. Or it's like you have no skin and everything hurts, even the air. It's the feeling that nobody loves you and you don't belong anywhere and it's all your fault."

"Like immigrants!"

"That's a feeling that other people give you, that you don't belong. It can make you depressed. I was just depressed on my own."

"Why were you depressed? Did someone do something cruel to you?"

"No, nobody did anything wrong. There wasn't a reason, not really. There is no blame."

"But why were you sad?"

"I wasn't exactly sad; my mind was full of noise like a cat with its claws out trapped inside my head."

"You had a headache?"

"No, I was very angry at myself."

"Why? What did you do?"

"Nothing. I was sick."

"Like a fever?"

"No, like a demon eating my thoughts."

"Oh."

She pauses for a few seconds.

"But why?"

"Because I was born with the demon inside me, just like my

mom and her dad and his dad and my uncle and my cousins. We all got the demon, just like we all got blue eyes."

"But you said nobody gave you this problem."

"Not on purpose; nobody was trying to hurt me. Nobody knew that the demon could travel from one person to another."

"How did your depression melt away?"

"People listened to my story."

"Who listened?"

"My therapist, my psychiatrist, my parents, and my friends; they all listened to me. And I also swallowed magic anti-demon potion."

"Really?"

"Yes. That's how it felt, anyway, the change."

The group carries on the conversation, asking each other what the returning flower represents. Sarah says it is her grandmother coming back from Mexico and hugging her; Alex says it is her trip back to Mexico, riding with her uncle in his car with the window open, feeling the breeze and relaxing because he accepts her for who she is: a pansexual, adolescent, Mexican-American human. Rebecca says the flower is her, every morning when she wakes up and goes to school; Percy says it's the weekend, when there is no school. "For me," says Dylan, "it's when my parents stop yelling at each other. And when my brother came back from the hospital after three days."

"The flower is Jesus," says the devout Catholic Miriam, whose family will move away days later when they are offered cash by their landlord. "Or Día de los Muertos," says Cleo, aged six, who after months of watching from the outside has

joined her big sister Sarah in the group. "When the ghosts come back to visit us."

"One word," announces Joshua. "Waffles. Waffles bring me back to life." Everyone laughs.

Sarah raises her hand again, and I call on her.

"The flower is like Quixote. He keeps falling down and then he stands up."

"You all amaze me," I tell the group. "Every night, after a long, exhausting day at school, followed by homework and some food, you come back to life, to read this giant book and to write and to listen to each other. That's devotion, and it's a miracle."

Their returns make my daily returning possible—an exchange of devotions.

Our songwriting conversations turn the students' lists of important words about "rescuing" into sentences, and sentences into lyrics. Once the group has written the first two lines of the "Rescuing Song"—"I beg you to understand me / To listen to my voice" —Kim suggests a pattern for rhyming the ends of lines three and four, a simple alternating scheme appropriate for beginners notated as ABAB, where A and B represent the sounds of the final words of each line.

"*Choice* rhymes with *voice*," says Felicity.

"What's a sentence that ends with the word *choice*?" asks Kim.

The kids come up with many sentences, including "Everybody needs a choice" and "Why can't I just have a choice?"

"I don't think the boy is thinking about 'everybody,'" says Joshua. "He's saying what *he* needs, right?"

"And," says Rebecca, "my character wouldn't be asking why. That's not what I want to know. Wondering won't do me any good. I just want people to listen to what I need."

It's Alex's turn to reconcile these ideas. "Put them together: 'I just need to have a choice.'"

"That's great," I say. "It's assertive but not threatening. Threatening the audience won't help. But is choice really a need, or is it a desire?"

"A desire," says Rebecca. "I can live without it, but I really, really want it."

"'I just want to have a choice,'" says Alex, and the fourth line is done.

"Okay," says Kim, "what do we write for the third line? It has to rhyme with *me*."

The rhyming dictionaries provide cascades of "ee" rhymes, but Joshua finds a word outside that list. "'I'm asking to be *revered*.'"

"That sounds demanding or even threatening," says Lily. "Like you're saying, 'Bow down to me.' Revered is dominant."

"What if I say the opposite?" asks Joshua, with a big smile, acknowledging the ease of his reversal. "'I don't want to be revered.'"

I jump in. "But I don't think you'd be opposed to reverence, of the right kind, like our mutual reverence for each other around this table."

"Oh, I've got it!" Rebecca shouts. "'I'm not *asking* to be revered.' That way, it's like I'm saying, 'If you *want* to revere me, please do, go right ahead, but that's not what I'm *asking*. I'm being very humble and confident at the same time; humble

not to ask too much but confident to make statements of what I want.'"

The first four lines are complete:

> I beg you to understand me
> To listen to my voice
> I'm not asking to be revered
> I just want to have a choice.

We leave the room with a bounce in our step, having ended the class with what is beginning to sound like a song.

The next day, Kim comes in with a rough draft of a melody for these words and plays it on our piano while singing along. The melody is in the key of C—a major key, she tells the kids. She shows the kids the staff paper with notes written on the lines and spaces, notes that go up and sound higher, and notes that go down and sound lower.

Joshua asks, "Isn't that a happy key?"

"Major keys often do feel happy," says Kim. "They mimic the tones people use in speaking when they are feeling joyful or strong."

"But this is not a happy song," Lily objects.

"We don't know that yet, do we?" I ask.

"It's all about the struggles of immigrants, right?" returns Lily.

"I do hear some sadness, too," says Felicity. "If it's happy why is there also sadness?"

"That's because I'm playing A minor chords alongside the singer's melody," Kim says. "Chords are groups of notes played together at the same time. The C major chord is composed of

the notes C, E, and G, while the A minor chord is the group of A, C, and E. See how they overlap? They both have the notes C and E. A minor is the relative minor scale of C major; they have the same key signature—no sharp or flat notes—so they're related, but they feel different. C major mostly feels happy or sure, and A minor feels sad or unsure."

Joshua asks everyone, "But it's not about giving up or feeling sorry for ourselves, is it?"

Everyone agrees that they are not giving up.

"I included A minor chords because your lyrics felt strong but melancholy, like the singer is stuck in a problem and trying to get unstuck," explains Kim.

"So let's think of it as being strong," I suggest. "We're stating what we want and not apologizing."

"The problem," says Kim, "is that the rhythm isn't working properly. The third line doesn't match the first line. It's one syllable short."

"What's a syllable?" asks Sarah.

"It's how a word is broken into smaller pieces," I tell her. And I demonstrate how I was taught syllables in elementary school, holding my hand under my chin and pronouncing the word *syllable* in a slow, exaggerated way: "Syl-la-ble. Each time my chin touches my hand, that's a syllable."

"Take a look at the first and third lines," Kim tells the group. "We need to add one more syllable to the third line, and it has to rhyme with *me*, the last word in the first line. Does anyone have any ideas?"

"Why does it have to match?" Sarah wants to know.

"That's how songs are built," explains Kim. "On patterns. The patterns help the people listening to remember what they

hear. They can hang the words on the structure we've built. Otherwise, without a structure, it's hard to follow and hard to recall. Music is organized."

The group goes silent; some are looking in rhyming dictionaries under the "ee" sound—a category that seems almost infinite—while others are sitting very still and thinking, pencils occasionally touching down on paper to make notes.

Then Joshua sits up and says, "It could go, 'I'm not asking to be revered, here.'"

"But *here* doesn't rhyme with *me*!" objects Rebecca.

"It's what's called a *near rhyme*" says Kim. "It's not perfect, but it works. And it has personality!"

Lily agrees. "Yes! When you add 'here' it really sounds like a person being down to earth and asking another person to pay attention, like 'C'mon dude, listen to me!' Person-to-person."

"I have another question," says Kim. "'I just want to have a choice' has a rhythm built on quarter notes. That means each note equals one beat." She sings that lyric. "It slows everything down."

"I like that," says Lily. "It sounds very deliberate, like the singer wants to be very clear about this."

"Yes," Kim says, "but it feels unfinished, like there's another step to take. So I added another measure."

"What's a measure?" asks Percy.

"It's a grouping of notes according to the number of beats," Kim explains. "In this case, the pattern is four beats per measure."

"Ok, thanks."

"My pleasure! So here's what I added: 'I just want to have a choice,'" she sings, repeating these words from the lyric

before, only now, the second time, the notes come quicker: twice as many notes as what came before in the same space of one measure.

"What do you think?"

"I'd like to hear from someone who hasn't spoken yet today, please." I'm looking at the kids. "Felicity, I know you have thoughts about this."

"But I don't know music," says Felicity.

"Oh, yes you do!" I answer. "You listen to music every day, and there are songs you like and dislike. Everyone has feelings about music."

"That's true," she admits.

"So when you hear the words 'I just want to have a choice' at double the speed of those same words right before, how does that make you feel?"

"Like the person who is singing the song is desperate for the other person to know what she wants."

"That's very helpful," says Kim. "Thank you, Felicity."

"You're welcome, Kim."

This conversation goes on for six months as Kim asks the group to use the structures they've built to accommodate more verses. Throughout the conversation, Kim is strict about adhering to the rhythm and rhyme, and insists that the kids place only very important words at the ends of lines, because those are the "remembering" words, the rhyming words where the rhythm lands strong, words that listeners will take with them when they go. In the first half of the first verse, those words are *me*, *voice*, *here*, and *choice*. In the first half of the second verse, the end words are *protection*, *night*, *preciosa patria* ("my beloved homeland," already a departure

from the rhyme scheme for the sake of its emotional power in Spanish), and *burning light*. The second verse tells the story of an immigrant's journey through the desert from Mexico to the United States. Each time we return to the pattern of rhythm and rhyme, we add layers of life to the story.

"We need more Spanish," says Alex one day, after we've written the first halves of the first two verses. "My parents won't know what we're singing about, except for *preciosa patria*."

"Ok, great!" I say. "What do your parents need to understand?"

"Just the main idea of the song."

"And what's the main idea of the song?"

"Asking people to listen. Please."

"How would you say that?"

Percy jumps in without raising his hand. "Por favor escúchenme."

"Actually," says Alex, "I would vote for *entiéndanme*."

"What's the difference?" I ask.

Percy jumps in again. "*Entiéndanme* really means more like 'understand me,' but it also means 'listen to me.'"

"Do we have that duality in English?" I wonder.

"Kind of," says Joshua. "When you say to someone, 'Please hear me,' it can mean literally to hear the words you're saying and also to understand those words."

"Bravo!" says Kim. "It sounds perfect!"

Kim doesn't speak Spanish, but throughout this ongoing conversation she is able to respond in her primary language of music. I grew up playing the violin and singing in choirs and musicals, so I can read and follow music, but I am in awe of Kim's ability to *speak* through music. Her answer to the

Spanish "Por favor, entiéndanme!" is a melody that yearns for understanding, reaching up the scale and giving three full beats to each of the final syllables in the words *favor* ("please") and *me*—three full beats of desperate outcry.

My daughter Zadie used to scream when the words she spoke weren't understood. Now that she is five years old, her growing vocabulary and improving pronunciation allow her to clearly communicate an ever-rising flood of sophisticated thoughts. "Daddy," she often repeats, "I can't stop thinking. I'm always thinking all the time about everything, even when I sleep."

But as recently as one year ago, when she was four, she pronounced *thinking* as *inking*, and I asked, "Inking? Like a squid?"

But Zadie balled up her fists and yelled, "Not inking, *inking*!"

I knew what was coming if I didn't find the right translation in a hurry, so again I guessed, "Sinking?" then, "Singing?" Zadie screamed—a primal, high-pitched sound of anguish—and she curled up in the corner of her bedroom and wept.

"Oh, sweetheart," I said as she pushed away my hand from her head, "I'm sorry. Can you try to explain it to me, please?"

She stopped crying and, pulling in deep breaths and renewing her faith in me and in the act of speech, she said, "It's what happen in my head. Inking."

"Aha! Thinking! You can't stop thinking! Right?"

The sunshine of her face, smiling through the prism of tears, made our own private rainbow of the heart.

"Thank you, sweetheart, for being patient with me."

Zadie, one year after this episode, reflects that she used to think there was something wrong with her voice, something

wrong with *her*, when people couldn't understand what she was saying.

That's the same desperation in our song.

———

One day, Kim announces, "We need a hook!"

"What does that mean?" asks Felicity, as if she's a tiny bit worried—a hook sounds dangerous to her.

"It's the really catchy part of a song, the part that gets stuck in your head and you can't get it out."

The kids all laugh. They know this experience, though not having known its name until now.

"Let's get out paper and pencil," I say. "Time to brainstorm!"

For ten silent minutes we all write down, as fast as we can, our ideas for a hook. The group produces single words—such as *embrace*, *love*, and *freedom*—and phrases—such as "Can we help?" or "I will protect you," or "I will lift you up." Each person reads his or her list aloud, then we vote on which ideas "hooked" us.

Far and away, the winner is "Can we help?"

"It's because it says *we* instead of *I*," explains Lily. "We're singing to the shepherd now. He asks for us to listen and we sing back that we want to help. It's strength in numbers."

"I also think it's beautiful that you, who are immigrants, want to help another immigrant," I say.

"We're not waiting for someone to save us," says Alex.

Kim plays on the piano and sings the words, "Can we help?" in the style of opera, long notes that seem to rise up all the way from her toes.

"I think," says Joshua, "that it has to sound like kids who

really do want to help because they think it will be fun. Kids have this way of being cheerful even in dark times."

I get excited. "My daughter Zadie loves to help at home! She's always saying, 'Daddy, can I help?' She wants to wash the dishes and sweep the floor, and it's an adventure for her."

"Like this?" asks Kim, and plays and sings again, this time with quick little notes that bounce and chirp like the song of a sparrow. She plays it twice: "Can we help? Can we help?" The repetition delights everyone.

"One more repetition," says Lily. "Can you please try it singing 'Can we help?' three straight times?"

Kim does, and everyone smiles.

"Can we help? Can we help? Can we help?"

The kids all sing along as Kim plays our hook for a third time.

"I will never, ever get that out of my head!" says Joshua, smiling as he feigns distress.

Somehow, in the depths of desperation, the kids are happy again, pleased by their own resilience and generosity.

"It's just like Quixote," says Sarah. "All he wants to do is help."

"There's one more ingredient missing," Kim tells us along the way, about four months into the six months it takes to write this song.

"Salt?" asks Percy, and he gets the laughter he was hoping for.

"It's called 'the bridge.' Can anyone guess what it might do?"

"Allow people to go from one part of the song to another?"

"Yes! Wow, Percy! That's a really accurate definition."

Percy goes back to reading *Calvin and Hobbes*.

Kim completes the explanation. "The bridge is a verse somewhere in the middle of the song, usually near the end, that sounds quite different from the other verses and the refrain, and it brings everything together in some way, to stop and look at what it is we're saying."

"I have a really good idea." Percy prefaces all of his ideas this way, preempting any doubt about the worth of his thoughts. "We can use the Statue of Liberty poem."

Right after the election last fall, I had brought in Emma Lazarus's poem "The New Colossus," which is inscribed on the pedestal for the Statue of Liberty. We had focused on these lines:

> Give me your tired, your poor,
> Your huddled masses yearning to breathe free,
> The wretched refuse of your teeming shore.
> Send these, the homeless, tempest-tost to me,
> I lift my lamp beside the golden door!

Percy, whose mind has powers that are not normal, memorized these lines after hearing them only once, all those months ago, and he recites them now for the group.

"Yes!" cries Lily. "We could just say those words, all of us together, instead of singing it. That would sound different from the rest of the song, and it does reflect what the song is saying!"

Sometimes the group's discoveries happen after long, tussling debates, and at other times they strike like lightning: problem solved.

"But what about our parents? They won't understand this," says Alex.

"I have something," says Sarah. "When I heard the 'Golden Door' I thought how Quixote says, 'Siempre deja la ventura una puerta abierta.'"

"'Fortune always leaves an open door,'" translates Joshua.

Kim raises both hands above her head and bows reverentially to the kids. "Brilliant," she says.

———

After translating and adapting the whipping scene—including the "Rescuing Song"—the *Traveling Adventures* group goes back to add a beginning to their show. Mimicking the novel, they agree that the play needs to open as the book opens, with the hero reading. The only visible action is Sarah slowly turning pages, her eyes scanning the words.

They consider a number of books she could be reading, including superhero comic books, which Sarah loves—the present-day equivalent to the adventure stories Quixote reads in the novel—before agreeing that the book that Kid Quixote reads is *Don Quixote*.

"It's like all of us," Sarah says. "The way we're all reading *Don Quixote* together."

"And our stories cooperate with that story," adds Joshua.

"Everything in the play comes from her reading," says Rebecca. "And the action goes from her imagination into the world, just like in the book."

"Yes!" Lily is excited. She speaks and her face opens wide; then she recomposes herself quickly, as if taking back her words, before opening up again right away. "The whole story

starts in peace and stillness and wondering. People are going to want to know what comes next! They'll want to know what's in that book!"

Next, Sarah's stage mommy, played by Lily, the eldest girl in the group, puts her to bed, where Sarah secretly keeps reading, by flashlight, all night long. In the morning, Mommy gets her daughter ready for school as Kid Quixote continues to read, holding the book open in front of her while her hair is braided, her school uniform is wrapped around her and her backpack is hung on her back.

As soon as the girl is away from her mother, she turns off the path to school and begins to act out what she has been reading. A voice yells, "Help! Auxilio!" and Kid Quixote, the novel tucked under her arm, comes to the rescue.

This is where the whipping scene happens, the part already adapted by the group as dialogue and song. In performance, when that scene begins, the audience will always gasp. A sweet story about a little girl who loves to read suddenly is plunged into violence.

"Are we going to use a real whip?" asks Felicity when we start to think about staging.

"No way," says Rebecca. "Nobody's going to whip me!"

"So what do we do?" I ask.

Sarah suggests using a soft scarf as a pretend whip. "Then Rebecca won't get hurt."

"But the audience will just think it's fake," says Dylan. "Like we were trying to make it real but we couldn't."

"Maybe we could use fake blood to make it look more real," says Felicity.

I ask the group what they mean by *real*. Do they mean replicating the abuse in a way that would fool the audience into thinking it's really happening? What do they want the audience to feel as they watch the abuse?

"They need to be upset," says Sarah. "Because it's wrong."

"But if they're too upset, they'll give up." This is Joshua. "They'll be depressed and disgusted. We want them to think about the problem."

"What if we have no whip at all?" I ask. "I could just wave my arm and everyone else can make whipping sounds."

That almost works, using only the motion of my arm and the hissing sound of the whip traveling through the air, made by the rest of the Chorus hissing with their mouths, and their collective hand-clapping to make the sound of the whip striking the boy's back: "Sssssss (clap)! Ssssss (clap)! Ssssssss (clap)!"

The problem is that Rebecca's body reacts to each blow, and the sight of her spasms is sickening in its reality.

Next, she decides to stand still and say only "Ouch!" in a tone of protest, a "Hey! Stop that!" attitude, as if she were the one in charge. Her adjustment changes the whole scene.

All of these choices put the kids in control of their story. They agree that any realistic depiction of abuse would simply replicate abuse, whereas this staging is the product of their imagination. The kids choose to copy a harsh reality not in any realistic way but to signify it instead—there is no whip or blood, the sound of the whip is made by the hissing and clapping of the Chorus in plain view, and the shepherd's re-action is almost bored. The political and moral conscience of the story—the desire for justice and kindness and the

opportunity for the audience to think about these problems as they watch—would be distracted by a fascination with the details of broken skin.

This was something I didn't know when working with Real People Theater. The whipping scene is the opposite of the portrayal of violence at the end of our *Hamlet*. Instead of the climactic sword fight, the boys wore boxing gloves and punched each other hard, even knocking out a tooth and splitting more than one lip. That was real blood on the floor.

As the whipping scene opens out, and the two little girls playing Kid Quixote and the shepherd boy rise above the landlord in their intelligence, grace, and fluent bilingualism, the audience begins to laugh, and by the end of the scene, when the shepherd mocks and dismisses the violence itself, saying, "You call that a whipping? It felt like a butterfly!" the laughter—what Felicity calls the Laughing Power—becomes a kind of triumph, a cheer for resilience, although the child's problem has not been solved.

This defiant, parting joke could be considered another version of the "Fuck you!" that characterized the work of Real People Theater, but it is not the same. The specific choice of words matters. The voice of Real People would likely say exactly that to the landlord, "Fuck you!"—or, as Lucy said often in real life, "Suck it, motherfucker!"—daring the abuser to battle. And that response would be brave and even heroic: an underdog's revenge on abusive power in the tradition of Nat Turner's bloody slave rebellion. The audience's vocal response to Real People's use of taboo language was sharply divided between disapproving gasps and the kind of yell you might hear at a boxing match or in that fight in the Bushwick

High School lunchroom, a raucous noise that means, "Stay on your feet and keep punching!"

I brought this practice of profane revision of classic literature with me to *The Traveling Adventures*—my release from the oppression of "supposed to" in the academic world and a boyhood lived in fear of "bad words"—and as the Kid Quixotes began to translate the whipping scene I even suggested using a curse. When the landowner offers to pay the shepherd at home and the shepherd replies, "Írme yo con él? Ni por pienso!" (or "Me go with him? Don't even think about it!") I asked if the group wanted to say, "Me go with him?! Are you fucking crazy?!" The kids, eyes wide open, declined the offer, shaking their heads "No" in silence. Alex, a teenager who may well say that word when she's with her fellow teenagers, said, "The little ones don't need to hear that." The little kids in the group refer to Alex as their mother, and she was right in her protective kindness.

In both cases—the speculative and vulgar Real People line "Fuck you!" and the actual line written by the Kid Quixotes, "You call that a whipping? It felt like a butterfly!"—the message at the end of the whipping scene is that the shepherd has not been defeated. The verbal punching of Real People, who were schooled by the streets in the hard reality of neighborhood violence, is a "Beware of the danger of me" strategy for survival, while the butterfly joke by the Kid Quixotes, the work of informed innocence, is making light of the problem. Lightness is the Kid Quixotes' response to the heaviness of abuse in the dialogue between kid and oppressor.

One day, late in the process of writing "The Rescuing Song," I digressed from the task at hand by telling the kids what my Zadie said to me that morning. "Daddy," she had said, staring at me, "I can see myself in your eyes." She had noticed that the shiny surface of my eyes could serve as a mirror that revealed her own image to herself.

Alex raised her hand, and spoke while barely moving her lips, saying, "I've got the missing lyric."

We'd written the final line of the song already, inviting refugees to "Come across, reach the lost paradise," so we needed a rhyme with *paradise* and a rhythm that matched the pattern established by the refrain. For rhymes we'd generated *ice, wise, lies, spies, dice, flies, tries, mice,* and *nice.*

"Okay," I said to Alex, "go ahead."

She said, "'We are reflected in your eyes.'"

It's perfect, matching the structures of rhythm and rhyme and distilling the whole song to the central problem of perception, articulated in the very first line, "I beg you to understand me." The way we see someone, Alex was saying, has power to define that person. And she has arrived at this line by listening carefully to other people's stray thoughts and knitting them together as one.

− 2 −

The Friendship Song, or the Adventurous Adventure Song

The Kid Quixotes are fighting against their common enemy: the force of exclusion. As our government unites against them, pushing them away, telling them there is no room at the inn, their radical response is to make more room: physical room for each other in the class and seats around the table (even when we run out of chairs the littlest ones share a seat or sit on a big kid's lap); room for all feelings, even the unpleasant feelings, such as sorrow and rage; room for questions and disagreement; and room for their stories. They answer exclusion with inclusion. Strangers walk in and are welcome. This is how the group assembled itself and how its numbers are replenished. Strangers walk in.

The powers that rule over the fate of immigrants in the United States have, in order to justify persecution and expulsion, described them as "infesting" the country, as if the immigrants were rats. When this is reported in the news we speak about it in Quixote class, as we do at the beginning of every session during "Right Now" time, when we relate our project to what is happening in the world around us.

My students debate passionately whether or not it is right to kill a rat or any living being. The kids all have stories about rats, and so do I. One boy says he watched his father kill a rat in their kitchen with a shovel. A friend of mine, while waiting for a train, had a rat climb up his leg. And a rat jumped at me when I opened a garbage can to throw away a banana peel. A little girl says she has seen a rat running around in the local grocery store.

We talk about how amazing rats are—they can chew through brick and iron; they can fall five stories onto concrete, hop up unharmed, and carry on as if nothing had happened. They're very smart, creating and mapping out for each other a vast, complicated network of tunnels throughout the city.

We all admit that coexisting with rats in our homes is not a good thing. They bite and they carry disease. But what to do? We talk about poison and spring traps, both of which are horrible ways to die. Then Lily says, "We need to understand the rats." Over some strenuous objections to the idea of considering the rats' needs and desires, she continues, "If we understand what rats need and desire, we can imagine nicer ways to get rid of them. Like taking away garbage from the streets."

The kids have managed to turn racist propaganda into a meditation on kindness toward an enemy, and in the process, dismiss an attack by an even more dangerous enemy.

Even if rats didn't end up in our next song, those digressions, the stories we told that day, were important. Spoken stories, like these tales of rats, nourish the children's writing and reading by making them aware of the vast, complicated network of human narratives, including their own. In conversation face-to-face, they feel immediately the power of story and then they can summon that feeling, that relatedness, when faced with a page of text on their own.

───

In the spring of 2017, after completing the whipping scene and "Rescuing Song," we begin to translate the relationship between Quixote and his neighbor, Sancho Panza. This launched a weeks-long conversation about how neighbors become friends and how we know that another person has become a friend.

We notice how businesses send out sales pitches in the mail addressed to "Our Neighbor;" a famous insurance company says it is "Like a good neighbor;" and Amazon, the astronomically wealthy international corporate behemoth, when planning to open a headquarters in nearby Queens, referred to itself in mailings to our homes as, "Your future neighbor." Fred Rogers, the kindly host of the children's television show *Mr. Rogers' Neighborhood*, asked generations of kids, "Won't you be my neighbor?" They are all speaking to our human need for belonging by pretending to be known to us, and us to

them, in a way that is safe and helpful, an emotional aspect of neighborhood that verges on friendship.

Quixote makes promises of glory to persuade his neighbor Sancho to run away from home. At this point, when the two neighbors agree on a plan and depart unseen in the middle of the night, abandoning the lives they were living, the kids say the two have made sacrifices but have not yet become friends, only professional partners.

Although they come through hardship together after suffering abuse at an inn that Quixote believes to be a castle, they are still not friends, in the opinion of the group.

Something changes during the episode when Sancho tries to stop Quixote from attacking the windmills that Quixote sees as giants. Quixote crashes into a windmill and is picked up and dropped by the machine, falling bruised and baffled to the ground. Sancho then expresses frustration with Quixote, asking why he didn't listen to Sancho's warning that the windmills are not giants but machines, saying his boss has "windmills in his head."

But as he says this, he is also caring for Quixote's damaged body.

When Quixote explains that a wizard changed the giants into windmills, Sancho says that he believes him and sympathizes with his physical pain and encourages him to sit up straight, saying, "You're tilting sideways; it must be the pulverization of the fall," according to the kids' translation. This loyalty is typical of Wendy, our Sancho, in real life. She makes room for everyone.

Sarah asks Wendy to read a passage from *Don Quixote*, but Wendy reminds her that while she, Wendy, can read, in the

book, Sancho can't. Sarah welcomes this revision of the game and reads the passage, which says that "Knights are not allowed to complain about any injury" ("No es dado a los caballeros andantes quejarse de alguna herida"). The kids decide to keep this part in Spanish for their parents to understand the topic of conversation, and because, they say, their parents have suffered greatly on their behalf without complaining.

The original Spanish then reads "aunque se le salgan las tripas" ("even if your innards come out"), which Sarah translates as "even if your guts are gushing out," choosing *guts* and *gushing* because they sound funny to her in alliteration and the image is extreme; gushing, she says, is like a fire hose.

Sancho then confesses, "Me he de quejar del más pequeño dolor que tenga," which Wendy translates as "I will complain about the pettiest pain there is," choosing *pettiest* and *pain*, like Sarah chose *guts* and *gushing*, for their alliterative humor, and also because the explosive sound of *pettiest* enhances the Spanish *más pequeño*, "the smallest," with a sense of Sancho's being proud. The way she delivers this line in performance is in keeping with Wendy's unperturbed nature; she allows for her own complaining matter-of-factly, at peace with herself.

In both cases, the dramatic word choices emphasize that these two are ready to receive the most extreme boundary of each other's behavior. In our staging, they then shake hands as they stand up together, and Kid Quixote declares that Sancho has permission to complain, "however and whenever" and "with or without reason."

I explain to the kids that this dialogue is part of a tradition of thought called dialectic reasoning, and it can be summarized this way:

Thesis: Quixote claims to see giants.

Antithesis: Sancho says the giants are really windmills.

Synthesis: Quixote and Sancho yield to each other's outlook.

Now—having seen each other closely, having accepted this revised view of the other, having created this synthesis—*now*, say the kids, they are friends.

This is where a new song begins to be born.

At first, the kids call it "The Friendship Song" because, says Percy, "It's about two friends."

The song eventually will reach backwards and trace the path of Kid Quixote and Sancho's friendship from Sarah's invitation to adventure to Wendy's preparing for the road, with a pause for the windmill scene, followed by a sung declaration of mutual acceptance and a preview of their shared destiny.

Based on our group's reading of the relationship between Quixote and Sancho, and based on each person in the group's experience of friendship, we come up with a list of seventy words and thoughts that occur to us when we ask ourselves, "What does a real friend do?" As meaningful as the words on the list are, there is one just as meaningful by virtue of its absence: *same*. Nowhere on the list do the kids say that your friend has to be the same as you are. As a matter of fact, one pattern they recognize in their writings is steadfast loyalty despite variance, including "support in hard times" ("like arches in a cathedral"), "they see the mess of you," "they come back for you," "like a shield to protect you," and "on your side; even breaking rules."

Next, when asked for other possible song titles, the kids say:

"The Opposites"

"Like Night and Day"

"Giants and Windmills"

"The Paradox"

"The Optimist and the Pessimist"

"Happy Song and Sad Song"

"Reality vs. Imagination"

"Huge Adventure Book Nerd and Illiterate Farmer Guy"

"Rich Person Who Has Lost His Sanity and Poor, Wise Person"

"The Awkward Moment when Finally You and Your Friend Realize You're Opposites"

"Los Amigos Who Are Opposites"

"Light Loves Dark"

"Down Needs Up"

"One in the Sky and One on the Ground"

"Side by Side"

None of these titles calls for sameness or merger into one. Friendship, say the kids, is a balance—what I mathematically call an "inverse symmetry."

Rebecca objects. "Friends need to have something in common. They have to agree."

"Not all the time," says Lily, her older sister.

"But sometimes," answers Rebecca. "If you fight all the time, how are you friends?"

"Fighting and disagreeing aren't the same thing," says Joshua. "You can disagree with someone and still love that person."

Sarah speaks up. "Like a mountain can love a valley and a valley can love a mountain. They are side by side even though one says 'up' and the other says 'down.'"

"That's because there's a place where they meet," says Percy. Sarah and Percy have recently turned eight years old.

This idea of opposites meeting and working together eventually becomes part of the "bridge" of the song, that single verse that departs from the patterns of rhythm, rhyme, and melody established by the other verses in order to reflect on what the song is saying.

Once again, Kim comes to class with musical ideas governed by the kid-written lyrics. Sarah (Kid Quixote) opens the song pleading to Wendy (Sancho) to join her, painting a verbal and musical picture of the adventures that await them:

> I promise soft ground beneath our feet
> Walking on grass instead of the street.

The tone of her first two verses is colored like sunshine by the G major key, full of eager anticipation expressed in many long-held quarter and half notes ("soft grouuuund," "feeeet," "streeeet") complemented by several brief groups of dancing eighth notes that mimic the light-hearted joy of kids' adventures ("Even broccoli will be sweet").

Kid Quixote tells Sancho that she needs her on this journey, and that simple sentence, "I need you," pulls a reluctant Sancho from her upstairs bedroom down to the street in the middle of the night to join the adventure, just like the knowledge that they are necessary rallies the kids in rehearsal.

When Sancho agrees to join Kid Quixote, Wendy sings a

checklist of items they will need to bring along, which is Sancho's job in the novel, too. The rhythm shifts a bit in this verse to include more groups of eighth notes, and all of the notes are played in a brisk, staccato style to match the swipes of Wendy's pencil as she checks necessities off the list: "We need BLAN-kets, COO-kies, BA-by CAR-rots WASHED and PEELED."

The catastrophe of the windmill brings out opposing views of reality in fanciful, dreaming Kid Quixote and practical, organized Sancho, and this basic difference of vision could destroy the potential for love. As they recognize and agree to accept the differences, the lyrics say—in both Spanish and English, with music that surges from minor to major, from contemplative to triumphant:

> Some of us are Dreamers
> And others work the land,
> Learning to walk through the day;
> El norte es el sur,
> They make the same road,
> Leading ourselves far away.

This small, bilingual verse—the bridge—summarizes and synthesizes the group's list of opposite traits belonging to the two adventurers: "reader vs. illiterate," "imagination vs. the five senses," "fantastical vs. practical," "boastful vs. humble," "thoughts vs. food," "heaven vs. earth."

To say "el norte es el sur" ("the North is the South") and "they make the same road" is to say that opposites are relative to your location and point of view, a point of view that shifts when the language shifts between Spanish and English. Alex

says in class, "If you are standing on the South Pole, the rest of the world would seem like it was below you, even though everyone says that's the bottom of the earth." The road, the structural backbone of the whole story, our "walk through the day," is shared by these relative realities.

———

When I first came to Bushwick in 1998 to interview for a job at Bushwick High School, I saw streets and sidewalks broken and rubble everywhere, as if, to my middle-class Canadian vision, the neighborhood had been bombed in a war. Along the four blocks from the L train station to the school, I passed by vacant lots full of trash and burned-out, boarded-up buildings marked for condemnation with orange Xs spray-painted on their doors. Multiple cars had garbage bags taped over windows that thieves had smashed in search of radios. Rats dashed in front of me. Among the many faces I saw, none were white like mine. They stared at me from darkened doorways, and I imagined that they didn't want me there. This was, I thought, the ghetto, a place of danger and ruin. I couldn't have guessed that soon—and for decades—these strangers would become my neighbors.

Aspects of my assessment were true. Bushwick was in disrepair. The people who lived there were poor, and there was danger from street gangs. But as I daily walked that path to and from the school, having begun to know specific kids and then their families, I no longer felt in danger, and I began to understand that the ruin was not the fault of the people who lived there; they were just people trying to get by. By the time I broke down, seven years after I first arrived, I had learned

that just as individuals can be depressed and suicidal, so can a neighborhood.

That very first day I came to Bushwick I also fell in love with the laughter and warmth and immediacy of the students, with the Spanish language and street speech, and with the idea that here I could be useful.

In Bushwick I knew nobody, and there was nobody like me. As a visible, audible oddity, I had a place, and there was no competition for that place. The students needed an English teacher and here I was, in a neighborhood where few white people would go, a neighborhood that maps in New York tourism guides left unnamed and blank; the known world did not include Bushwick. Here, I could disappear, belonging where I did not belong. I rented an apartment above a bodega in a building that was slowly sinking on one side.

The longer I stayed and the more I listened, my students at Bushwick High began to trust me in deeper ways, especially the members of Real People Theater. They brought me to their homes where their mothers and grandmothers cooked for me. My favorite food was called tostones—pan-fried, sliced plantains—and my favorite drink was morir soñando ("to die dreaming")—a blend of orange juice and milk—both stand-ards in Dominican cuisine.

My student Easy, ever restless, took me on walks around Bushwick while I helped him memorize his lines as Hamlet. He told me he thought of me as his father and had no idea who his real father was. One day he pointed across the street and said, "That's my mom over there." I saw a young woman with ebony-colored skin sitting on an overturned milk crate on the sidewalk and slowly tilting to one side until she was

almost parallel to the ground; then she righted herself and began again to lean to the other side. This was the tilting, Easy told me, of a person addicted to heroin. We walked on.

This was my journey of understanding the neighborhood; the broad assumptions I brought with me were undermined over time by the relationships I formed with many different people.

Growing up in Canada, I became sensitive at an early age to the emotions carried by language. Canada is officially a bilingual country, with government services and product labels in both English and French. Despite being rooted in a very English-speaking town in Ontario, I fell deeply in love with Québec, the faraway romantic other—my own version of Quixote's imaginary ladylove Dulcinea—and every chance I had I would read, write, speak, and listen to the French language.

Every can of soup or box of breakfast cereal was an opportunity to learn more. When my parents took me with them to the post office, I would grab French notices and forms and take them home to translate. When we flew on Air Canada, I would keep the bilingual card with illustrated instructions on what to do in the event of a disaster, I would choose to watch the French-language onboard movie, and I would respond to the flight attendant's question by saying, "De l'eau, s'il vous plait," and then, "Merci," when the glass of water arrived in my hand.

My favorite hockey team was Les Canadiens de Montréal. No only were they located in Québec, with a French name, but their roster was, and had been through their history,

full of Francophone players. I loved repeating their graceful names, like whispered prayers to saints: Guy Lafleur, Jacques Lemaire, Jean Béliveau, Maurice Richard. During the Quiet Revolution—the movement for an independent Québec, rising up against the injustice of Francophone subjugation by the ruling Anglophone society—the success of Les Canadiens struck a blow for the oppressed.

This boyhood long-distance love affair with Québec and everything French—a pure romance with pure beauty—was the root of my future political passion.

In high school I also fell in love with Latin. Although it didn't have the living pulse of French, I adored its intricacy and the way a Latin sentence could separate its principal subject and associated verb with multiple clauses in between and switch the word order any number of ways, and it was up to me to solve the puzzle by using the endings of words to decide how all of them related to each other and then choosing a corresponding word order that sounded right in English. I found this to be an absolute pleasure. As the mother of the Romance languages, Latin provided me with a deeper understanding of the inner workings of French, the logic of verb tenses and moods, the cooperation of nouns and adjectives, and a reliable structure at the heart of language—the architecture of thought itself.

This structure would also one day serve my learning of Spanish, which really blossomed when I began interacting with the Mexican and Ecuadorian parents of the younger kids at Still Waters. Their knowledge of English was fledgling, as was my Spanish, so, with the children as intermediary translators, we began to learn from one another.

As I learned more and more Spanish every day, the Latin language—la lengua latina—rose up inside me like a tide pulled by the Spanish moon. I guessed at vocabulary by using Latin and discovered that Spanish is practically a dialect of the Mother Language, even more closely related than French. In return for the gift of learning Spanish, I could teach the kids Latin and enjoy its beauty again myself.

The Still Waters kids are deliriously infatuated with Latin. Their knowledge of Spanish makes them confident at guessing the meaning of Latin words. As we read aloud and translate a Latin passage into English and Spanish, the kids come up out of their seats, stretching their arms and waving their hands as high as possible to be called on and making sounds of desperation, such as "Oh! Oh!" or "Oo! Oo!" or "Me me me!" or "Please!" I've told them that I call Latin "The Big, Beautiful Puzzle" and that their job is to translate the pieces and solve that puzzle. This is adventure, and, just as in *Don Quixote*, mistakes are only stories along the road.

After the election in 2016 that traumatized my students and their families, we switched from a study of conversational Latin to ancient Latin readings about politics and leadership. The first reading, in direct reference to our new and terrifying ruler, was a description of the Roman emperor Caligula. "De monstro, necesse est narrare," reads the opening line from the Roman historian Suetonius. Following the Latin word order, the kids arrived at, "Of monster, necessary it is to tell story." Alex, who I nicknamed our "Closer" in Latin class because she loved to listen to everyone make guesses and then put it all together as one, reassembled these pieces to say, "It is

necessary to tell the story of the monster," although the kids liked how the Latin original placed the word *monstro* at the beginning of the sentence.

"It grabs you right away," said Sarah, sensitive to an effect we couldn't replicate in English.

The kids went on to learn that Caligula once appointed a horse to be a senator and declared war on the Mediterranean Sea, ordering his soldiers to attack the tide. They read that in general, from the time Caligula was a boy, "Valde sibi placuit supplicum et poenas spectare." The puzzle pieces discovered by the kids read, in Latin order, "Very much to him pleased suffering and punishment to watch." Reorganized by Alex, the answer to the puzzle was, "It pleased him very much to watch suffering and punishments." *Poenas*, the kids noticed, is the root of the Spanish *pena*, which in our show launches Kid Quixote's threat to the landlord that, if he fails to do the right thing, she will return and inflict on him "la pena de la pena"—the "penalty of the penalty"—in the name of justice; not, as in the case of the emperor and of our new ruler, for what appears to be pleasure in another person's agony. A temporary silence surrounded this reading, as Caligula's ancient cruelty resonated in the hollows of our recently broken hearts.

We also read about the brothers Gracchus, both Roman tribunes in the late second century who tried to redistribute property from the wealthy to the poor. The Roman historian Sallust wrote, "Tiberius et Gaius Gracchus vindicare plebem in libertatem et patefacere scelera paucorum coeperunt." The pieces in Latin order read, "Tiberius and Gaius Gracchus to

defend the common people in freedom and to reveal crimes of the few began." Reordered by Alex and adjusted for historical context, the sentence says that the brothers "began to defend the freedom of the common people and reveal the crimes of the powerful few." In addition to "defend," the word *vindicare* has multiple translations, including "justify," "support," and "avenge." This passionate advocacy was bold and dangerous business. The brothers were both assassinated by sword for their attempt at economic fairness.

Recognizing that the problems of today have their roots in yesterday allows us to contemplate the recurring patterns in human civilization, to become aware of the hazards on our own path, and to be brave in facing what has come before and will come again; but studying only the hard truth can, without reassurances, ruin us. In need of comfort (from the Latin for "strength") we turned to the Beatitudes, the blessings spoken by Jesus in the Sermon on the Mount, such as, "Blessed are the humble, for the world belongs to them."

As we translated each blessing, for the poor, the hungry, the peacemakers and those who suffer for justice, Rebecca said, "These words feel like a hug from my mother when I'm sad or when I fall down." I know this feeling, too. My mother's hugs, given without asking for explanation or justification, were always healing. In *The Traveling Serialized Adventures of Kid Quixote*, Mommy's hugs begin and end Kid Quixote's day and resurrect her when she has fallen to the ground.

The kids were eager to write their own Beatitudes in English, Spanish, and Latin. First, they composed their thoughts

in English or Spanish, then they translated those words into Latin, reaching back into their linguistic ancestry to build a blessing across time, a blessing with the stature of eternal and universal truth. Their original Beatitudes express basic needs:

> *Beata sum, quia pater meus laborat.*
> Blessed am I, because my father has a job.
> —SARAH, AGED 8

> *Beatae matres, quia semper benignae pulchraeque sunt et vitam creant.*
> Blessed are mothers, because they are always kind and beautiful and they make life.
> —ALEX, AGED 13

> *Beatae familiae, quia dant tibi domum, ut mare est domus animalium ingenum et contortiplicatorum.*
> Blessed are families, because they give you a home, like the ocean is the home of huge and complicated animals.
> —PERCY, AGED 8

Translating their thoughts into Latin begins with looking up words in the English-Latin dictionary, an activity that makes the kids dizzy with desire for knowledge. But Latin is a highly inflected language: the meaning of a word and its relationship to other words in a sentence are revealed in the ever-changing word endings, which aren't listed in the dictionary; they must be studied. *Amo* means "I love," but *amas* means "you love." *Amica* means "a female friend" and

amicae means "to a female friend." With no penalties assessed for making mistakes, the kids are fearless in asking for help and revising their work.

———

My father, a professor of mathematics, often repeated Keats's statement, "Beauty is truth, truth beauty, and that is all ye know on earth and all ye need to know," to convey his passion for his discipline. Without his wisdom I would have been completely seduced by my quest for perfect scores—by the idea that your answers are either right or wrong, that there is no mystery or room for imaginative interpretation. While I was mastering prime factorization—the expression of any whole number as a product of prime numbers, which cannot themselves be expressed as a product of primes—Dad taught me that despite knowing much about these fundamental building blocks of all whole numbers, nobody has found the pattern to predict their occurrence; a secret rhythm has yet to reveal itself, and the pursuit of this secret is a global adventure occupying many thousands of minds.

Transferring this way of seeing the world to the Kid Quixotes, I tell them about the symbol, "\sqrt{x}," meaning "the square root of the number represented by the symbol x." A square root is a number that, when multiplied by itself—or "squared"—produces the square x. It is called a *square* because the area of a square is found by multiplying its length times its width, which are always the same number. Some numbers—such as 4, 25, and 100—are called *perfect squares*, meaning that their root is a whole number, with nothing after the decimal point.

For example, the perfect square 25 is formed by multiplying 5 times 5 (often written as 5^2, or "five squared"):

$$5^2 = 25$$

But not all squares are perfect; in fact, *most* squares are not perfect: they cannot be made by whole numbers. (This is where Dad's voice always quakes as he is explaining this concept—he returns to beautiful ideas with the reverence many people give their favorite songs.) All other square roots—all the numbers that have to be multiplied by themselves to achieve another whole number—have *infinite* decimal expansion. So, while $\sqrt{25}$ = 5 and can easily be drawn and measured with pencil and paper and a ruler, as above, in $\sqrt{24}$ = 4.89897948557 . . . the numbers after the decimal point go on and on forever, with no discernible pattern. It's still a real number: if you were to draw a number line that included every number that can exist, there is a corresponding point for this number on it, but its location defies precise

physical depiction and measurement by human hands. We can get *near* to the exact point, but approximation is as close as we can come:

$$\sqrt{24}$$

$$\sqrt{25}$$

−10 −5 0 5 10

(Origin)

I think of another mathematical example of approximation. Using chalk on the wall, I show the kids that when you graph the equation $y = 1/x$ (where a point on the y axis matches the inverse on the x axis), you produce a curve that draws closer and closer to the axes without ever touching, an infinite yearning across an always-diminishing but never-to-be-bridged separation. Here is $y = 1/x$:

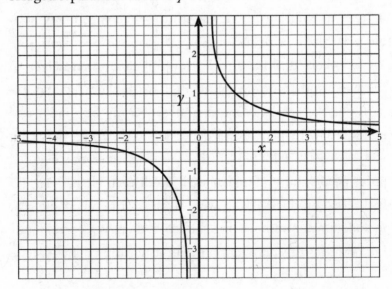

"These ideas can be applied to translation," I tell the *Traveling Adventures* group, some of whom are still—after more than two years of collective translating—afraid to speak their ideas for fear of being wrong.

"There are words that match each other precisely, such as *gato* in Spanish with *cat* in English, like perfect squares match their roots and can be expressed as a precise, representative drawing. And there are other words or phrases, such as the antiquated idiom from *Don Quixote*, 'No ande buscando tres pies al gato,' whose literal meaning, 'Don't go looking for three feet on a cat,' can take us only to the threshold of its real meaning, and we, in English, can only approach it by approximation. 'Don't go looking for trouble' comes close, but it lacks the visibility of the Spanish idiom. There's nothing to picture when you read that. 'Don't go kicking the hornet's nest,' which has visibility but a different personality (substituting danger for mere fascination) also comes close."

We remind ourselves that the "no desface" debate in the whipping scene doesn't have a clear winner, unless you count the ever-changing tally in our democratic vote during the performance of the play. As we go back and forth, at every performance, considering the state of mind or set of circumstances that allow or forbid Quixote's action, we come closer and closer to an answer—perhaps infinitely close—but can't ever be exactly right or wrong, like an eternal decimal expansion or that desirous curve that never will meet its match.

"Never?" asks Percy.

"Never," I answer.

Early in the process of translating the whipping scene, the kids notice that Quixote likes to use repetition and multiple ways of saying the same thing. When he hears the cries of the shepherd boy, he says that this must be someone "male or female," who "requires my assistance and help," and he threatens the landlord, saying, "I will exterminate and annihilate you," reveling in the variety and power of words and boosting the drama of his heroic majesty. The kids choose to test the boundaries of his verbosity by exhausting our thesaurus (from the Latin for "treasure") and compiling as many synonyms as they can find. This gathering is sometimes brief—as in "Yo lo mande:" "I ordered / demanded / decreed / commanded"—and other times a flood of words, as in his sentencing of the landlord.

The original sentencing speech in the novel, responding to the landlord's offer to pay the shepherd boy at home with coins that smell "sweet with benevolence," says, according to the kids' first draft of their translation, "From the perfume I pardon you; pay him in reales—" a denomination of Spanish money in the age of Cervantes "—and with that I will be satisfied; and watch that you complete this as you have sworn; if not, by my own swearing I swear to return and find you and punish you, and I will find you, even if you hide better than a small lizard. And if you want to know who has ordered you to do this, to stay more focused on completing it, know that I am the brave Don Quixote of la Mancha, the undoer of wrongs and not-rights; and go with God, and don't depart from what you have promised and sworn, under penalty of the penalty I have pronounced."

Again, the kids notice that Quixote uses repetitions and synonyms to aggrandize his authority: "by my own swearing I swear," "wrongs and not-rights," "what you have promised

and sworn," "under penalty of the penalty." This verbal excess is their license to amuse themselves.

After several days of gathering synonyms, the kids produce sixty-nine ways of saying "money" in English and Spanish, fifty-one ways of saying "boss," twelve ways of saying "brave," five ways of saying "injustice," and five ways of translating "pena." In doing so they feel they are acknowledging Quixote's aggressive weaponizing of language, much like the landlord uses the whip. They are reaching for his true voice by stirring crowded verbal cyclones around what was originally a single Spanish word. And there is great joy in this assembly; the kids keep laughing as they add yet another word, and another, to the collection.

As we rehearse the scene over the course of a week— alternating writing and acting, testing our words in action then returning to pencil and paper—the kids gradually decide that they don't need all these synonyms. The joke was funny in class, but it doesn't advance the narrative. The dispute about money is already at the heart of the scene, and Quixote's authority is more dramatically and actively articulated by his threat to return and punish the wrongdoer than by listing many ways of saying "money" and "boss."

"When Quixote speaks here, he's trying to scare the landlord," says Rebecca.

The kids are looking for action through language, rather than the vain and static decoration of self, like jewels in a crown.

At the end of the week, they retranslate this speech as, "I release you from that aromatic burden—" Joshua's elegant revision of "From the perfume I pardon you" "—You need not exude perfume or bake cookies."

Joshua supplies this extra line, in love as he is with the word *exude* and its rhyme with its neighboring word *perfume* to make the most of what the kids find to be a funny idea, that money has a smell. "And the word *cookie* is always funny," he adds.

The speech continues:

> KID QUIXOTE: "Pay him in reales / dinero / money / dollars / pesos / and with that I shall be satisfied. You will comply with what you have sworn; if not, by the same promise, I promise I will come back to find you and to punish you; and I will find you, even if you hide better than a type of small lizard. And if you want to know who commands you / who is your boss / jefe / patrón / dueño / chief, to give you more motivation to complete this task, know that I am the valeroso / valiant / brave / courageous / heroic / Don Quixote of La Mancha, the undoer / righter / fixer of hurts / injuries / wrongs / injustices / unfairnesses; and let God decide, and don't separate yourself from what you have promised and sworn, or suffer la pena de la pena / the pain of the pain / the penalty of the penalty / punishment of the punishment / shame upon shame / suffering upon suffering I have pronounced."

They decide to keep the original Spanish and multiple translations for "pena" at the end of the speech because in their accumulation these words—*pain, penalty, punishment, shame, suffering*—describe multiple facets of the single Spanish word, each adding to the weight of advancing and inescapable doom.

Weeks later, after much rehearsal, in the final draft of the speech, all of the words for "money" and "boss" have been cut, and the speech reads,

> KID QUIXOTE: "I release you from that aromatic burden. You need not exude perfume or bake cookies. Just pay him and I shall be satisfied. If not, I will come back to find you and to punish you; and I will find you, even if you hide better than a lagartija! And if you want to know who commands you, to give you more motivation to complete this task, know that I am el valeroso Don Quixote de La Mancha, el Desfacedor de Agravios y Sinrazones, the Righter of Wrongs."

The kids keep his self-given title in both languages because, they argue, he would be proud to be bilingual. "That's twice as many words to use!" says Joshua.

> KID QUIXOTE: "Do not break your promise or you will suffer la pena de la pena / the pain of the pain / the penalty of the penalty / punishment of the punishment / shame upon shame / suffering upon suffering I have pronounced!"

The original speech in the novel does not include alternative meanings of "pena," but these alternatives replicate Quixote's oratorical style, his use of words as objects to be hurled at, and to break, an adversary's shield.

Rehearsal is an opportunity for revision. As the kids recite their words to the other actors and hear them out loud, they receive new information about their writing. When in rehearsal Sarah spoke the sixty-nine synonyms they had gathered for "money" and the fifty-one words for "boss," the group realized that Sarah was buried; not that she was incapable of saying all those words, but that her personality was lost and the many words had become a barrier between her and the audience. Once these verbal avalanches were removed, the speech built up to its climax of five threatening synonyms for "pena" and the true, active, passionate voice of Kid Quixote had been uncovered.

By reciting and revising the characters' lines in relationship to one another, the actors understand each individual's desires and how specific words are used to pursue those desires in those relationships. Every word they speak becomes their own, and this ownership makes them brave.

Still Waters in a Storm took a long time to come to fruition.

After about a year of psychotherapy in Canada—at the beginning of my recovery I couldn't read anything at all—the therapeutic process of self-study brought me back to reading *Paradise Lost*, which I had read originally in college, John Milton's epic seventeenth-century poem about the fall of Adam and Eve from their state of grace in the Garden of Eden, and the fall and rise and fall of Satan.

The story opens with Satan and the other Fallen Angels lying unconscious on the floor of Hell, having been thrown out of Heaven after losing a civil war brought on by Satan's

jealous rebellion against God. They were hurt by God's apparently arbitrary choice of Jesus as ruler over the angels, who had until then lived in egalitarian peace.

Deep down in the "darkness visible," burned by fire that gives no light, Satan, a warrior giant with a shield the size of the moon, stands up and, despite his fading luminescence, with tears falling from his eyes, tears of compassion and remorse for those who followed him into damnation, he rallies the troops, calling out, "Awake! Arise, or be forever fallen!" This became a prayer for me during my recovery as I woke every morning and chose to stand.

Paradise Lost called to me in my own fallen state, and it was also alive in my mind as the last completed adaptation project of Real People Theater: a profane, raunchy, Spanglish show about defiant sinners, kids in the ghetto seizing restricted knowledge—which is what these kids were actually doing by reading and remaking this advanced, college-level poem in defiance of the school system's low expectations for them and their own depressed self-worth, these drug dealers and gang members and drop-outs, or "'hood rats," as they referred to themselves.

Satan, played by Angelo, was—in our version—a hero, leading his incarcerated people, the Fallen Angels who in Heaven had followed him into rebellion and had been banished. He was now rousing them from the darkness of Hell to the light of Earth, against the irrational tyrant called God, played by me, a character who alienated and isolated himself by punishing those who could be friends, designing tests for them, such as the forbidden fruit, that said more about His suspicious, distrustful nature than their betrayal.

"No wonder God is lonely," said Angelo. "Everyone with power is alone."

Eve, who grabbed that fruit—as recreated and played by Lucy—was a feminist trailblazer, refusing to be kept down in ignorance and oppression by males. "My life, my rules, my choice," she said as she plucked and ate.

Then the tree spoke knowledge to her, a soliloquy written by Lucy, her girlfriend Charlotte, and an assembly of authors we read together in class—including Blake and Emerson and the physicist Richard Feynman—and recited by Charlotte:

> "Knowledge is Power"
> this phrase is said to a person
> every hour
> But me, I feel like screaming
> From a great big tower
> "Self-knowledge is Power."
> In the back of your mind you're like, "That's just a tree."
> I say not just a tree
> The Tree of Knowledge of Evil and Good
> Warning you, there's too many downfalls in the 'hood.
> It's said Bushwick is one of the worst high schools
> I say we need books, desks, and art tools
> People be hating their job at Mickey D's
> I say hey go to college get a real job don't take it out
> on me!
> I was told I would never amount to anything
> And was up to no good;
> So the hell what if I'm living in the 'hood?
> But look at me know, I have my own pledge

And yes I am spitting knowledge

And I'm not even in college

But in due time I will

Malcolm X said, "See for yourself, listen for yourself,
 think for yourself,"

(aka "Be Yourself")

I say he's right, but a lot of people need help.

They say take your hat off during school

But according to some cultures God says that's not cool.

Ready?

There are more chickens than people in the world

No word in the English language rhymes with month,
 orange, silver, or purple

A goldfish has a memory span of three seconds

If you keep a goldfish in a dark room it will eventually
 turn white

A cockroach can live nine days without its head before it
 starves to death

Donald Duck comics were banned in Finland because
 he doesn't wear pants

"I am" is the shortest complete sentence in the English
 language.

"I am."

We must admit that we DO NOT KNOW.

The stars are made of the same stuff as the animals and
 the plants and the water

The stars are made of the same stuff as we are

It's an adventure to contemplate

To imagine the Universe without people; shhh . . . let's
 contemplate . . . [silence]

The guidance counselor says you need this many credits
 to graduate;
What is a goddamn 'credit' anyway?
I say I can quit school and get a real life and a real
 education.
We are shut up in schools and college recitation rooms
 for ten or fifteen years and
Come out at last with a bellyful of words and don't
 know a thing.
If your eyes were cleansed
Everything would appear to you
As it is:
Neverending.
The most sublime act is to set another being's happiness
 before your own.
The crooked roads are roads of Genius.
Everything that lives is holy.
EVERYTHING

At every performance the audience stood and applauded and whistled at the end of this speech, in praise of the crooked road.

At the end of the story, after Adam and Eve have been banished from the Garden for disobeying God, Milton writes, "The World was all before them, where to choose / Their place of rest," and "They hand in hand with wand'ring steps and slow, / Through Eden took their solitary way." Lucy said that this ending was really a beginning, and she chose to adapt these last words as her uplifting speech to a dejected Adam, played by Easy: "Nigga, look up. We got the whole world in

front of us. Hold my hand. Now walk with me. Let's go make some choices."

Blazing their own trail out of the neighborhood, two of the boys in Real People Theater, Julius and Easy, were admitted to an elite northeastern college—the most expensive college in the nation—on full scholarships, despite their having low grades in high school, no SAT scores, plus criminal records. Their admission was based on their performance of *Hamlet* on that campus for a crowd of white professors and wealthy, white students delirious at the brilliant difference in their midst. This audience already knew Shakespeare's *Hamlet*, so when the lights went out in the repurposed barn they expected to hear one of the most famous and suspenseful beginnings of any play:

> [Two palace guards are on night watch. The stage is dark and the mood is dense with fear. One guard speaks the play's first words:]
>
> "Who's there?"
>
> [The other, unseen, replies:]
>
> "Nay, answer me. Stand and unfold yourself."
>
> "Long live the king!"
>
> "Barnardo?"
>
> "He."
>
> "You come most carefully upon your hour."

Instead, they heard:

"Who's there?"

"Nah, you tell me. Who that?"

"Hands up, bitch!"

"Yo, it's me, nigga!"

"Fuck! Coño! You scared the shit outta me, bro!"

The audience went berserk with excitement and laughter.

When Real People Theater traveled with what the kids named our "Ghetto Shakespeare," just the idea that kids from the barrio were reading Shakespeare (and later Milton) was what got us in the door at elite theaters and colleges. The juxtaposition of "civilization" with "savages" surprised and delighted people like a carnival freak show—"How did you get *those kids* to do that?" many people asked; "They're brilliant," I answered—a tethering of monsters to the stage.

This was adventure for the Real People, a voyage to meet strange people in a strange place, and adventure for the audience who had never met such people as made up the troupe, those depicted in popular culture as dangerous gangsters and rappers. The revised plays—full of curses—scandalized some audience members, such as a group of public school teachers assembled for a pedagogical conference at Yale where we performed our *Hamlet*, who were appalled by the blasphemy of profaning a sacred text and accused us in the post-show conversation of dumbing down the original play and robbing it of its poetry.

Others, including professors at the college Julius and Easy would attend, heard in that translation a partnership of poetries.

All of these valid reactions proved that Real People Theater had achieved its goal: a glorious, virtuoso "Fuck you!" to everyone—dynamite at the gates of paradise.

Surrounded by forest on our first visit to his future campus, Julius marveled that trees had a smell, that he could actually smell a tree—an impossibility in Brooklyn. When I delivered the boys to the college the following August for enrollment, they removed their city shoes and vowed to walk only barefoot on grass until the coming of winter snow. This was a new beginning, a return to the Eden they had never known.

Midway through his second year, Julius was expelled for selling drugs in the college dormitories. The college offered to reinstate him if he performed community service; he told them to go fuck themselves. The punishment, he said, was a racist conspiracy. After all, white kids who did the same thing went unpunished. Easy committed the same crimes as Julius but was never apprehended. After he received his bachelor's degree he had a job waiting for him with a prestigious New York City theater company, but he blew off rehearsals and returned to selling drugs in Bushwick. Julius, too, returned to the neighborhood and to selling drugs.

Despite their falls from the heights of opportunity, they did not give up. Both boys eventually joined Still Waters in a Storm in the early days, pulling their broken selves up the stairs and through yet another doorway.

In the fall of 2015 I would invite a group of much younger kids, aged eight to twelve, to meet with me at Still Waters in a Storm Mondays and Tuesdays after school to read *Paradise Lost*, not to adapt the poem as theater—I couldn't travel back into the stress and pressure of putting on a show, not yet—but to translate the seventeenth-century English verse orally into present-day vernacular as we read, and to use that process to study ourselves, to read its mythic battles as stories of the human mind and its power to remake reality and recover from trauma. To this day the kids in that group can quote their favorite lines, explain the meanings they have assigned to those lines, and retell the whole story as if they were the authors. They have learned that the interpretive choices they make as readers are as creative as the choices made by writers; a specific reading is its own story.

"The mind," says Satan in double-edged defiance of his underworld incarceration, "is its own place, and in itself / Can make a Heaven of Hell or a Hell of Heaven."

"To me," said nine-year-old Melvin, "that means that what happens in my brain is what is real."

"Or," added Rebecca, "I can always hide in my mind when life is too rough."

Devout Catholic Miriam said, "The Bible says, 'The kingdom of God is inside you.'"

"That makes me think of Stephen Hawking," said Percy, "The scientist who is stuck in a wheelchair and can't talk but inside his brain still works and he can imagine galaxies."

"For me," I told the kids, "It means that wherever I go I am the person responsible for my happiness."

Satan's journey is a visible, mythical model both for my own

recovery from bipolar depression and for the heroic travels of refugees. He talks his way past Sin and Death, who open the gates of Hell, then he flies across the vast and hazardous cosmos, "the void profound / of unessential Night," negotiating with Chaos, voyaging "O'er bog or steep, through strait, rough, dense, or rare, / With head, hands, wings, or feet pursues his way, / And swims, or sinks, or wades, or creeps, or flies," every step a struggle, before arriving, after all, on Earth, and leaping the wall into Paradise.

This description of a physical voyage gave adventurous gesture to the sameness of my days, to the daily climb of my mental voyage, an image I could use as an example of lionhearted perseverance along recovery's dragging path.

A year later, with the Kid Quixotes, I would recall to the kids Satan's journey as analogous to our journey as readers and writers, an adventure that demands relentless resolve and daily resilience. "Think of your parents," I said. "What they've been though and what they are still going through."

My return to Bushwick in 2007 was rough. I went through four jobs in six months at programs in Brooklyn and the Bronx, where I was teaching day and night classes for kids who had dropped out of high school and were trying to pass the exam for their GED (General Education Diploma).

At each program, I declared war on the administration for what I saw as their oppression of the kids. As I had at Bushwick High School, I let the kids go to the restroom whenever they chose without an official hallway pass, I skipped faculty meetings, and I refused to follow the curriculum. I thought

I was there to rescue the students because, I imagined, they were being made to sacrifice their dignity in order to pass a test—and I despised tests, gatekeepers of opportunity.

The administrators barked orders at the kids, made them sit up straight, and physically invaded their personal space to go nose-to-nose in displays of public shaming. One principal made the students—seventeen, eighteen, nineteen, or even twenty years old—clap back a rhythm he had clapped to them, as a show of their obedience. The bosses would also reprimand the teachers in front of their students by asking what it was we thought we were doing if we seemed to be deviating from their recipe for success, a plan that consisted of making the students take sample tests again and again for six months. This treatment was demeaning and counterproductive, as it raised up the ghosts of failed and brutal schooling, triggering the very trauma that had driven these kids from school to begin with.

Not yet having internalized my two years of lessons in psychotherapy, I remained righteously deluded; what I failed to understand—or refused to acknowledge in my zeal—was that the kids didn't come there to join my rebellion: they came to pass the test so they could qualify for a better job and stay out of jail and pick their lives up off the ground, and I was hired to prepare them for the test. There was merit, I believe, in my social approach to literacy, to a learning based on the interrelatedness of the members of a group and the facts of their lives and their common state of oppression, but these students did not have the leisure time to wait around for their own transformation to happen. I eventually quit every job in fury, and the kids carried on without me.

Meanwhile, I was also trying to resurrect Real People

Theater. I called up the kids—now adults—who were still around and invited them to my apartment (I had moved back into the falling building above the bodega) where we sat on the floor and read and remade *Timon of Athens*, Shakespeare's unfinished tragedy about a wealthy man who gives everything to anyone who asks, always in the name of friendship, only to be abandoned by his friends when he runs out of money and turns to them for help. Timon, the wealthy man, then stages a feast, fooling the friends into thinking he has regained his wealth, only to serve them stones and to use those stones to drive them out of his home forever. Having lost his sanity, Timon goes to live in a cave by the sea, and while digging for root vegetables to eat, he unearths golden treasure. The rumor of these riches reaches town and a parade of supplicants visit Timon, who curses them. After all of these ups and downs, Timon walks alone into the sea and drowns himself.

But we weren't able to resurrect Real People Theater. It failed because we each believed we were the victims in the conflict that had doomed the group. Back in the days of our *Hamlet*, the kids and I had gone together to get tattoos on our bodies that said "RPT," a permanent text and testament to a love that fell apart. Here we were again, the kids now grown-ups, a room full of Timons cursing each other's betrayal.

"I gave you everything!" I said, on the verge of tears. "All of my time and money and education! I even gave up my job, my pension and health insurance, and my girlfriend, so I could work with you! I chose you over everything else!"

"And we chose you," said Lucy. "We gave our time, we gave up jobs, we gave up street cred, hanging with a white man putting on plays. We made you our Dad. And you left."

With everyone claiming to be Timon, we couldn't go forward, and we agreed to quit. Julius and Easy went back to selling drugs, and Lucy moved to Florida with her girlfriend.

Then Angelo asked me if I wanted to do some writing together; not to perform, just to write, read our writing aloud, and listen to each other, as we had tried to do in my English class at Bushwick High.

This invitation was the beginning of Still Waters in a Storm.

By this time, spring of 2008, I had quit my fourth teaching job, and I was surviving on unemployment insurance, food stamps, disability benefits, and Medicaid. Angelo was supported by his wife's job in the Army. Our meetings offered what we both really needed: the associations that rise up in dialogue, the closeness of shared thought. Gone was the desire to reach people beyond the room. Now, sitting on the sloping floor in my apartment, with no agenda, we found peace.

Word of this peaceful place traveled quickly as Angelo and I asked friends to join us, and soon more of my former students came, students I had taught at Bushwick High and at the academic recovery programs in the Bronx and all around Brooklyn—even a family I had worked with a long time before at a theater program in Manhattan. They came with their friends and cousins and siblings and children of their own. My former colleagues in teaching and theater came, too, occupying seats alongside the kids and young adults as intellectual equals and partners. After a couple of months, Julius and Easy came back, released from jail. My living room became too small.

Our practice of listening and our goal of understanding require us to be humble. The chief obstacle to this practice within the group early on was a desire for the individual power of control over others instead of the nurturing collective power of friendship or neighborhood. Julius, a former gang leader, especially enjoyed telling people what was "good" or "bad" in their writing and how they could satisfy his judgment in revisions, no matter how many times I asked him to stop. His behavior reminded me of what I liked least about my time at Yale, the way classmates made their reputations based on their ability to tear others down and intimidate. He spoke loudly and fast and used his great height and broad, massive size—even when seated—to loom over people. His nickname was "Julioso," a combination of Julius and oso, Spanish for "bear." Even when it was someone else's turn to read, his loud, hyperbolic reactions to their writing pulled all of the attention to him. My job (appointed by myself) was to protect each person's chance to be heard and understood. I announced to the group that bullies were not allowed here, that we are here to make it safe for us to be vulnerable, and I banished him, in private, after class.

"You need to go and not come back," I told him, and when he breathed, I smelled alcohol. "You're not going to fuck this up for everyone."

The contemptuous grin that curled his lip in response injected poison directly into my heart. He turned and walked out without a word.

Near the very beginning days of Still Waters a little girl named Abbie, six years old, came to a meeting. Her father delivered pizzas for Joey's, the pizzeria whose upstairs party room was where Still Waters met after we outgrew my apartment, and she asked what we were doing.

I lived alone around the corner with my two cats, so I ate a lot of meals at Joey's and spoke with whoever happened by. Abbie and her brother Noah, eight years old at the time, would always join me when they were there, and I started helping them with their homework. They liked to draw, so I brought paper and pencils and we would draw together and narrate our drawings to each other.

"What's that?' I asked Noah, pointing at a huge drawing of something with wings.

"It's a butterfly."

"Are those teeth?"

"Yes, a lot of teeth. It's a very dangerous butterfly."

"Yikes! What does it eat?"

"Humans and pizza."

One day Abbie asked, "What are you all doing upstairs?"

"We write," I said, "We eat pizza, and then we read our writing out loud while everyone listens."

"Can we come?"

Abbie and Noah would become stalwart members of the group. In her second session, Abbie wrote about why she liked this gathering even though in school she didn't like to write. What she wrote defined the feeling that connected everyone: "Class is fun. I love class so so so much. We get to listen." Not we *have* to listen, but we *get* to. We're lucky. It's a privilege and a joy to be trusted this way. There is a sacred relation-

66666666666666666666666555 р

girls to the door and asked if there was room. Almost always I said yes, until I just couldn't take on any more kids; then I started a waiting list that quickly snowballed to more than two hundred names.

Abbie, then fourteen, whose family soon would move to Florida and take her away, walked right up to Sarah on the younger girl's first day and said, "Hi! I'm Abbie. Don't worry, you're safe here. Everyone writes and then they read to the group and everyone listens. It's actually really fun."

Sarah shared a chair with Abbie, who took dictation, writing down what Sarah told her to write. Then, when it was Sarah's turn to read, Abbie read for her, and at Sarah's request she didn't say who the author was. The room grew quiet as the words traveled.

Sarah learned from this experience that her thoughts mattered to the group and she was encouraged across time to write more and more, always anonymously. She began to enjoy the voyage of her thoughts from secret to spoken, from private to public, and she liked the opportunity to know what her neighbors were thinking when it was their turn to read. They would speak to *her*, kids of all ages, even teenagers and college students and grown-ups, and they needed *her* caring attention. Sarah had a purpose. She belonged.

One year later, at age eight, Sarah is Kid Quixote, working with her friends on what is now called "The Friendship Song" and will become "The Adventurous Adventure Song." She has grown accustomed to reading her own words to the group.

As hundreds of thoughts accumulate on our note pads during our early brainstorming about the topic of friendship, we notice that our description of friendship, which relies on trust,

has started to become a description of adventure, of what brave and trusting friends can do together.

Sarah writes, in one brainstorming session, that a true friend "goes on adventures with you," and Alex writes that a true friend "walks with you." And, as we continue to generate possible titles for what is being called the "Friendship Song," the kids propose "The Walking on a Road Song," "The Traveling Friends Song," and "What Do You Want to Do Today?"

Quixote's adventures begin as a solo act, but after an especially brutal beat-down, he decides he needs a partner. Cervantes devotes only two paragraphs to the recruiting of Sancho, with no dialogue—an almost accidental mention of what will become an enduring love. The Kid Quixotes choose to dramatize the initial persuasion in song to demonstrate Quixote's desperate need for faithful company and to express their own true love for each other.

"This is us," says Sarah. "Friends going on adventures!"

This, says my brother, Kevin, an Air Force rescue helicopter pilot and veteran of three wars, is why he originally enlisted, for the brotherhood of shared purpose. Despite severe trauma to his body and mind, those bonds remain strong.

On an early day of writing toward the "Friendship Song," each person in the group is going to write a story about adventures with friends in the form of a vertical list of half a dozen single words, a way of arriving at the most important words as a base for building our song.

Before class, the kids have been playing on the sidewalk, as always, when they suddenly vanish from my window view. I dash out the door, search left and right and see them all uphill

about half a block away, lying down on the concrete and peer-
ing under a parked car. As I run, ready to scold them for dis-
appearing, I stop myself when I understand what is happening;
they have spotted a stray cat. The cat—actually a kitten, they
tell me—roamed through their game of tag and they followed,
worried by how visibly skinny and dirty she is. They have no
realistic plan, only a desire. I tell them that there is nothing
we can do for the stray and that they aren't allowed to touch
her because she is wild and likely infested with parasites, and
members of our group and guests have allergies to cats. The
kids hang their heads in disappointment.

During class that day their list-stories are dominated by cats,
including this one:

stray cat
alone
parasites
adopted
beloved
belonging

From the very beginning of the *Traveling Adventures* proj-
ect, the kids have desired to help stray cats. The Bushwick
neighborhood is densely populated with strays. People place
open cans of cat food in parking lots and on the sidewalks,
and homeless, spectral beings materialize around the offerings.
This adventure eventually becomes the lyric, "We'll save the
stray cats from parasites."

The group's real-life collective adventures are woven

together with the path of the novel's heroes on their quest to rescue the world. As they write this song, based on their friendships and celebrating their love and their shared experiences, the kids are trying on sentences as possible lyrics, each sentence a promise by Sarah, as Kid Quixote, to persuade Wendy, playing Sancho, to come along, such as "We'll escape school, the shadow that haunts us and makes us into slaves, and turn the world into our school," which survives in the song as "Our classroom will be all of Spain" (the setting of the novel). "We can run around in the rain as much as we want" becomes "Playing in the rain," and "We can play in the grass so we won't bleed when we fall" takes final shape as "I promise soft ground beneath our feet / walking on grass instead of the street."

When Sarah sings the promise of "soft ground beneath our feet," she is recalling an exotic fantasy for city kids, which we actually explored on a trip north of New York City to ride horses on a farm, a wide-open space covered with grass, our research for understanding both the feeling of contact with the earth and the power that horses possess and confer on their riders, as Quixote's horse, Rocinante, does for him. The kids were, as they would write in class, turning the world into their school.

At first, Sarah was afraid of the horses and refused to ride. Then as the day was coming to a close, having watched all of the other kids ride, she decided to try, and she sat on the biggest horse of all—a giant called Hero—who carried her and responded to the simple signals she had learned to ask the horse to turn, to stop, and to go.

And when she offers Wendy the promise of "playing in the rain," Sarah is remembering the day I allowed the group to run outside on the sidewalk in a downpour in defiance of parental caution, a day of bonding by breaking rules, a day that has become mythic in its repeated, glorious recall.

————

To organize the lyrics that are being born, the group needs a structure. I bring in Robert Frost's poem, "Stopping by Woods on a Snowy Evening," the first two stanzas of which read:

> Whose woods these are I think I **know**.
> His house is in the village **though**;
> He will not see me stopping **here**
> To watch his woods fill up with **snow**.
>
> My little horse must think it **queer**
> To stop without a farmhouse **near**
> Between the woods and frozen **lake**
> The darkest evening of the **year**.

"Let's try this structure," I say after reading the whole poem to them.

Across four weeks, the kids explore and discover rhymes for the first two verses that agree with the pattern of AABA:

> I promise soft ground beneath our **feet**,
> Walking on grass instead of the **street**,

Cartwheels, pinwheels, playing in the **rain**,
Making our own world, even broccoli will be **sweet**

and BBCB:

Our classroom will be all of **Spain**,
Riding the wind like a paper **airplane**
Roller coasters, L train, discover what you never **tried**
Our adventures will be crowned with glory and **fame**

This pattern of rotating symmetry, I explain, connects the friends while moving forward, as the rhymes turn like a wheel and travel from one verse to the next; the subordinate B (*rain*) in the first verse becoming dominant B in the second verse (*Spain, airplane, fame*) and so on. It's a pattern that says both "friendship" and "adventure."

Eventually, Kim supplies a melody for these rhyming verses: another layer of structure that reshapes the rhythm of the words, strictly requiring compliance from verse to verse as its pattern repeats. The group makes subtle adjustments, adding and subtracting syllables, condensing or expanding the length of those syllables, and remembering that the emphasis always needs to land strongly on the most important words, the words that tell the story.

After two weeks of collectively revising the first two verses according to the demands of the melody, Lily says to the group, "So far the song is sweet and funny in a gentle way and full of longing, but I think we're missing the actual feeling of adventure, the excitement, like saying 'Here we go!'"

Everyone agrees.

"We can have that in the refrain," says Joshua. "We need the hook!"

Kim starts playing rowdy horse-riding music on the piano, in a much quicker tempo than the verses, shouting out over the piano, "Tempo means speed! This is a faster tempo!"

Percy entertains everyone by standing up, away from the table, and dancing like a rodeo cowboy swinging a make-believe lasso above his head.

Alex, in a deadpan, monotone parody, calls out, "Yee-haw."

Everyone laughs.

"That's it!" says Lily. "That's the spirit!"

"I think this part needs to be very silly," says Joshua. "Everyone gets to go bananas!"

The littlest kids in the group laugh at the word *bananas*.

"What do we say?" I ask them. "What's the message?"

"Adventure time!" shouts Percy, still dancing.

"We could just say 'Adventure Time' again and again!" says Rebecca, who has loosened her brooding, spark-shooting grip on the process and begun to giggle.

"I think you've got something there!" says Kim. "And if everyone dances together and you just keep saying, 'It's Adventure Time!' the audience will want to join the dance!"

"It reminds me of SpongeBob SquarePants!" says Sarah, who has been watchful of the hijinks until now. "He always says, 'I'm ready! I'm ready! I'm ready!'" The kids all love this connection and they laugh again.

"What about our parents?" asks Alex, as before. "We need Spanish in the hook."

Lily says, "What about, 'La hora aventurosa!'"

"*Aventurosa* isn't actually a Spanish word," says Joshua. "It's Spanglish, I guess."

"Even better!" says Rebecca, in full surrender to wackiness. "We made up our own word that everyone will understand!"

After much back-and-forth among Kim and me and the kids, a dialogue of dance and words and song and piano, another layer of devil-may-care, who-knows-what-it-means lyrical silliness has been added to better match the joyous, galloping rhythm of the music, and the refrain has become a bilingual-plus-Spanglish verse about the singing of an adventurous song about adventure, an "Adventurous adventure song," or "Aventurosa canción aventurosa," repeated again and again, alternating with "Vamonos!" and "Let's go!"

"Perhaps," says Lily, in retroactive reasoning, "the song itself is an adventure, and we are adventurous just for singing it."

Adventurous adventure song
Va-mo-nos!
Adventurous adventure song
Va-mo-nos!
Adventurous adventure song
Va-mo-nos!
We're going on an adventure!

Aventurosa canción aventurosa
Let's go!
Aventurosa canción aventurosa
Let's go!
Aventurosa canción aventurosa

Let's go!

Nos vamos a una aventura!

By the end of the song all of the kids, giddy with collective friendship, are square dancing to that same rowdy tune, arm-in-arm, spinning like windmills, and "The Adventurous Adventure Song" has become the official title.

Three months of negotiating on this song never devolves into an attempt by any one person to push the group in one direction, but rather seeks—and ultimately reaches—true consensus, the same as when they agree on nine of their original list of fifty-five possible items Sancho could be compiling for our heroes to take with them on the journey, including objects that provide domestic comfort, such as "my favorite trusty blanket" (changed simply to "blankets" in the final draft), "cookies," plus "keys in case I need to go back home," and "If I'm homesick, a bunch of toronjil" (a plant used by their parents to make a calming tea—the first proposal, in English, was "chamomile").

By building a song together, they build trust and reliable kindness, gain the security of knowing each other's lines, make each other laugh, and practice choral singing, all of which require mutual attention and cooperation and add up to the friendship necessary for them to go on adventures outside the classroom and—together—to tell their story.

The neighborhood, visible through our large storefront window as we inside are visible in return, is part of our classroom—as in the "Adventurous Adventure Song" lyric, "Our classroom will be all of Spain"—and the barren patch of sidewalk in front of

Still Waters in a Storm is our playground, shaded in spring and summer by a small white-blossomed fruitless cherry tree rooted in a square of dirt, bounded by an iron railing and rat holes and surrounded by concrete. (The kids, desperate for the touch of nature, climb up and rip off twigs in order to press the blossoms against their faces.)

Here, the kids learn how to be aware of other people and accommodate strangers, an important rehearsal for their travels with the *Traveling Adventures* show. Whatever game the kids are playing, soccer or tag or just running around, they stop when anyone, child or grown-up, hollers, "Pedestrian!" and they wait for the person to pass by. At times, pedestrians stop to smoke tobacco or marijuana, and I ask them please to move away from the kids. Drunken folk have wandered through a soccer match and spooked the kids with their slow, distorted smiles and their staring, watery eyes; the kids know to run inside the classroom when such behavior comes too close. Once, a drunken man stole their soccer ball and I steadily commanded him to give it back, which he did only when I said I would call the police.

I want the kids to be safe outside, and also to be brave. That means that I, *in loco parentis*, need to be brave, or at least appear to be brave.

As a parent, when my Zadie runs down the sidewalk in front of our home, her limbs each going their own way—four independent, disagreeing vectors somehow propelling her forward—it seems to me that it's only a matter of time before she tumbles to the concrete. Nevertheless, she runs. She needs to run and I need to let her run. Her body shows faith that life will catch her, and it is this faith of hers that makes a private spasm in my heart.

My mother—Zadie's grandmother—diminutive and hushed,

light enough for the wind to blow her away, has always loved storms, the same storms that made our big, wolf-like dog cower in the basement under the laundry sink. When we were kids, Mom would bring me and my brother to the huge back window of the house to watch storms approach, whip the yard into a frenzy, and move on. She was absolutely fearless at these moments—and grateful. Storms, she told us, are adventures. Once on a family camping trip in northern Ontario, when we were surprised in our canoe in the middle of a suddenly stormy lake, I could hear Mom behind me saying, "Oh, wow!" in awe, each time lightning made the air above explode.

Early in the life of Still Waters, a tornado raced through Bushwick. The kids and I watched it through our big window. The noonday sky went instantly as dark as midnight and we could feel that the air was pulsing, as if we were closed up inside a giant heart. Then the rain fell so thickly it obscured everything, even the streetlights that had switched on automatically at the premature night. As the rain let up a little, we could see, up the middle of the street, uphill in mid-air, a garbage can and a metal awning, flying by end over end. "Don't worry," I told the kids, with my arms around their huddled group.

Just as suddenly, the storm was gone. We all went outside to study the damage and marvel at the return of the sun. The streets were crowded with neighbors walking around baffled and amazed. Trash was everywhere, windows were broken, and later that day I would visit the local park and see that giant, ancient elm trees had been pulled up and out of the earth and smashed onto the children's playground, destroying the fences that guarded the park's perimeter. I was heartbroken at the demise of the trees after their hundreds of years of patience with

the changes whirling around them. Their roots, now exposed to the sun, reached more than three times my height up into the air, and they had opened up great holes in the ground that kids could fall into, holes which later would be filled with soil supporting new, young, flexible trees.

The smashing of the fences, too, upset me. Even though anyone could easily have climbed them before, they had marked a sacred boundary, a meeting place for play. That the trees, who had given shade and the soft, kind sound of leaves rustling in the breeze for many generations of children could have become a violent force to break down that boundary and ruin their place of play was a drastic inversion of the way things were supposed to be.

But the image that struck me with the greatest feeling of awe and made me dizzy with my own breakability was the scene on the block just around the corner from Still Waters, where Wyckoff Hospital stood. The face of the five-story building had been torn away and the pink insulation ripped out, and the insulation was stuck in great big gooey rectangles to the other buildings on the block, as if a giant had been chewing bubble gum and spat wads of it all around in casual, bullying rudeness. The absence of insulation revealed dangling bare wires where before only brick could be seen. The outer walls looked very fragile now, as if the whole hospital would collapse. I thought of Mom in the lightning storm in our bobbing canoe and, with a thrill in my voice, I said to the kids, "Oh, wow!"

My job in rehearsal is to banish fear. Apart from arranging the kids in basic physical poses, such as kneeling or cradling or

clasping hands, I do very little. Rehearsal is repetition, and the kids need a chance to repeat their lines and songs and actions as often as possible. Repetition gives them the confidence of second nature, and when at last they discard their scripts, the words they speak and sing—which they have also written— are truly theirs. Every day in rehearsal I listen to the kids recite their lines as they strike symbolic poses and I ask them, repeatedly, to please do it all again.

A friend who attends an early rehearsal asks me privately, "Are you sure Sarah can do this?" He has seen her swaying side to side as she struggles to read the script.

"Yes," I answer.

I ask Sarah to read aloud the sentencing speech, her lengthy warning to the abusive landlord ("You will suffer the penalty of the penalty"), five times in a row, then hand her script to me so I can prompt her, and recite it five more times. By the fifth off-book repetition she delivers the speech without error, looking me in the eye the whole time, as everyone watches with breathless anticipation. Her voice teeters and totters; she's a verbal acrobat high above the circus floor, and it seems she might fall, but she recovers, speaks all of the words, and closes the recitation with an emphatic "Hmph!" while pumping her fist like an athlete celebrating a goal. The sound and the gesture stay in the show.

"Wow," says my friend. "She did it!"

Parallel to this process of mastering lines, I tell the actors in *The Traveling Adventures* that if they forget their lines onstage during the show all they need to say is "Help!" and one or more of their partners will speak the first few words for them. This accommodation includes the music; kids will prompt each

other for lost lyrics, and Kim, accompanying the song on the piano, will simply wait and adapt if a singer is confused. We practice this assistance every day until it becomes habit. Liberated from the fear of making mistakes, the kids radiate ease and joy. In the very first performance, early in the whipping scene, Rebecca goes blank and says, "Help." Right away Sarah says, "Por la pasión de Dios," and Rebecca says the words and moves on. Everyone in the room, in the playing area and the audience, smiles. The culture has been established.

"Acting is not pretending to be someone else," I say to the kids in rehearsal and repeat before each show. "It's being yourself as you tell a story. When the audience watches you onstage, they are witnesses to your opening of yourself, to the story of your blossoming. You don't need to make this happen, and there is no way to be wrong. As you speak and sing, everything you are is carried by the words like ships setting sail; you speak and sing these words, especially the words you've written, as nobody else can, with a voice unlike any other."

Kim and I never tell the kids how to speak or sing a line, only to make it loud and clear so the audience can understand the story. The actors need to enunciate and project their voices, and reach the right pitch in song. Apart from that, their voices and their personalities are their own.

"And you do this for one another," I continue, "by listening to each other onstage and making eye contact, like spring touches tulips, awakening the promise that has been buried inside, asking each other to speak and sing. The story happens between you; you're telling it together. By listening to each of the other actors onstage you are also teaching the audience how to hear you, and when you forget your line and call out

'Help!' and your fellow actors speak your line for you, and you repeat the words and carry on, you are also showing the audience how to love."

———

The shows on our tour are vessels for our personal stories, and they carry us to bases of power that have been out of bounds for these kids. Our hosts welcome the kids into their worlds and the kids welcome these strangers into theirs; this is theater as reciprocal welcoming.

In their first-ever public performance of *The Traveling Serialized Adventures of Kid Quixote* in the spacious living room of generous, affluent friends in Manhattan early in December of 2018—for an audience of more than fifty people—they make the stage on a square rug in the middle of the room. Despite the best efforts of our hosts to welcome everyone, the parents and siblings of the kids stay against the wall by the entrance and the rest of the crowd sits in front of the stage area and along the wall opposite the Bushwick families. I visit with the parents and tell them that the food and drink laid out on the tables is for them, too, but they quietly decline. On the next trip, Maggie will bring a big basket of conchas (a sweet Mexican bread) and hand a small loaf to each person in the audience. She and the other parents, she tells me, are shy about receiving food without giving anything in return.

Our kid actors make common ground on that rug bordering the two separate populations as they always will in every show to come: performing on the same floor where everyone else is sitting, never on an elevated stage, never with a gulf between them and the audience. Everyone, on all sides of the

room, can come together in loving the kids who are right there in between.

Two months later, at City Hall in Manhattan, the Kid Quixotes perform in a huge, round, high-ceilinged room called the Committee of the Whole, where the mayor holds his morning staff meetings—a last-minute change of venue because many more city officials have asked to attend than the initial room could hold. As soon as the kids walk in, they stop and look up and around in amazement. The towering windows reach as high as the roofs of the kids' Bushwick apartment buildings.

As we set up our electric piano, music stands, and props for the show and decide where to make the stage, we discover that the gigantic, thick ancient dark wooden meeting table, about six yards in diameter, can't be moved from the middle of the room where we would like to place the audience; it is far too heavy.

The kids choose to put the stage against the fireplace wall facing the center of the room and divide the audience into two groups, one on either side of the table. The kids' job then becomes, yet again, the unifying of a divided room around a common obstacle. At the house show, the obstacle was a cultural, linguistic, and economic gap; here at City Hall, the weight and bulk of history and political power (represented by the immovable table) can't stop the crowd from rejoicing as one at this show. One man stands up during the post-show conversation and says, "I grew up in Bushwick, and I am in awe of you. You belong here."

During the writing of what began as the "Friendship Song" and later became the "Adventurous Adventure Song," Genesis said the word *power.*

Genesis, who has been with the *Traveling Adventures* project from the beginning when she was eight years old and is now aged eleven, rarely speaks up. She attends every reading and writing session and rehearsal, is unfailingly kind, sings and acts as part of the Chorus in *The Traveling Adventures,* and almost never tells the group her thoughts during class. But on this day, adding to the list of associations we think of when we hear the word *friend,* including "patient," "humble," and "hug," Genesis said, "I think of power."

"What kind of power?" I asked.

"Your friend could protect you. The more friends you have, the more places you are safe."

"Safe from what?"

"Safe from bullies."

"Do you mean that your friends would fight the bullies?"

"No, it's just that when the bullies say mean things you don't have to listen to them because you have your friends and your friends say nice things to you."

———

What began in Still Waters as private empathy now has a public agenda: a story needs to be told, a story of kids on the margins of our nation's love. People need to meet the story-tellers so that they can begin to know each other in person, as people rather than as crowds.

The discovery of common ground with the other side is one possible result of an adventure—a risk, a reliance on bravery

and even luck. As the Kid Quixotes wrote in "The Adventurous Adventure Song," "Our salvation from fear is to face the unknown." Telling your stories to people who know you but may not understand you is an act of bravery, a request to be better known. Traveling with your stories into other people's private homes, classrooms, and government offices—the domains of strangers—is a type of conquest, a winning of hearts that calls for even more bravery than what we practice in our classroom.

Each venue where we perform is unique, in dimensions and acoustics and in the size and composition of the audience. The way we prepare for such variety is by solving problems as they arise in rehearsals, whether the problem is a forgotten line, a misplaced prop, a missed entrance, interruption by an ambulance siren, or someone walking into the room from the street to ask if we are a library. Miguel, who had been part of the *Paradise Lost* group before his family moved away, showed up once in the middle of our rehearsal for *The Traveling Adventures*, two days before a show. The group stopped, waved and said, "Hi, Miguel!"—and then got back to work. He stayed and watched for a while, then left. The answer to every interruption is always to acknowledge it, then to keep telling the story.

Thank goodness for the very many distractions that visit us in rehearsals. During performances, the kids have dealt with a dog walking across the playing area, babies talking or crying, telephone ringtones, and a three-year-old girl entering and sitting down next to Sarah, taking in the show from the heart of the action. The actors handle everything with balance, acknowledging the distraction—by stroking the dog,

saying "Hello" to the little girl, even laughing at the babies and phones—because they expect to face obstacles, and the obstacles offer a chance to recognize the reality around us, to say that all of us—actors and audience and dog—are present in the room, and we're not pretending otherwise.

By welcoming a variety of guests to attend rehearsals, we grow accustomed to a variety of responses to our show. Some people find everything funny and laugh a lot, while other people watch quietly, paying close attention without laughing or clapping, then cheer robustly at the end.

During our ongoing tour, after the first two shows, the kids get used to the idea that people applaud after each song, so they start making room for the applause. The day of the third show, in a classroom at Hunter College, when the audience (about fifty students and professors) does not applaud after the first song, the kids pause only for a couple of seconds in antic-ipation before recognizing what is happening and carrying on. When yet again the audience doesn't applaud after the second song, the kids have already adapted and breeze onward. Dur-ing the final bow the crowd claps in adoration at length, and after a brief post-show conversation between the audience and actors—our formal, group-to-group dialogue—individual people take time to talk to the kids one-on-one and praise them in detail. They have been paying close attention.

Visiting the home of a friend in the Bronx, the kids adapt to their smallest performance space of all, a shallow alcove no more than six feet wide for our group of fifteen that night. The audience of fifty crowds into the living room and the ad-joining kitchen, the hallway, and the stairs, sitting on the floors with their legs drawn in close to make room for each other and

for us. Their toes and our toes are touching. Everything the actors do with their bodies has to be compressed, but the kids can speak at a normal conversational volume, which makes the performance less a performance and more an evening with friends. With no boundary between the audience and the actors, audience members are easily able to hug the kids at the end of the show, just by reaching out.

Deep into our tour, on the campus of Drexel University in Philadelphia, we face by far our biggest venue and biggest audience: two hundred students and professors in a deep and high concert hall with a balcony. Before this show, the largest crowd has been about fifty people and the farthest person in the crowd was fifteen feet away from the actors. The kids could be heard even when they whispered, and their subtle faces were easily seen. At Drexel, the farthest person is at least one hundred feet away and some 30 feet higher. The kids' faces are lost to the balcony, and they will have to broadcast their voices. I tell the strangers staring at us that this room is gigantic to our group, and that we need their help in testing the reach of our voices. One by one I ask the actors to stand and speak a line from the play to the balcony, and I ask the audience in each case to say if they can hear that kid or not. If a kid can't be heard, that kid repeats the line until the audience says they can hear every word.

We're telling a story, and it's the story of the people in the room, the dialogue between actors and audience. The pressure here is now lifted: both the pressure on the actors to sustain a perfect artifice and pressure on the audience to believe that the artifice is real. Judgment has been removed on both sides in favor of conversation. The audience at Drexel is rowdy with

joy throughout the performance, cheering on the kids they have come to know.

The same result happens at New York University, when the audience, an acting class in a rehearsal studio, is encouraged by me and by their instructor to introduce themselves to the Kid Quixotes before the show. This takes about ten minutes of people traveling around the room shaking hands and saying "Hello" and smiling at each other. That audience—our new friends—hang on every word and note of the performance, vocalizing their joy, and they give the kids a standing ovation at the end.

———

When traveling with Real People Theater, I had to anticipate disaster.

After Real People had performed our *Hamlet* at Repertorio Español, a Spanish-language theater on the Upper East Side of Manhattan, I came within inches of being run down by a van as we were crossing the street together. Angelo slapped the van as it passed by and the driver stopped, reversed, stopped again, jumped out, eyes blazing, and strode toward the group, carrying a crowbar. Easy, who seemed with the lightness of his stepping always to be walking on the moon, grabbed a large bucket of yellow roses from the corner store, slipped around behind the driver, and dumped the roses and all their water on the attacker's head. The driver spun around to face Easy, raised the crowbar high in the air, and I immediately placed myself between them and yelled, "Stop! Please! These are my students! We just performed *Hamlet*! I apologize!" The drenched driver blinked away water from his eyes, his body heaving

with every breath, baffled as he processed what I had told him. He turned and walked back to his van, which was blocking the street, hollering, "Shut the fuck up!" at the other drivers who were honking their horns, and drove away, his wheels crushing the flowers in his path.

Before the plane took off on a cross-country flight, Lucy leaned her chair back, lowered the tray table in front of her, and put her feet up on the tray. When the flight attendant asked her to take her feet down and restore the tray and her seat to their original, upright positions, Lucy stared back and did not move. The attendant repeated her request and Lucy once again did not move.

"Are you having trouble complying with federal aviation regulations?" asked the woman.

"Lucy," I said from across the aisle, "for our sake, please do as she asks."

Never dropping her gaze from the authority's eyes, Lucy slowly, slowly complied.

Such trouble is the polar opposite of my experience traveling with the Kid Quixotes. Never once have they been anything but polite and respectful: toward strangers on the subway, toward the drivers of our buses, toward everyone we encounter between our classroom and the performance space, and toward everyone who welcomes us when we arrive. The kids always say "Please" and "Thank you."

Their rowdiest behavior has been singing the songs they wrote for the show on the trains and on the sidewalks as they approach their destination skipping. Once inside the venue they are joyful and excited, so the volume of their voices goes up temporarily before returning to normal on its own. This

ease in transit is certainly thanks to the watchful mothers who travel with us, and to our teenagers who understand their job as guardians and role models for the younger ones. It also comes from a classroom practice that is based on attentiveness to other people and awareness of other people's needs.

———

As they travel to strange new places, adapting to new people, the Kid Quixotes also are learning to adapt to absence within the group.

Being absent from a typical public school means the student has missed a lesson and has some catching up to do upon returning. But that student's falling behind does not affect anyone else; it's a private obligation that will be evaluated by the teacher, and the teacher does not need the student's participation in order for the class to move forward. The class is a random assembly of kids whose togetherness is not essential to the work at hand. The teacher's methods of teaching probably will change depending on the size of the group—a single kid is a very different assignment from thirty kids. But even if each child in the class is universally beloved, in their absence the class goes on; the material is still studied. This was true for me at Bushwick High School. I personally missed any kids who were absent, but I went ahead with my lesson as planned.

The material at Still Waters is made by and of the kids; it *is* the relationships among them, the ongoing dialogue. The absence of one kid fundamentally changes the work of that day: a voice is missing, a voice that is unlike any other. Dialogue does still happen, but no one person can truly be

replaced. A conversation between Sarah and Alex is not the same as a conversation between Sarah and Joshua.

To be needed in this way is a new idea for the kids; there is no punishment or threat of punishment for absence, only people waiting for you.

The kids are needed, each one of them, but the paradox is that the show must go on regardless of who shows up.

Rehearsal for *The Traveling Adventures*, as the script is being written by our ongoing conversations, requires the presence of the actors who are playing the roles, but the actors sometimes are absent. When that happens, another kid steps in to play the absent kid's part, in rehearsal and even in public performance. The color of the show changes as various actors with their various personalities play the roles, each of which has at least two, often three alternates.

The day before our stop at New York University we hear that, of our three alternates for Andres (the shepherd boy in the whipping scene), none can do the show. Seven-year-old Cleo, who has already mastered her part as an incarcerated refugee girl in the second half of the show and is singing her solo with the confidence of the shining sun, volunteers to save the day. Like most of the kids, she has watched the scene many times, so she knows what to sing and say and do.

"Cleo, we need you to step in as the shepherd boy tomorrow," I say.

"One time," she says, very, very softly, only to me, "There was a little girl who thought she was only a little girl, but really she was a tiny, tiny star that twinkled in the sky and sometimes came down to earth if people needed more light, like when you have to do your homework but the light bulb in my room

is burning out. She went everywhere for everyone who was in the darkness and they didn't even know it was her, all they saw was the light. One day she sang a song to another little girl who was lonely at night and the little girl had sweet dreams."

Cleo does this often, answering direct questions by spinning yarns about fantastical adventures, spontaneous fairy tales that somehow in her mind associate with what she has been asked.

One rehearsal later—just two repetitions of the scene—the very next day, Cleo performs both roles and sings both solos; she gives us a way to carry on. After that show I tell the audience what Cleo has accomplished and we all cheer for her, our hero.

———

Associations of thought assembled in class make up our script and songs, and associations of friends—from the Latin *socius*, for "belonging"—can remake our lives.

Sarah's mother, Maggie, who took seven tries to enter the US and has been living in Brooklyn for fifteen years, suddenly has found herself in danger of deportation. A person close to her reported her to ICE.

Maggie called me via a fluently bilingual Mexican-American friend of Still Waters named Monica, because she wanted to make sure I understood exactly what was happening. Maggie had been separated from her children for the first time ever (not counting school days), and she was moving from home to home of siblings and cousins and neighbors.

Monica and I began calling everyone we knew who might be of help, including lawyers, government officials at the city and state levels, friends who might know someone with power

and influence, advocates for immigrants, and journalists. Everyone we called also called others, and so on. The Still Waters neighborhood reaches way beyond Bushwick.

As Robert Louis Stevenson once wrote in a private letter, acts of kindness can multiply, "making one happy through another and bringing forth benefits, some thirty, some fifty, some a thousandfold." Three excellent lawyers agreed to represent Maggie pro bono, and our bilingual grassroots rally searched all five boroughs for a place where she could live, a place that was safe and where her family could eventually join her.

Maggie has been reminded in the process of hiding that her name is not on the lease of her home, a three-bedroom apartment which her family shares with two others—a total of fifteen people—which in turn reminds her of how her father used to shout in a violent, drunken rage, waving around a whip, that his children were on his land, his property, and he could do anything he wanted on his property. The very ground beneath her feet has always been owned by someone else.

Our radiating phone calls may not save her, after all, but now she is not alone. Monica has been calling Maggie every day, talking with her in Spanish, staying in touch with her lawyers, being a true friend to a woman who says she has no friends. "I never go out," says Maggie, again and again, repeatedly appealing to the decency of the universe, to whomever decides what is right and what is wrong. "I don't drink or smoke or go dancing. I have no friends. All I do is care for my children day and night."

During her time away from her mother, Sarah draws a picture.

"Is that a tiger?" I ask, when she shows me the drawing.

"Yes."

"The same one who brought your mother across the desert?"

"Yes."

"And who's this way over here?"

"My mom."

"Why are they so far apart?"

"The tiger escaped from Animal Control and he's lost and my mom is trying to find him."

"What will she do when she finds him?"

"She will hug him."

"Anything else?"

"Then she will bring him to a safe place."

"What place is safe for a tiger in the city?"

"I don't know. I need to think about that. Maybe they will go back to Mexico."

"I don't know" and "maybe" are hard words to speak when Sarah feels responsible for the separation from her mother. She blames herself; she must have done something wrong. And because she believes that she caused what the family now calls "The Problem," she, Sarah, at nine years old, needs to come up with an Answer.

But what can she say or do?

– 3 –

Ruler of Myself

Nearly two years into the project, in the summer of 2018, the *Traveling Adventures* group bases a song on an extraordinary example of making room and listening. Our hero's travels bring us to the burial of Grisóstomo, a young shepherd songwriter who has killed himself because—he says posthumously in verse—Marcela, a young shepherdess of awe-inspiring beauty, did not respond to his love. Grisóstomo's friends also blame the girl, calling her cruel and ungrateful, a monster and a plague.

Marcela appears at the burial on a hill above the boys, and speaks—uninterrupted, uncriticized, page after page, articulating her story—asserting that she is the ruler of herself. Marcela asks the boy shepherds to stop following her and idolizing her beauty: "I was born free," she says, in our group's translation, "and to be able to live free I have chosen the solitude of the countryside. The trees of these mountains are my

company, the clear waters of these streams are my mirrors; with the trees and with the waters I communicate my thoughts and my beauty. The honest conversation of the other shepherd girls of these valleys occupies me. I am a separate fire and a faraway sword."

Having promised nothing, she is not to blame for Grisóstomo's choice to pursue her or to take his own life. Warning the boys to back off, she describes herself as dangerous: a fire and a sword.

In a book written more than four hundred years ago by a man, this—stopping the story to hear a girl speak and to allow her to refute, point-by-point, the accusations of boys—is brave and unusual. The *Traveling Adventures* girls seize on this rarity.

"I want to be her," says Alex. "I want to sing her song."

Our musical adaptation of Marcela's speech—originally called the "Girls and Boys Song" because, says Lily, "That's what Marcela's speech is all about"—is based also on an essay by Alex, and results in a statement of self-determination that is equally brave and unusual. "We choose to love how we love," asserts the Chorus, in defiance of bias against LGBTQ+ people, and Alex sings that she and her family are "dientes de león"—dandelions, from the Latin for "teeth of a lion." The kids choose this metaphor to describe themselves, their families, and their people—immigrants—as flowers growing in the wrong place, fierce and beautiful, offering food and sunshine. "Who decides," goes one lyric, "if a flower is a weed?"

As the Kid Quixotes start to work on the scene when Marcela corrects the narratives imposed on her by a series

of shepherd boys, I ask the kids to write their answers to the question, "Am I the Ruler of Myself?" This question eventually provides the title of the song, as who we belong to—who owns us—becomes its central power struggle. "It's obvious," says Alex about the title, after the song has been written. "That's the battle of my life."

Most of the answers describe authorities in the children's lives, such as teachers, parents, coaches, older siblings, and police, people who can tell the kids what to do and who must be obeyed in order to avoid punishment.

When it is Alex's turn to read her writing to the group and we all stop moving and wait, she says nothing. I think she's playing with her neighbor and fellow adolescent (from the Latin word for "growing to maturity") Joshua, tormenting his anticipation by refusing to speak, so I say, "Come on, Alex, we're waiting."

Alex began attending Still Waters when she was just seven years old, nearly half of her life so far, though there was a gap of two years in the middle when she stopped attending. Her older sister, the one who always did everything right, had moved on from Still Waters, and Alex, the middle child in her family, was attached to her. Then one day, at age eleven, Alex showed up again, a foot taller, walking through the door. Her parents said she needed help, that she was failing in school and she appeared to be depressed. Alex had asked to come back to Still Waters, her sanctuary, and promised she would begin doing her homework.

Now, three years after her homecoming, she knows the practice of reading our writing to the group, having done so hundreds of times before, though quietly, often asking others

to read for her. About once per day, if we're lucky, Alex speaks in class, from inside her hooded sweatshirt.

But today's prolonged and total silence at her turn to read is unusual. We can hear her inhale and exhale for what feels like a very long time, and the kids look at each other and at me as if to ask, "What do we do?"

What they do is wait—silently, patiently, making room.

Then Alex reads this:

"I sometimes am the ruler of myself. Although I'm scared. Many people of my life are accepting, but I'm scared when I come outside of this New York City bubble, hate will burst in. I'm scared I'll never have the life I want with her. Yes, a her, not a him. I'm not lesbian nor am I bisexual. I am pansexual. I do not just like boys or girls, I like those who define themselves as gender fluid, when you define yourself as not a boy or girl. I believe everyone should feel loved no matter their race, religion, sexual orientation, anything at all. Leaving New York is my dream but also my nightmare. I'm scared of what others may say of me. I'm never ashamed when people call me gay. I want to be free, yet I'm always stopped because of my age and gender. I'm either too young to know love or too young to really understand society. The people I surround myself with make me who I am; the choices I make change my path. My parents say I'm free to be who I want to be, love who I love, dream what I want to dream. But I'll always be their little girl, the troublemaker and the one with emotional issues. I let everything around me happen; I don't direct it, for I am confused as to where I am going in life. My parents just want me to live a happy life but every choice I seem to make

is the wrong one. I disappoint them. I can get rid of the pain of my life. But I enjoy endless car rides in Mexico, feeling the wind as if it was freedom. Because of my race I'm also entitled to such things that represent my country and culture. I can be my own ruler, I just choose to let others tell me what is right or wrong for me. I'm only surrounded by those who are younger or older and have been through so much. Everyone has taught me something; they influence my thoughts and choices and I adopt their advice. Everyone influences my life; my own experiences aren't enough."

After another prolonged silence, Sarah says, "It's a prayer asking us to understand her."

Everyone knows right away that Alex's statement of self-sovereignty will become our next song. Marcela and Alex are now one being, girls asserting their right and power to tell their own story and define themselves. The desire to do this—to say, as Quixote does, "Yo se quien soy" ("I know who I am")—is so strong that it insists on becoming music.

The whole group knows the potential oppression of stories; every day, they and their families carry the heavy burden of narratives imposed on immigrants and refugees, narratives that define them as "criminals, rapists, and murderers" and "bad hombres" and gang members, an "infestation," always the "other," the "alien," the stranger whose whole life and being is, by definition, against the law.

"The word *define*," I tell the kids, "comes from the Latin for 'the end,' where something or someone reaches its outermost edge, where I stop being 'Me' or where you begin to be 'You.'"

"I think of our skin," says Alex, when I tell the group about this definition of *definition*. "Our clothing, or the chalk outline drawn by police around a dead body on the street."

A name is posted at the border of the self, facing out. At the beginning of *Don Quixote,* obsessively reading countless adventure novels at the expense of sleep, Quixote renames himself after a piece of armor (he used to be "Mr. Quixano") and decides that he is a knight errant, a hero placed on Earth to rescue the needy and defend the defenseless. He also renames his tired old horse as Rocinante, meaning "The One Who Used to be a Tired, Old Horse" but has been reborn. Then he names his make-believe lady love Dulcinea, or "Sweetness." As he rides out looking for adventures he is making a narrative path of his own choosing.

At the beginning of *The Traveling Serialized Adventures of Kid Quixote*, after obsessively reading *Don Quixote* day and night, continuing to read even as her mother readies her for school, Sarah, on the path to school and away from her mother's gaze, removes her uniform skirt, revealing pants; she holds the skirt up and shakes it violently as she declares, "I don't like dresses!" and stuffs the skirt in her backpack. Then she raises the novel above her head and hollers, "Yo soy Don Quixote!" After she interrupts the whipping of the shepherd boy, she names herself "El Desfacedor de Agravios y Sinrazones," translated by the kids as "The Righter of Wrongs."

When I ask in a writing session if she wants the other characters to call her "he" or "she," Sarah emphatically chooses "he." This follows Sarah's own revelation in class that, at age eight, she feels like she is both a girl and a boy and that she hates wearing dresses. In our play, Sarah, as

herself and Kid Quixote, is making a narrative path of her own choosing.

A year later, when Alex at fifteen finds the courage to say who she is, and to admit that she's scared to say who she is, she thanks little Sarah, now nine years old, for blazing that trail. Sarah's eyes and mouth pop open and she says, "Me?" Everyone laughs with familiar delight at her surprise. "Yes," says Alex, "you."

Alex's statement, her public voyage of self-discovery, is built on binary oppositions, such as, "not a boy or a girl," "yes a her, not a him," "I'm not lesbian nor am I bisexual," and "others tell me what is right or wrong." In every case, Alex describes herself in opposition to binary restrictions and she begins to build her own structure for her own narrative, beyond the binary. If other people are to understand her, she needs to begin by trying to understand herself. This process of self-definition fluctuates across time: "The people I surround myself with make me who I am," writes Alex. She defines herself by a multiplicity of relationships that transcend borders, repeating, at the end of the speech, "*Everyone* has taught me," and "*Everyone* influences my life."

After her revelation, Alex is absent for a month. This is common for her, and I don't ask where she has been or what she has been doing; I only celebrate, with the whole group, when she returns.

While she is away, the rest of the group digs for associations, such as images and stories, that relate Alex's words to our lives, so that the song we're writing can belong to everyone. We agree, after close reading and several rounds of voting, on the most important words in Alex's essay; then, brainstorming

again, we write what associations come to mind when we hear each of those important words:

SCARED: separated from my family, little girl in the dark, monster in the closet

DEFINE YOURSELF: dictionary, being born, who I love = who I am

FEEL LOVED: grandma kisses me on my head when I leave her factory, hugs like rose petals, What is a weed?

FREE: School is over, go to the park alone, Statue of Liberty

CHOICE: two bathroom doors and neither one is right, Which color crayon will I use?, naming a baby

UNDERSTAND: sympathetic vibrations, teach me Polish during recess, a question mark

FEELING THE WIND: playing in the park on the grass, my dog's tongue flapping out the window, a kite flying off

RIGHT OR WRONG: Is it wrong to do a dance in a public place?, answers in school, the scales of justice

EVERYONE: holding hands, choral singing, group hug

As always, I take notes while everyone reads aloud in turn.

Having gathered these ideas over the course of two weeks, we turn to the binary classification assigned to all of us: "Boys" and "Girls." I ask everyone to write a list of what is expected of boys and girls under the headings "Boys are supposed to" and "Girls are supposed to." After we write, we take turns reading our lists to the group and I collect the responses, along with all

of the brainstorming we've done on Alex's important words, to type and copy and distribute to the group as research for our song. This second phase has taken another two weeks.

When Alex returns, she inherits all of this collective thinking, a validation of her bravery and raw material for her song.

The "supposed to" lists total more than a hundred expectations each for boys and girls.

"Can we summarize the lists?" I ask the group.

There is a long silence as the kids, now including Alex, scan the papers.

"'Girls are supposed to,'" says Tabitha, a soft-spoken adolescent who has just joined the group, "can be summarized, I think, by saying 'Please everyone.' 'Boys are supposed to' can be summarized by saying 'Be strong.'"

The Kid Quixotes on both sides reject the burden of imposed identity. They say that they dislike the feeling of failure that comes when they don't fit these definitions, the limits described for them like the geometry of a cage. They wonder how these "supposed to" ideas came to be, and they object to these decisions being made for them, calling it all unfair. Rebecca, now twelve, with an authority that could make destiny doubt itself, says, "It's wrong for the world to decide who we are when they don't even know us."

The girls in class, the ones who have brothers, protest that girls have to do more chores at home, helping their mothers to cook and clean while the boys do whatever they desire.

Sarah repeats that she hates wearing dresses but her mom keeps putting them on her. When Sarah wears a dress, it seems to be following her around as she tries to walk away

from it, like the time my cat, Robin Hood, put his head through the handle of an empty shopping bag and then got spooked and ran and ran but couldn't outrun the bag. "Plus," Sarah says, "I hate princesses because they just wait for boys to save them."

Lily gets excited.

"That is very true!" she shouts, suddenly sitting up straight. "Everyone thinks that girls are supposed to please everyone! Like it's our job to do whatever they ask us to do! It's as if we're born under a heavy weight, like parking a bus on top of a garden! We have to push up the bus just to reach the sunlight!"

We have returned to George Herbert's "The Flower" twelve months later, this time as our own idea.

"Yes," Alex responds, her eyes wide open to show the passion that's not present in her uninflected, humble voice. "And it's like there's only one way to be a girl, one kind of girl, when really there are many different flowers in the garden."

"I don't sometimes know what I am!" says Sarah, with urgency. "My dad calls me a tomboy."

Joshua holds up one hand and says, "Wait! Girls aren't the only ones with a bus sitting on them. Look at both lists! Boys have 'supposed to' burdens too!"

A seven-year-old boy named Joseph, who accepts most of the list of "Boys are supposed to," protests that sometimes he does need to cry, like when his dad, separated from Joseph's mother, promised to take Joseph to a movie but then failed to show up; or when Joseph fell and skinned his knee. "It makes

me feel better to cry," he says, wounded all over again as he speaks with the passion of a political activist. I tell him that I agree, and that my mother told me always to cry whenever I needed to, and I do, and it always brings relief from the tension of holding back what needs to escape.

"And immigrants," says Percy. "Immigrants have 'supposed to.'"

Tabitha says that at the grocery store someone told her and her mother, "This is America! Speak English!"

"I was born on the moon," says tiny Talia, and everyone laughs.

"Seriously, though," says Joshua.

"I am serious!" says Talia, "I was born on the—"

"Talia," I warn her.

"Go ahead, Joshua," I say.

"A lot of people are born needing a second chance," he continues.

Felicity jumps in. "Like that lady and her baby by the train station who sleep outside on a cardboard box even in the winter." She is visibly and audibly on the verge of tears.

"And how Oscar Wilde was locked in jail for being gay," says Alex.

This conversation eventually becomes a Spanish lyric in the "Ruler of Myself" song:

> Un jardín de flores
> De todos los amores
> ("A garden of flowers
> of all kinds of loves.")

Originally the kids write *colores* ("colors") at the end of the second line, but Alex objects, saying that *colores* makes the image only about skin color or types of people instead of types of loving. The whole song, the whole show, and our whole approach to learning, she says, is based on loving relationships. "On second thought," she adds, "we're not the flowers. We're the gardeners, and the flowers are all the different loves."

Alex insists that this couplet be in Spanish, so that her parents will understand.

———

Describing the beauty of Marcela before she arrives in the story, Pedro the goatherd first says that Marcela's mother's face "Del un cabo tenía el sol y del otro la luna." The Kid Quixotes apply this description to Marcela instead, and translate this straightforwardly as, "One side of her face held / had the sun and the other the moon."

Then the debate begins about what this means. Does the skin of her face have two colors, one side yellow and the other side white? Does her face display a continuous, uninterrupted beauty from morning to night? Does her face inspire the same awe as all of the cosmos at once? Are we in the middle of a boundary-blowing contradiction or collision of opposites? We consult other published translations, including the following:

"The sun in one cheek and the moon in the other"
—JOHN RUTHERFORD

"That face that rivaled the sun and moon"
—SAMUEL PUTNAM

"Looking as if she had the sun on one side of her, and
the moon on the other"
—E. C. RILEY

"That face that had the sun on one side and the moon
on the other"
—TOM LATHROP

"That face of hers shining like the sun on one side and
the moon on the other"
—EDITH GROSSMAN

Only Edith Grossman's "shining" decides on a precise, visible verb, but what it means at heart to shine "like the sun" as opposed to shining like the moon—and Cervantes's desired effect of the pairing on the reader—still baffles the group. The kids want to discover their own word, a choice that would somehow resolve the broken, binary image and specify the meaning of the whole. Dissatisfied with our research, our imaginations stuck like ants in honey, we agree on our initial literal translation and vow to return to this struggle. Alas, when we do return the next week, we cut the phrase from our script and move on, never to revisit the poetry whose meaning has escaped our grasp.

Or so we think.

—

Before the real Marcela arrives, four different boys narrate her legend, including the self-deceased Grisóstomo, posthumously

via song sheets lying on his corpse. The boys control the girl's story. All of these male points of view add up to an avalanche of bias against the female.

The Kid Quixotes choose to present these stories using hand puppets, a choice that represents the power of the storyteller to manipulate (from the Latin for "hand") the narrative to serve the agenda of dominating a powerful girl. The Marcela puppet, which the kids made and a boy performs, is a caricature of arrogant prettiness, spitting on the noble, worshipful puppet of Grisóstomo.

By the time Marcela herself reaches the scene and speaks she has already been portrayed as wicked; her response, which the kids write as an anthem reclaiming her story and redefining herself, disputes the boys' portrait of her and turns a biased account of single perspective into dialogue.

The boys say they love Marcela; they carve her name into every tree in the forest, blame the power of her beauty for their despair, and sing out the sorrow of their unrequited love.

"That's not love," says Alex in class as we read and talk about the scene. "That's worship."

Worshipping Marcela's beauty, says Alex, is an aggressive act, part of the boys' attempt to define and thereby rule her. As this idea of aggressive worship dawns on the kid actors in rehearsal, they ask to bring back the sun and the moon, heavenly bodies, to exalt Marcela heavenward as a goddess. The more intense the adoration, the more powerful and brave is her rejection of being deified by the boys.

Returning to the original Spanish, "aquella cara del un cabo tenía el sol y del otro la luna," we remember that one problem is the verb *tenía*, meaning "held" or "had" or "kept." That

word doesn't produce anything visible. The kids offer instead that Marcela's face "pulled," "held in orbit," "swallowed," "captured," "devoured," or "outshone" the sun and the moon, all of which are more specific, active, and visible verbs than "held" or "had" or "kept."

Another problem is the idea that Marcela's face is split into two parts. This image confuses the kids, and when they imagine it they see something scary, more demon than goddess. Alex reminds everyone that at this point in the story the boys are portraying Marcela as a conquering monster. Joshua responds that gods are scary because they are powerful and beyond our understanding. Tabitha says that the power of Marcela is her beauty. Felicity, now ten years old, says that beauty isn't just how a person looks, but Tabitha answers that the boys who stalk Marcela don't know her; they are obsessed with her outward appearance only. The beauty, she says, has to be transcendent, has to be divine.

Then comes the revelation. Pharaoh, the eight-year-old boy who, as Pedro, is telling the story of Marcela in this phase of the scene, says, "Maybe it could be, 'She *is* the sun and the moon.'" Pharaoh is not only bringing the speech into the present when Marcela's arrival is fast approaching, but he also is using the word *is*. *Is* is a tiny word, not nearly as vivid or active on its own as *swallowed* or *captured*, but it transforms Marcela, lifting her up beyond the sky and making her become two heavenly bodies in one. Removing *cara* ("face") and *del un cabo* ("on one side") and *del otro* ("on the other") means that her face is no longer divided in half. *Being* both the sun and the moon makes her self into a universal beacon, a power always visible and always out of reach from the surface of our Earth. The

clear, simple statement "She is the sun and the moon" carries the rhythm and mythic balance of opposites used to define God and to defy the defining of God, as in the Biblical book of Revelation: "I am the Alpha and the Omega, the First and the Last, the Beginning and the End." Stating that opposites are one is easy to say and easy to read, but such a statement transports us to the heart of what nobody can know, the place where awe is born.

When my dad introduced me to imaginary numbers, I felt this same awe, and I relay his lesson to the Kid Quixotes at this moment in class. As we discovered before, we know that \sqrt{x} means "the square root of x," and a square root is the number that, when squared, equals the number inside the symbol, so $\sqrt{25}$ is 5, because $5 \times 5 = 25$. But what if we write: $\sqrt{-1}$? We are asking what number, multiplied by itself, will result in the number -1.

Ordinarily, any whole number—positive or negative—multiplied by itself will always yield a positive and measurable number. The square root of -1, however, has no visible geometric meaning in our daily lives and appears to be an unresolvable contradiction. Mathematicians represent this theoretical number with the letter i, and they call i and all multiples of i the *imaginary numbers*—not because they don't exist, but because an act of imagination was required to discover them.

Desiring a visual expression of this idea, mathematicians gave it a place on the real number line—the horizontal depiction of all non-imaginary numbers—by adding the vertical imaginary axis intersecting at point zero, also called the Origin; coordinate pairs on that graph form what are called *complex numbers*, like the complex relationship between

Quixote's fantasy and Sancho's earthbound common sense. The Kid Quixotes will refer back to this image often in rehearsal, to remind us that the meeting place, this dialogue between opposites, gives our story its multiplicitous concept of truth.

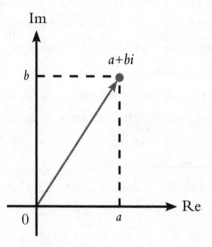

Making room for this idea of imaginary and complex numbers has swung wide the doors of thought onto a whole new world before which we stand in amazement and ask what it means to be real.

By saying "Marcela *is* the sun and the moon," Pharaoh has precisely articulated the same kind of apparent contradiction and amazement.

And in the returning to an abandoned poetic failure, the kids give themselves a transcendent metaphor that becomes an instrument of the obsessive and oppressive actions of the boys.

Marcela tries to remove the boys' oppressive illusion that she might someday love them, but the boys won't let go of that story. The word *desengañar*, "to disillusion," or *desengaño*, "disillusionment," repeats itself a number of times in the span of these few pages.

Disillusionment, I suggest to the kids, is an opening of ourselves to more than one point of view. Ambrosio, Grisóstomo's best friend, identifies the final disillusioning of Grisóstomo by Marcela as crossing the threshold from hope to hopelessness and the reason for his friend's suicide, whereas my own disillusionment—the ability to accept more than one side of a story, a side that may not agree with my belief—painful as it can be, has rescued me.

When the Kid Quixotes encounter Pedro's description of the "desesperadas endechas" of the shepherds who follow Marcela, they quickly translate it as "desperate requiems." They find *requiem* in the dictionary and choose it over *dirge*, *hymn*, and *song* because it is the Latin word for "rest," and they love Latin. They also like the idea of "rest" as peaceful self-soothing for the troubled boys.

Then one of our professor friends visits us in class and explains that Cervantes couldn't actually write the word "suicide" in his novel because Catholic law considered suicide to be a mortal sin and its mention to be blasphemy. Instead he chose the word *desesperación* ("despair" or "desperation") from the Latin for "without hope."

After the professor tells us about this prohibition against saying or portraying suicide at the time Cervantes wrote the book, we have a decision to make. Do we try to be historically accurate by using the word *desperate* or do we depart from

Cervantes and his era and say *suicidal* instead? I repeat my story to the kids, about how hard it has been to say that I am mentally ill, for fear of being feared and avoided by other people who might call me "crazy." Although there is no longer a law against saying "suicide," there is ignorance and there is bias that can separate people from the treatment and companionship they need because they are afraid to speak the words to ask for help.

The kids are quiet, and then Alex says, softly as always, "I think if we don't say it's a suicide, the audience won't understand. Plus it hurts to have a story you can't tell." Alex's own struggles with depression give her a voice of knowing authority in the room.

The rest of the kids agree that they want the audience to know exactly what we're talking about, so the problem doesn't have to be secret and people can begin to feel sympathy for the mentally ill, even though Grisóstomo's aggressive, misogynistic behavior toward Marcela was very wrong.

"Speaking of sympathy," says Joshua, "I think we need to change *requiem* to *lullaby*. It's more personal and kind." In our script, Pedro now says, "If you listen, you can hear their suicidal lullabies." The rhythm of "suicidal lullabies," say the kids, matches "desesperadas endechas" in its rocking cradle musicality. The origin of the word *lullaby* is in the soft, comforting sounds a parent makes to a child at bedtime, "Lu lu lu" sounds that say, "Don't worry, sweetheart, everything is all right." Add to this the two soft "s" sounds in "suicide" and you have a tragically tender phrase.

The last time I saw Lucy, after a five-year gap, she just showed up at Still Waters one afternoon, walked in the door, sat down on the couch and looked around, as if she had forgotten something.

I sat next to her and said, "Hello, Lucy. Welcome."

She said, "Thanks, Haff."

I introduced her to the little kids and suggested she might want to help them with their homework.

"Nah, I gotta be out. Thanks for letting me into your sanctuary."

She stood and I stood and she hugged me the way she used to at the end of every rehearsal when she would say, "Be safe. We need you, Dad."

But this time, as she walked out the door on her way back to Florida where in two weeks she would take her own life, all she said was, "Bye."

Not a day goes by without my thinking of her and being grateful; she taught me to grow a backbone. As society teaches the *Traveling Adventures* girls—and my own daughters—that girls are supposed to please everyone and be generous and compassionate, I also want them to carry some of Lucy's spirit inside.

Later that day in rehearsal for *The Traveling Adventures*, while practicing the whipping scene, I coach tiny Talia, who is playing the role of Andres the shepherd boy after Rebecca's family has been forced to move away when they can no longer afford local rent. I tell Talia, thinking of little Lucy's ferocious, fearless strength—fresh inspiration after her farewell visit—to show more anger toward me, the cruel landlord. "Look me in the eyes," I say, "and talk to me like you're not afraid." The line I focus on is, "You'd better pay me what you owe me." I keep asking this little girl, only eight years old and high as my

belly, to battle me, to scare me, thinking that such a chance to stand up to a grown-up would be thrilling for a kid whose life is run by grown-ups. And I have experienced Talia's real-life anger before, when she walked into the classroom last week complaining about the food at school, and then about the redundancy of her homework.

"Every day the food is the same, always hamburgers and some kind of mushy stuff, and it tastes disgusting like toilet water," she said, her brow scrunched up together and her normally soft voice now quite loud. "And every day the homework is the same. I already practiced division yesterday! Why do we have to go to school? Why don't we have a choice?"

Her sister, six-year-old Roxana, echoed, "Yeah, why don't we have a choice?"

I praised Talia for matching her feelings to words, to help me understand what was happening inside her. "Even if you can't change your situation, you can disapprove."

"Why is that good?" she asked, as she always does, with pure, intense curiosity, desiring to own all available knowledge.

"It's like rehearsal," I said. "You practice thinking and articulating your thoughts and then, when you have a chance to make a change, you're ready."

"Have you done that before?" she wanted to know.

"Yes, I have, many times."

"Tell me one time."

"Once I lived with a person who was mean to me and I told her I didn't like how she treated me."

"What did she do?"

"She told me everything I did was wrong."

"What was wrong?"

"I brought home the wrong kind of bread from the store."

"What did she say?

"She said, 'I told you to bring brown bread, not whole wheat. You never listen.'"

"What did you say?"

"I said that her voice, the way she spoke, hurt me."

"So what did you do?"

"I kept telling her that I didn't like being spoken to that way, and I asked her please to stop."

"Did she stop?"

"No. So I left."

"Where did you go?"

"I went to my own apartment."

"Oh."

She thought.

"Remember, Talia," I said, "It's never okay for anyone to hurt you."

She continued thinking.

Back in rehearsal, a week after I had praised her for articulating her anger, I push her too much, repeating, "Come on, Talia, get mad at me!" and Talia begins to cry. I put my arms around her tininess and reassure her, saying, "Oh, honey, I apologize. That was too much, wasn't it?" Sniffling and gulping air, she nods. I can feel the frailty of her little bird body, a body that is too light for the heaviness inside her.

"I thought you would have fun telling me off!" I say.

She steadies herself, takes a couple of deep breaths and says, "But I can't get mad at you. You are the boss!"

"Ah, I see. Remember this is just pretend. When I ask you

to get angry at me, I'm really asking your character to get angry at my character. We're telling a story together."

"What is the story?"

"What do you think the story is?"

"A girl did something wrong and the boss is punishing her by whipping her."

"What did she do wrong?"

"She lost a sheep."

"Is the punishment fair?"

"No. The boss doesn't even pay her."

"How do you feel about that?"

"I feel angry."

"Good!"

"Why good? I thought angry was bad."

"Angry means you care and you want justice."

"What is justice?"

"It's the happy feeling when everything is fair."

"So angry is good?"

"It can make us do something about our problems."

"But I'm supposed to be a nice girl."

"What does 'nice' mean?"

"Not getting angry."

"It's okay for girls to get angry."

"No."

"Yes."

"No."

"What about Sarah?"

"What *about* Sarah? Sarah is *nice!*"

"Yes, she is kind, but she also gets angry. She calls me a

coward and she bosses me around and she attacks anyone who says bad things about her mommy, and she attacks the guards to liberate the galley slaves."

"But that is all pretend."

"Yes, but she needs to believe in what she does when she is acting. Remember when she says, 'I don't like dresses?'"

"Yes."

"That's really how she feels."

"What about you?"

"What do you mean?"

"Do you agree with your character?"

"No, but I have punished my students at the high school."

"You whipped them?"

"No, but I yelled and I threw things."

"What things?"

"Books, chalk, a chair."

"You threw it at the kids?"

"No, but close by. I scared them."

"Why did you do that?"

"I was angry."

"You said angry is good."

"Angry is a feeling that can help us to do good but also to do bad; it all depends what you're angry at and what you do with your anger."

"What made you angry at the kids?"

"They weren't listening to me."

"That doesn't mean you can throw stuff at them."

"You're right, sweetheart; I promise never to do that again."

The next time we run the scene, Talia's voice bursts like

a firecracker when she says, "You'd better pay me what you owe me!" and as I leave the playing area, she tracks me with incendiary eyes.

"You call that a whipping?" she hollers. "It felt like a butterfly!"

The girl is unbroken.

———

In the process of adapting Alex's essay as song, the group studies the poem "Miracles" by Brooklyn's own Walt Whitman for its varying line lengths that correspond to the size of Whitman's inclusive desire.

Ruth says, "It's like the more excited he gets, the faster the words go."

Joshua adds, "And the more words you speak in one breath."

Alex riffs on this: "To me it feels like the words are miracles, and because he believes that everything is a miracle he tries to fit everything into one poem, and sometimes everything goes into one line."

"Or even in one word," says Felicity. "Like 'wonderfulness.'"

I read the poem aloud to the group, using their ideas to shape my delivery, exaggerating my inward breathing at the beginning of a line and not breathing again until the line has ended. The rhythm of the verse becomes obvious with this exercise:

Why, who makes much of a miracle?
As to me I know of nothing else but miracles,
Whether I walk the streets of Manhattan,

Or dart my sight over the roofs of houses toward the sky,
Or wade with naked feet along the beach just in the
 edge of the water,
Or stand under trees in the woods,
Or talk by day with any one I love, or sleep in the bed
 at night with any one I love,
Or sit at table at dinner with the rest,
Or look at strangers opposite me riding in the car,
Or watch honey-bees busy around the hive of a summer
 forenoon,
Or animals feeding in the fields,
Or birds, or the wonderfulness of insects in the air,
Or the wonderfulness of the sundown, or of stars
 shining so quiet and bright,
Or the exquisite delicate thin curve of the new moon in
 spring;
These with the rest, one and all, are to me miracles,
The whole referring, yet each distinct and in its place.

According to her similar enthusiasm for including "Every-one," Alex, drawing from the reservoir of material provided by the group, also builds the bridge of her song on similar lines of varying length, accentuated by singing each line on a separate, single breath:

I believe in hugs
People stuck together like the petals of a rose
En mi familia de dientes de león
Growing love for everyone
I believe everyone should feel loved

no matter their
looks, language, idioma, capacidad, raza, religion
no matter their
country, status, dinero or difference
orientación
anyone at all
Un jardín de flores
de todos los amores
Who decides if a flower is a weed?

After we read "Miracles," Kim has the kids listen to songs that use a flexible structure that adapts to the story of a search for self and universal love, including "Bohemian Rhapsody" by Queen, a tale told in six movements, each expressing a different key and rhythm and personality. The group listens to this song a half dozen times, noticing the moments where the musical "changes of feeling" happen, from melancholy dreaming to desperate confession to comic opera, as the lyrics ache with a plea to be understood: "Is this the real life? / Is this just fantasy?" The idea is that the Kid Quixotes, too, can build a song with multiple tones and perspectives shaped by rules that change from verse to verse.

This time Kim works closely with Alex in private, the kind of privacy many teenagers need but don't always receive.

As Alex works privately with Kim, relying also on the encouragement of her fellow teenagers who are involved in their own journeys of self-definition, they daily play for the rest of the group what they have worked on, and the other kids, who have been rehearsing dialogue with me, cheer and describe how the song makes them feel. "It makes me feel brave!" or

"It makes me want to sing, too!" or "I know how it feels to be afraid!" or even, "I feel confused about what I'm supposed to feel."

At first, the song opens with righteous anger, "I want to love who I love" being sung as a demand, but the little kids say that the anger scares them, and it doesn't sound like the Alex they know, so Alex and Kim revise the opening verse as asking to be heard and trying to understand, and this more humble approach, built of soft, prolonged notes ("I want to loooove who I loooove") allows everyone to receive and contemplate those desires.

The second verse ("Am I too young?") is all questions. The questions are generated when Alex describes to the group the idea for the verse, "Wondering what's going to happen to me," and they jump in with so many questions Alex can't keep up; she has to ask them to repeat what they say so she can write it all down.

The younger kids say that the singer sounds scared. "It sounds like she wants to run away and hide," says Percy. "But she also has to go forward."

The revised verse comes back with a drumbeat driving the music at a quicker tempo, and a new tune built mostly on questions ("Am I too young? / I am afraid / Where do I go? / Will I be brave?") with identical pulses, the dynamics—the range of volume—shifting from the tentative racing of a nervous heart to the bold slamming of that same heart like the percussion that drives the rowing on a galley. And the second line, "I am afraid," is new. It's a statement among questions, the brave act of articulating and facing fear. Sarah likes this, telling Alex, "Now you sound like you know you're afraid but that's not going to stop you."

The bridge, which shifts from the key of E to the key of G and takes on its own unique tempos and rhythms, is a confident statement of personal beliefs, including Tabitha's poem unto itself, "I believe in hugs / People stuck together like the petals of a rose," and Alex's "Everyone should feel loved." It begins with a graceful melody longing for a world that at present can only be imagined, minor chords in a major key speaking of the separation between aspiration and fact, then becomes a recitative, a "talk-singing," as Kim describes it, where the song marches through a roster of people in need of welcome. At the end of the roster, the song takes off with a loud, brief aria on the words, "Anyone at all," the ultimate inclusion.

Tabitha, who has just joined the group at the beginning of our work on "Ruler of Myself," and who at age thirteen is herself a bridge between the older teens and the younger kids, asks for one change. "If we say that the dandelions are immigrants," she begins, "And we say they are 'spreading love,' the word 'spreading' sounds like the immigrants are weeds. The lyrics say, 'Who decides if a flower is a weed?' I think that means that we're saying these so-called weeds are actually really flowers, aren't we? Maybe we can change 'spreading' to 'growing.' That sounds positive."

Alex agrees by slowly nodding her head.

Percy says, "Wait! I have a great idea! What if you say 'everyone' twice in a row, because it's very important?"

Alex nods again.

"And make the second 'everyone' super long," continues Percy. "Like, 'Eeeeeeeveryoooooone.'" The kids laugh with delight; Percy is brave to demonstrate his idea. "Like that word is wide enough for everyone."

Alex and Kim make the change.

The words "good" or "bad" are not allowed in this process, because they communicate almost no useful information. Learning how the group feels and what they think as they listen is exactly the information Alex and company need in order to return to the song and revise it.

This conversation continues for three months, private work alternating with group response, and produces this:

> I want to love who I love
> Dream what I want to dream
> Feel the wind as if it's my freedom
> I want to understand this frightened little girl
> Am I the ruler of myself?
>
> Am I too young?
> I am afraid
> Where do I go?
> Will I be brave?
> Where is my path?
> Who will I follow?
> Do I have to follow?
> Am I the ruler of myself?
>
> I believe in hugs
> People stuck together like the petals of a rose
> En mi familia de dientes de león
> Growing love for everyone
> I believe everyone should feel loved
> no matter their

looks, language, idioma, capacidad, raza, religion
no matter their
country, status, dinero or difference
orientación
anyone at all
Un jardín de flores
de todos los amores
Who decides if a flower is a weed?

We choose to love how we love
Believe in what we dream
Feel the wind and feel our freedom
I am no longer that frightened little girl
I am the ruler of myself

Yes I am young
And I am brave
And I will go
where injustice goes
And I will stay
for those who need my help
Soy valiente!
Yo se mi propósito
Y domino mi destino
I am the ruler
I am the ruler
I am the ruler of myself!

The song has almost no rhyme. The structure is the result of repetition ("Am I the ruler of myself?") and matching rhythms

("Orientación / Anyone at all"); it is a dynamic voyage from pianissimo longing ("I want to love who I love") evoked by plaintive minor chords to soaring, fortissimo, roof-lifting major-key pride ("I am the ruler of myself!") inspired by Alex's discovery that "Yo se mi propósito / Y domino mi destino" ("I know my purpose / And I rule my destiny").

The bilingual bridge is a two-way mirror: before the bridge, the first two verses, all in English, are wishes and questions, respectively, each with a unique rhythm.

After the bridge, the two verses mimic the rhythm of the pre-bridge verses, but they have become statements, answers to those wishes and questions, now with Spanish as well as English, completing Alex's picture of who she is. The structure of the first half is reflected in the second half, and the hook, "ruler of myself," serves both halves.

This structure came about in one of the conversations between Alex and the group, right after the bridge had been completed. As the group studied the lyrics so far and thought about what to write next, taciturn, lantern-eyed Tabitha raised her hand and said, "I noticed that in the first part of the song there are things she wishes for and things she wonders about. Maybe she could just answer all of that in the second part. She can ask 'Am I the ruler of myself?' and answer 'I am the ruler of myself.'"

"Aha!" shouted Kim. "You just chopped our workload in half! The second part of the song is already written! Bravo, Tabitha!"

Alex nodded yes.

The symmetry of the structure has the effect of intensifying the change in feeling from the first half to the second half.

The song is a braid of three musical storylines: from wishes to choices; from questions to answers; and a coming out in the middle.

"Wait!" said Tabitha. "I have more to say. I think that in the second part, all of the girls in the group could sing the answers, as if Alex is influencing the girls and they are becoming brave, too."

The answers, the brave statements, are sung in the show in first person plural, as in "We choose to love how we love," by all of the girls in the group, "those who need (her) help," as they are sitting on the floor and looking up to Alex.

At the start of practice, however, Alex does not sing the song. She misses her rehearsals, and at the first three public shows, her best friend Ruth—also a very private person who suffers chronic, paralyzing anxiety—sings the song in her place while Alex accompanies her on the ukulele. This is an extraordinary sacrifice by Ruth, whose distress over school and all public occasions is visible in the crumpled posture of her body. In rehearsal, Kim coaches her to stand up straight and breathe, and when she sings that she is the ruler of herself, the audience witnesses her taking control of emotions that until recently had controlled her. I rarely see Ruth smile, but as she sings there is a sparkle in her eyes, like distant lightning, that can only be joy. All of this she does for her friend.

Then, in Philadelphia, in front of our biggest audience in our biggest space, Alex chooses to sing. Ruth, who switches to ukulele, sits next to her friend to steady her, and sings along so softly that nobody but Alex can hear.

The lyrics of the song map the journey to that moment, from the first verse, which says, "I am afraid" to the matching line in

the last verse, "I am brave," followed by "I am no longer that frightened little girl."

I ask Alex after the show what it was that made the act of singing scary, more so perhaps than speaking, and she says, "When you sing the focus is on your voice more than on what you are saying, and your voice is you. You can't hide anymore."

———

"What is Kid Quixote's mom doing all this time, while you are rescuing the kids?" I ask.

"I don't know," says Sarah.

"What do you guess?"

"Maybe she's worried about me."

"Can you send her a message?"

"No, if I do that she will tell me to come home."

"And you don't want to go home?"

"Not right now. I have to save these kids."

"You said that saving them would take five years."

Sarah is silent for a while.

"I'm not a baby anymore. I can make my own decisions."

Tears gather along the lower rim of her eyelids.

She blinks them away.

- 4 -

The Song of Basic Needs

It's fall of 2018, two years into the project, and our first performance is scheduled for early December in a private home in Manhattan. Lily and Rebecca have moved away, so they are not around for the writing of the next scene and song, but they will come back on occasional Saturdays to rehearse—the Kid Quixotes have displaced Saturday writing sessions in favor of rehearsal as the tour approaches—and for the show's public debut. After that, we rarely see them anymore. Felicity, too, goes missing as the opening show draws near. She is afraid of acting and her mother is worried about what could happen to her little one away from the neighborhood.

The next scene in our play is an adaptation of Quixote's encounter with a group of galley slaves, prisoners of the king who are chained together and led by armed officers to a ship

where for many years they will row and row. Quixote receives permission to ask each prisoner why he or she has arrived in such disgrace.

The first slave admits to stealing a basket of laundry, the second to confessing under torture, the third to lacking money to pay a lawyer or bribe a judge. The kids decide to keep the laundry theft because they find it funny—"I would actually do that!" says Percy, making everyone laugh. "Fresh, clean laundry smells irresistible!" He quickly claims this comedic role.

But the kids change the second crime, confessing under torture, to not doing homework, saying that, in the world of kids, homework is torture, and not doing homework is a serious offense.

The crime of poverty, committed by the third slave, is one they all share, and as the injustice of their situation comes to light, the kids internalize the shame of having less than others. Rebecca, who played the shepherd boy in the whipping scene—the one whose boss won't pay him for his work—until her family moved away, used to come to class every day after school without food, and as she said that she was hungry, she looked down at the floor.

In the novel, the fourth slave, an old man with a long, white beard, refuses to speak and begins to cry when questioned. A fellow slave speaks for him and explains that the old man was a "go-between," someone who was paid to procure prostitutes. I choose not to tell the kids about this profession, saying only that it's something not relevant to our story.

They decide, based on stories in the news that scare them at night more than monsters under the bed, to change this

prisoner into a tiny Mexican girl named Cleo, the real-life six-year-old sister of Sarah. This, say the kids, is where the song happens, their response to the silencing of incarcerated migrant children separated from their families.

"This is what we can do," says Tabitha, softly. "We can speak for them."

"She has to be totally innocent," says Joshua. "So the audience can feel the injustice. When I look at Cleo, the first word that comes to mind is *innocent.*"

"What do you think, Cleo?" I ask. "Cleo?"

Everyone looks around.

"Where's Cleo?" I ask. This is a common refrain.

"She's in the bathroom," says Sarah. Her sister spends a lot of time in the bathroom. Noticing this at first I was worried about Cleo's health, but she has told me that the bathroom is her "private place," the only refuge where she can close the door on everyone else. At school and in her crowded home this middle child has a reputation for being difficult; her mother asks me every day after class if Cleo has behaved properly and I always say yes, even when she has been maniacally scribbling with crayons in a flurry of noise and motion that I refer to as "squirrel behavior." "Imagine," I say to the group at these times, "if we had a squirrel at the table. We'd never accomplish anything."

After about five minutes, Cleo returns to the group.

"Welcome back, Cleo," I say. "Could you hear the conversation?"

"Yes."

"Will you do it? Will you represent the girls who are in jail?"

Cleo, with a single nod of her head, tacitly agrees to be brave.

In the galley slaves scene, when the girl refuses to speak, Sarah performs a song and dance to distract her from her apparent sadness, which fails. Cleo remains silent and looks down at the ground.

Sarah then sings, very gently, a series of questions which the group has generated. I had asked them what they would ask the refugee children we read about daily if they could meet those children, the ones who have been separated from their parents. The kids say they want to know where the girl comes from, who her family is, what happened on her journey across the border, and why she is alone.

Emphasizing the five senses in the answers is Sarah's idea. "Our senses," she says, "are how we understand what's around us."

Then Ruth, who has lost her voice because of a sore throat, hands me a written note that says, "Please read this to the group" at the top. I read, "If we can see the colored house the girl sees and smell and taste the tamales her mother makes, we can imagine being her."

"What do you mean by 'colored house?'" I ask, and Ruth writes back, "In Mexico people paint their houses bright colors, like yellow and turquoise and pink, inside and outside. And the roof is usually silver colored, a wavy sheet of metal. When I saw the roofs when I was a kid I thought they really were made of real silver."

Alex says that the line about tamales has to be in Spanish,

because it's deeply personal, the relationship between the child and her mother and their culture that is made of food and language.

Those two sensory details, the house and the tamales, encourage the group to come up with the next sensory detail, the sound of the song of a coyote—which here is the name both of a wild dog and of a person paid to escort refugees across the desert.

Swiftly, after a couple of days, the group has opening lyrics for a song in the form of dialogue:

KID QUIXOTE: Where is your home?

CLEO: A rainbow house with a silver roof where the sun will always shine.

KID QUIXOTE: Who is your family?

CLEO: El aroma de los tamales que mama me hizo para mi.

KID QUIXOTE: How did you come here?

CLEO: We followed the path of the singing coyote.

Imagination and sympathy are bridges we build between us when the gulf feels impossibly wide. This imagining and sympathizing is phase one of our rescue mission, our attempt to save the stories of children who have been separated from their families and from the world outside their prison walls and, inside our play, to bring those stories to friends and strangers on our travels, so that many people can begin to imagine "being her." The basic

need not to be alone has to be conveyed in song, so that music can reach where words alone can't go, making sympathetic vibrations in a neighboring heart.

———

Accuracy based on sympathy can bring to the practice of translation a moral yearning—not a lesson on what is right and what is wrong, but a desire for what is right, a reaching for compassionate song.

When Quixote asks the guards to release the galley slaves because, he argues, the prisoners have done no wrong to the guards, one guard ridicules him by calling his request "Que donosa majadería!" or "What crazy / amusing / funny / hilarious nonsense / foolishness / stupidity," as the kids discover in their bilingual dictionaries and thesauruses. But none of these words agrees with the sensibility of the kids, who reject the cruel, belittling tone. They understand that Quixote meets unkind people in his travels, as they do in their own real lives, but they love him and they love Sarah. They ask each other for words that can express the guard's astonishment at the idea of releasing the king's prisoners without making anyone in the group have to ridicule their beloved brother or sister.

The guard's contemptuous verbal insults aimed at Kid Quixote would, like the realistic portrayal of physical violence, enact real contempt and distract from the contemplation of justice and kindness at play in the scene. There are words the Kid Quixotes will not speak in their daily lives, never directed at anyone, including "stupid" and "crazy." When these words are suggested as possible translations for "donosa majadería," the kids have an immediate gut rejection, like vomiting. The

words, they say, go off like bombs in the head of the person they're tossed at, bombs of worthlessness. The kids refuse to make Sarah feel worthless even when pretending.

Suddenly Sarah says, "Holy guacamole!"

Everyone laughs, and I ask her why she said that.

"The guard could say that," she answers. "It could show that the guard is surprised but he doesn't have to say anything mean to me."

"And it's funny like kids are funny," says Roxana, the six-year-old girl who is playing that guard.

The group accepts this answer to the problem of undesirable accuracy. "Donosa majadería" becomes "Holy guacamole!" The Kid Quixotes redefine "accuracy" in translation and change what could be thought of as "wrong," namely "Holy guacamole," into what becomes right.

———

For this, the final song of the show, Kim changes her approach to the collective songwriting process. She sits at the piano in our room from the very start and improvises music on the spot to match the words the group is writing as the words are being written.

There will be no rhyme in this song, no repetition, no bridge or hook or rhythmic pattern, only a moment-by-moment responsiveness to questions that take us ever deeper inside the heart of the little girl. Dialogue and the five senses provide the only structure.

"The other structures," says Joshua, "have broken down. In this situation, what was normal is gone. All that's left is person to person."

Over the first two years of the project, in writing the other songs, Kim has taught the kids about rhythm, tempo, and major and minor keys, so they can respond to her improvisations now by asking her, for example, to revise the song so that it becomes sad but hopeful—minor then major, slow tempo then quick tempo—instead of simply sad.

This happens during the writing of the "Song of Basic Needs," when little Cleo, playing the incarcerated refugee child, answers Quixote's first two questions, "Where is your home?" and "Who is your family?" by singing, respectively, "A rainbow house with a silver roof where the sun will always shine," and "El aroma de los tamales que mama me hizo para mi" ("The aroma of the tamales that Mommy made me just for me").

Kim's first attempt is in a minor key and slow tempo and feels irredeemably sorrowful, an expression of the girl's pain of being separated from her family. At this point, early on, the whole group is singing, not only Cleo, because Cleo needs the support of the kids and Kim wants everyone to feel the song from the inside.

Joshua responds by saying, "Actually, I think these are happy memories. She loves her house and she loves tamales made by her mommy." After the kids ask for a quicker tempo in a major key, the verse becomes bouncy with the child's joy, a relief from her heavy loss.

Throughout this songwriting process, the progressive dialogue between words and music, meaning and emotion, repeats itself.

Next, when Quixote asks, "How did you come here?" the girl sings, "We followed the path of the singing coyote." Kim

asks the group how this line needs to feel, and they answer that this is the beginning of the sad part of the song, a sweet sadness that matches the desires of immigrants. "The journey has hope," says Ruth, who has become more vocal after the departure of Lily for college out of town—albeit on paper, a practice she carries on from her recent days with laryngitis. "But it's going to be dangerous."

Kim responds with a melody that climbs the register, as if reaching for freedom in the optimistic A major key, only to dip back down into B minor and C-sharp minor chords on the last phrase, the three syllables of the word "co-yo-te." The mood of this memory has replaced the mood of the verse about tamales.

The families around me in Bushwick make food the way their ancestors did; recipes can be traced back through many generations. Sarah's mother makes the same mole poblano made by her mother before her, and her mother's mother, and on and on. Back home, the grandchildren had the job of crushing and blending six different kinds of chile peppers into a paste. That blend would be covered and kept aside for a whole month to gather flavor. One week before the meal, the family would assemble the rest of the ingredients, including peanuts, almonds, white sesame seeds, cinnamon, sugar, and plantains, all roasted except the plantains, which were fried.

On the day of the meal, a large block of chocolate was melted in the giant pot with lard and stirred until it bubbled, then poured into another pot while in the original pot, the sugar was cooked to caramel. The chocolate was transferred

back to join the caramel, and everything else, except the paste of peppers, was added and stirred until it reached a creamy consistency. One hour later, the spicy paste was added and the whole pot was then stirred and stirred and stirred for eight hours before being served.

The recipe calls for love, the many historical, traditional layers of love from an entire culture's entire past, like a giant cradle rocking and reassuring everyone across the ages. "You belong here," says the lullaby of scent and taste, "You belong, you belong, you belong."

Having a task or job gives a kid a role in the family, classroom, or neighborhood. My daughters take pleasure in helping at home, bringing food to each other, comforting other members of the family, and making drawings as gifts. If I appear sad, Zadie immediately moves toward me and rubs her tiny fingers in my hair. This Christmas, my older daughter, Kiki, was proud to pick out our tree, and she insisted on helping me to carry it back to our home. Zadie asks to lead us home from the grocery store, now that she knows the way. The kids at Still Waters always want to help distribute pencils, papers, or carrots, to collect the scripts at the end of rehearsal and to put the props away. They voluntarily sweep the floors and throw out the garbage. A very special prize is the responsibility of checking and retrieving the mail. In the refrain from "The Rescuing Song," they sing, "Can we help? Can we help? Can we help?" clearly desiring to save their immigrant peers.

"What's that?" I ask Sarah, pointing at the next drawing in the margins of her copy of *Don Quixote*.

"That's a big puddle from the Ice Person melting."

"Why did he melt?"

"Because I listened to him."

"But I thought that listening is a good thing."

"Not always."

"What do you mean?"

"Sometimes people don't want to talk."

"Why not?"

"Because they could be too sad or too afraid. They could lose control of their feelings if they start talking."

"Who's this over here?" I'm pointing at a stick figure of a person.

"That's the first kid I can reach."

"What's this?"

"That's the path of water from the melted Ice Person so I can just walk up to her."

"And what's happening here?"

"That's me hugging the girl."

"And what's all around you?"

"She's crying."

"What do you say to her?"

"Nothing. I only hug her for a long, long time."

"How long?"

"Five hours."

"That's a long hug."

"Yes. I'm squeezing out all of the tears. She has a lot of tears inside her."

"What do you say when the hug is over?"

"I say, 'I will get you out of here. I promise.'"

"How will you do that?"

"I don't know yet. I'll think of something."

Sarah draws this part of her story on a break during the same class in which the group writes the last two questions of the "Song of Basic Needs." Sarah asks Cleo, as Kim plays in a minor key expressing concern, "Why are you alone?" and right there in class the little one improvises a spoken response, "I lost my mommy's hand." Kim immediately sings back these words and plays the piano, ending in an unresolved cadence that matches the moment of separation, the disorienting, unresolved terror of a child pulled apart from her mother. This simplest of images, two hands reaching for each other as the distance between them grows, represents the deepest fears of the Kid Quixotes and their families, and the music, in its lack of resolution, is haunting, an indelible memory being born.

"We need one more question," says Tabitha. "It can't end like that."

Everyone thinks.

"What are their other basic needs?" asks Ruth on paper, giving us the eventual title of the song in the process.

The group offers "sleep," "taking a bath," "art supplies," and Felicity says "glitter."

Everyone thinks more.

"Let's try coming up with the question first," I suggest. "Then maybe the answer will arrive."

"What are your basic needs?" says Sarah.

"What exactly do you want?" says Felicity, whose desire to know is as strong as it was on the very first day two years ago.

"Open your heart to me, please" says Joshua.

"What do I need to know about you?" says Alex, herself a secret, even after writing her own song of coming out.

The lyric then bursts suddenly forth, fully formed, from Ruth, who hands me a piece of paper bearing these words in her meticulous handwriting:

"What do I need to know to enter your fragile little heart?"

"That's beautiful," says Kim.

"Let's try it!" I say, getting up.

I ask Sarah and Cleo to stand up together apart from the table, and to sing what Kim invents for them on the piano.

But where is Cleo?

"She's in the bathroom," says Sarah, who keeps track of her little sister.

"Again?" I ask. "How many times is that today?"

"At least four," answers Sarah.

Kim uses the waiting time to experiment with melodies while the kids begin talking about whatever's on their minds. Eventually, Cleo returns.

When Sarah is standing, a foot taller than Cleo, Kim plays a melody for "What do I need to know to enter your fragile little heart?" that is, say the kids, overpowering. Sarah is too dominant when she sings it. "She'll never get an honest answer if she's pushy," says Joshua.

Sarah then decides to kneel down, so her face is below Cleo's. Kim's next improvisation, from low in the scale with a minor chord, matching Sarah's kneeling, begging position on the floor, ever upwards climbs the scale to reach Cleo, ending in a generous major chord on the word "heart," making a melody that feels like compassionate wondering.

After Sarah sings this version, everyone celebrates.

"That's it!" exclaims Joshua. "That's the way to approach a frightened little girl."

"Ok, Cleo," I ask, "What would you say in this situation?"

Cleo says nothing. She just looks at me.

There is a long silence, and then eight-year-old Talia raises her hand.

"If I was in that situation," she says when I call on her, "I would want Sarah to do what my mom does when I wake up at night because I had a nightmare. She hugs me really tight and tells me to close my eyes and she tells me I'm safe and it's just a bad dream. That always makes me peaceful."

"Fabulous, Talia!" I say. "Let's sing that! Cleo, answer Sarah's question with what Talia said, please."

Sarah now sings her question and Cleo very softly speaks her answer (it will be days before she dares to sing), "Hug me tight; tell me to close my eyes; tell me I'm safe and this is just a bad dream," as Kim plays along in a descending tune that corresponds to Sarah's ascending question, a symmetry that is broken right at the end when the melody lifts up on the very last note, a needful, musical plea for reassurance. This comfort, say the kids, is what they would ask for.

Touch, as in the "hug me tight" lyric, can make us feel safe in a way that no barricade can. If we're watching a scary movie at home, Zadie will curl up against me, under my arm; at that moment I am her refuge. The actions of Cleo's song, in the words and music, mimic the yearning for that primal reassurance, a need forbidden to refugees in detention. Sarah puts her arms around her sister. Even though the real-life refugees are not allowed to touch each other, we keep this hug in the show.

Cleo's initial silence in this scene represents the hidden-ness of immigrants' stories in general, stories that can, if told to the wrong person, undo their lives. After our first performance of *The Traveling Adventures*, in the living room of the private home of a friend of Still Waters, a person in the audience asks the kids who among them are Dreamers, the nickname of migrant children who have been allowed to stay in this country under a special program called Deferred Action for Child Arrivals (DACA), under attack by the present ruler. Not one kid raises his or her hand. Regardless of how safe they are in this setting, the kids have learned to say nothing of their immigration status or that of their parents. Other people can see only what the children allow them to see. I am lucky to have been allowed inside.

"I don't belong here," says my mother via telephone. I'm at home in Brooklyn and she's in Waterloo, where I grew up in Canada, in a nursing home.

Mom, like Cleo in the "Song of Basic Needs," is separated from her home and her family.

"Everyone around me is crazy; I'm not crazy and I remember everything, everything from yesterday and from when I was a girl. There's nothing wrong with my mind."

"Mom, I think the problem is falling down. You were having strokes and every time you passed out and fell you broke a bone."

"I know," she says, with surrender in her voice. She has osteoporosis, tiny holes in her bones that make them as fragile as sand dollars that have been dried and bleached by the sun. We

219

used to love collecting sand dollars on the Florida shore when I was a boy. The challenge of transporting them home intact without their dissolving into dust raised an intense awareness of the potentially destructive power of our hands and the abiding pull of gravity.

"This is not my home," Mom continues. "I already have a home. I wish they would stop calling this place a home."

"Dad can't carry you anymore, Mom. If you go home, how would you get from your wheelchair into bed? Or how would you get in the car to take you home in the first place? That's the problem to solve. Dad's not as strong as he used to be, and you're afraid to walk, for good reason."

"I'm not afraid to walk, I'm afraid to fall."

"I know, Mom. I miss you."

"I miss you, too, honey." There is a reaching in the sound of what she says. She can't escape her confinement in those hallways crowded with forgotten ancients staring at the walls.

The last time we visited Mom, both Kiki and Zadie hugged her gently, having been warned about her fragile bones, and Kiki said it felt like she was hugging an angel, a being made of pure light. Mom has always loved hugs, and she taught me and my brother to align our bodies to hug heart to heart, so that our hearts could each feel the other beating. Zadie drew a picture for Mom, a picture of a heart "beeping," as she says; the drawing shows multiple concentric hearts to depict the beating motion. This multiplicity is a technique she saw in a photo of prehistoric cave paintings of charging bison. Mom hugged the beeping heart against her own. I was reminded of Tabitha's lyric in the song "Ruler of Myself:" "I believe in hugs, / People stuck together like the petals of a rose." This blessed state

of being stuck is a matter of faith in the other, a miraculous, even religious translation of vulnerable feeling into vulnerable flesh. I sang that verse to Mom and she smiled that impossibly wide-open smile that admits no barrier between her and the surrounding world.

Her favorite part of that world, apart from her boys, has always been flowers; her gardens in our front and back yards have been her refuge. Working the soil with her hands, she summoned phase after phase of spring and summer blossoms, from the white and purple crocuses pushing up through the remains of winter ice to sunshiny daffodils; lazy, extravagant iris; lush peonies that seemed to open up infinite layers of sweet-smelling, soft pink petals; tulips reborn from the dark and cold of their underground bulbs; and an extended family of daisies nodding "Yes" to the breeze.

The masterpiece, however, was her patch of sweet peas, which grew on vines climbing up strings suspended from a wooden frame built by my dad. Everything about them was quietly surprising, especially the tenderness and vulnerability of their ambitious tendrils. How could a being this insubstantial not only survive but also lift up the heaviness of human depression?

Over the years, our house filled up with broken objects that Mom couldn't bring herself to throw away, knowing that these objects—kitchen appliances, plastic containers, and lawn and garden equipment—would not be recycled by the city and would end up buried in the earth. Mom was waiting for the day, not yet come, when at long last these objects would be able to be remade and used again.

She also produced by far the least amount of garbage of any household I've known. By shopping at the farmers' mar-

ket, avoiding plastic packaging, and composting all scraps of food—which were very rare as Mom wasted no part of any food, including fruit peels in marmalade and the stripped carcass of a chicken for chicken vegetable soup—a week's total accumulation of garbage could be contained in a single coffee cup.

Mom's girlhood during the Great Depression prepared her for these environmental heroics. During that time of deprivation everything was used and reused. Pieces of worn-out old clothing, including a formal dress made for Mom by her mother, were braided to make rugs, two of which have survived in my boyhood home, and socks with holes, or pants worn out at the knees, were always sewn back together or patched. A chicken raised in the back yard could feed a family of five for a week. Such necessities became moral virtues and waste became a sin; to recognize and respect the value in everything was a lesson learned by the children of the Great Depression.

During the Depression, Mom likewise learned to value other people—a lesson she carries with her still, as she takes time to listen to her fellow nursing home residents who are routinely ignored by everyone else, people whose grip on reality is slipping. They come to her and tell her about their visions and their fears.

"I think I'm disappearing," whispers Martha to my mother in confidence, over and over. "I think I'm disappearing. Where am I?"

"You're right here," says Mom. "Next to me."

Mom's girlhood in Nebraska of the 1940s, like my father's in California, was a time when the neighborhood functioned as a

family. If a neighboring mother was sick, those nearby would come and clean and cook for her. The local doctor cared for his neighbors free of charge. Neighbors planted Victory Gardens in vacant lots where they harvested and shared vegetables during the war. This was simply what people did; they picked each other up, just as the kindly neighbor does for the fallen Quixote early in the book, a gesture that inspired the Kid Quixote lyric in the "Rescuing Song:" "We'll wipe the dust off of your face / pick you up, take you home and embrace."

Close and afar, my mother has resurrected me many times. As a boy, when I was learning to ride a bicycle, I fell again and again, opening and reopening the same scrape on my left knee, the same knee every fall. I staggered up the street, blood streaming down my leg, and I screamed, "I'm dead!" the worst thing I could think of. Mom could heal anything, and she was masterful at placing a painless bandage over the wound. A day later I would be back on the bike.

At Yale, when I was writing my Comprehensive Exams over the course of four eight-hour days, I couldn't sleep the first night from all the stress; my head felt stretched tight, empty and resonant like a drum being pounded to rally galley slaves in their rowing. There was no peace, and every time I looked at the clock my panic made my heart beat louder and faster. If I couldn't sleep, I couldn't take the rest of the exam and I would fail. At four o'clock in the morning of the third day of writing, I called my mom on the phone. She had been sleeping so it took a dozen rings for her to wake up and answer. All I remember saying is, "Mom, I can't sleep; please help me."

When I was a little boy, Mom used to help me sleep by tracing a circle around the outer edge of my ear with the tip of

her finger, around and around in silence. That gentle point of focus brought me peace. Now, sitting on the kitchen floor in a sleepless state of alarm and far away from her touch, I focused on her gentle voice. She was telling me to breathe and to notice that when the air came in through my nose it felt cold and when my breath came out it felt warm. Repeating this to myself I finally fell asleep, completed the exam and graduated.

What can I do for her now?

——————

Ten years after he disappeared, Ezekiel shows up and knocks on the glass door of Still Waters in a Storm. I open the door and surround him with a hug. He has thick hair and a thick beard, and his body feels heavy—very different from his days as Easy, days when his every movement was a dance on air. None of the kids has arrived yet, so we have time to talk.

He has just been released after five years in prison. He says in a rush that when he was incarcerated he thought every day of me and all of the good experiences we had together and all of the opportunities I had given him, and he was ashamed at how he had wasted those opportunities and fucked up his life, and he couldn't wait to see me when he was set free and he has come straight here to ask me, his real father, to forgive him. He says, "I want to thank you for everything you tried to teach me. Now I swear I understand. I'm a changed man, I promise. Do you forgive me?"

Of course I forgive him, although I am uncertain about what that means.

The little Kid Quixotes begin to arrive and I introduce

them to Ezekiel. I tell them that he was my student at Bush-wick High School almost twenty years ago, before any of them were born. They are, as they always are, welcoming.

The gap is vast between their transparent radiance and his darkness and heaviness, his tentative, half-hidden smile. Tears push their way up to the threshold of my eyes, as if they would flood that gap so that Easy could set sail from his lonesome shore and reach safe harbor, and I have to swallow the lump in my throat and bite my lower lip to keep from crying. He needs the blessing of these innocent children who know nothing of his past.

We are translating and adapting the galley slaves scene, the exchange when Quixote asks the third slave what he has done wrong and the slave explains that he didn't have enough money to bribe the judge in court. Ezekiel, dear old Easy, suggests, with a subtle stammer in his voice, "Maybe we could make him just say, 'I'm here because I'm poor.'"

He says the word *we*. "Maybe *we*."

I hear his plea, but never answer his subsequent phone calls.

Again and again, across my twenty years in Bushwick, doz-ens of my teenage students have told me that I'm their father or have asked if they may call me "Dad" or have just called me "Dad" without asking for permission. They became, by their choice, my children.

On Real People's first trip to the forested campus of the elite college where Julius and Ezekiel would eventually enroll, and where Angelo, who never finished high school, would wish he could have gone, we all stood together at sunset near a pond surrounded by tall trees. The boys were jumpy at all the new sensations of nature.

"What's that?" asked Angelo, eyes wide.

"Those are frogs," I told him. Some were singing high and reedy and others sang deep like a bass drum.

The boys waved their hands at fireflies, mistaking them for embers that could have floated from a nearby barbecue or marijuana cigarette.

I pointed up and said, "Look! Up there!"

The trees had become silhouettes that framed the pale but darkening patch of sky where small, shadowy creatures flapped in wobbly circles around and around.

"What are those?!" asked Easy, audibly nervous.

"Bats!" I said. "But they're harmless!"

My reassurance came too late; the boys had run for their lives back to the house where we were staying.

They were kids, once upon a time.

———

Angelo wrote to me once from prison. The envelope held two poems and there was a note at the top of one. "Dad," he addressed me, "Can you please read these aloud to the group, please? This is the last favor I ask of you."

The first poem in Angelo's prison letter, called, "My Reflection in Still Waters," was a song of self-hatred, a pollution of the grateful, metaphorical name he originally had bestowed on the group, his refuge, years before:

> Still Water won't never come clean
> No place to run from himself
> From afar Still Water looks magical,

Peaceful, strong, dark and deep.
It's not until you come close
That you see his murky waters
How shallow he really is
Still Waters won't never come clean
He's dirty and mean
Polluted by his neighborhood
Ain't never been treated good.
Even the cute ducks shit in his waters
Leaving feathers and debris
There's no way he'll ever run free.
Stuck in a hole
Made by man to keep him contained, constrained,
Trapped, disgustingly disgusted and disguised
Getting dirtier by the minute.
Still Water won't never come clean
Cause now he's too conditioned to move
And even if the drain opened
And all the dark dirty waters could freely run
Into the strong-moving ever-changing ocean
He wouldn't go
Cause Still Water won't never come clean
Cause Still Water's whole soul is polluted
Even the beautiful bird that sees him from afar
And wants to experience what she sees as beauty
Can't survive
He only drowns her in mud and self-pity
It's a never-winning game of love.
Ever wonder why dirty ducks flock to a dingy pond?

They are all he deserves
They are the mirror of Still Water's heart.

I believe that Angelo was asking to be understood, to be seen down in the hole where he was stuck, behind his wide, rapturous eyes, all the way down to the mud inside him that drowns those who, like the beautiful bird, come too close.

The second poem was called "Inside":

Incarceration
Equals daily lacerations
Multiplied by the years you're facin'
Divided by the tears you're wasting
Minus the probability of the cell you're placed in
Added by the race of the population
There won't be much communication
Just a lot of manhoods taken
You probably have a chance to survive
If you get a home-made knife
Or you got about 20 Gods on your side
And the soul of 4 niggas who died
And the ashes of 8 niggas who fried
And the tears of 12 niggas who cried
I'm telling you it's possible if you try
I seen a angel run up in Hell in disguise
Started bucking at the demons of the wise
And still made it back to Heaven alive
I buy the truth I sell no lies
I witnessed it with my own eyes
This is directed to those seeking the great American prize

It may seem as easy as baking a pie
When actually it's as hard as trying to spit at a fly
In the sky
Too small for the human eye

I never wrote back, fearing that I would drown if I did.

One day, years before he was taken away to jail, Angelo and I had found the door to the Bushwick High School auditorium open after hours, a rarity, and decided to try our *Hamlet* on a dedicated stage in an actual theater, instead of our classroom. Somehow, during the rehearsal, while my attention was on Lucy and Easy in the scene where Hamlet pretends never to have loved Ophelia and breaks her heart and mind, Angelo managed to tag every available surface using a fat, black permanent marker, outlawed by the school, in Wild Style: zig-zagging letters racing around at all angles on the stage floor, the theater curtains, the lectern, the back wall just beyond the stage, the walls of the manually operated elevator, which he confessed to hijacking for a ride to the top floor; everywhere I looked I saw his alias, "Satan." "I'm here," said the tags, in my translation, "I'm here," "I'm here," "I'm here."

Every once in a while, I see "Satan" written on a wall in the neighborhood, and I hope it means he's not in jail, although it could be a relic from long ago, or someone else who has taken his name.

Cervantes, too, spent time in jail. Returning from war on behalf of the Spanish empire, during which the valiant soldier had lost the use of his left arm and then been captured and enslaved for five years, Cervantes, expecting glory and thanks, was completely ignored by the king. By this time, he had lost

most of his teeth and was poor as dirt, and when eventually he was jailed for his money problems, the heart of the writer broke.

From this place of isolation and shame and heartbreak, Cervantes began to write *Don Quixote*, the story of a man who believes in the values of a time gone by and sets out, in the name of God, to rescue the needy, protect the vulnerable, and right every wrong. Again and again the character, like his author, is ridiculed and beaten down, but he refuses to abandon his beliefs.

———

"What's this?" I ask Sarah, pointing at new drawings in the margins of *Don Quixote*.

"Those are all the other kids who need me."

"How many kids are there?"

"I don't know. There are too many to count; they keep coming and the refrigerator goes on and on."

"And what's this?"

"That's me drawing a map of the place."

"Does the map go on and on?"

"Yes. It's going to take a long time."

"Why do you need a map?"

"It's a magic map. Look."

"A circle?"

"A hole. A big hole in the floor."

"Is there really a big hole in the floor?"

"No, it's only on the map."

"What does it do?"

"You crawl into it and you escape from the refrigerator."

"What's happening over here?"

"I'm telling the kid to go in the hole but she's afraid of vanishing."

"The girl you were hugging for five hours?"

"Yes, her. She's scared."

"What do you say to her?"

"I say to her, 'Believe me.'"

"Does she go?"

"Yes. Look here. She's gone."

———

As Quixote approaches the galley slaves, he is appalled to learn that the prisoners "van de por fuerza y no de su voluntad."

To translate the word *voluntad*, we use our knowledge of the Latin verb *volo* ("I want") and the English *volunteer* and the Spanish *voluntario*—someone who takes action because he or she wants to—to arrive at "wanting." The tiny Spanish word *de*, just as in Latin, can mean "of" or "by" or "from."

Sarah, following in the footsteps of Alex "the Closer," puts it all together as "They are going by force and not of their own wanting."

Joshua, the eloquent adolescent, offers an alternative: "They are going by force and not of their own free will."

This version sounded familiar, with the elegant and often-used phrase, "of their own free will," whereas Sarah's version sounded like the voice of a kid who is genuinely surprised and upset by what she sees and is trying to match her vocabulary to the basic idea that the prisoners don't want to go where they are going.

In this case, the group agrees, the voice of the kid is more important than the elegance of the phrase.

Like the galley slaves, the kids I work with are pushed by forces beyond their control and beyond my reach. "Tell me I'm safe," sings Cleo, but I can't.

A boy named Melvin, beloved by everyone at Still Waters, a benevolent joker who authored a series of stories called "The Adventures of Crazy Man and Smart Man"—in which Crazy Man would always get everything backwards, based on his abiding belief that up is down, and Smart Man would come to his timely rescue, stories which Melvin would read aloud every week to the group to universal laughter and delight— was uprooted from us after four years, ages six to ten, when his parents were evicted from their apartment to make room for higher-paying tenants and they moved to Philadelphia. There was nothing I could do to rescue their home. Undocumented families rarely fight eviction; the process in court exposes them to unwanted attention and the possibility of being banished to their country of origin, so they move on.

Nor can I save the kids from bullies inside their homes or inside their schools or in the daily news, but when the kids are here, inside their "second home" and "second school," as they and their parents call Still Waters, our group is a shelter— not by accident or automatically by nature, but by daily practice. We can, with each other's cooperation, keep each other safe from the violence of speech that diminishes self-worth, as does relentless criticism at school or mockery on the playground, or the ostracizing, nationwide verbal assault on their people, speech that makes them feel that they are—in their very being—wrong.

In the galley slaves scene, Sarah physically places herself between violent guards and the captives, making her body a shelter, and then she attacks the guards and sets the prisoners free. Before risking bodily harm, however, our Kid Quixote asks slave number four, tiny Cleo, her real-life sister, what she has done to be locked up, and slave number five answers for the silent girl, in our version, "She didn't do anything wrong; she's here because she's an immigrant."

The boy who speaks this line—Paulo, aged ten, who joined the group at the start of our work on the galley slaves story— cannot at first be heard in rehearsal. He clenches his teeth together and mumbles the words. Paulo also works the puppets in the "Ruler of Myself" scene, and I notice that when he's the puppeteer he opens his mouth, just as the puppets do. I point this out to him, and he is able to transfer the power of articulation into his role as a slave, speaking on behalf of Cleo. When he speaks up and speaks precisely, his voice takes on authority and courage.

The defiant response "She didn't do anything wrong" is an act of resistance. By writing and enacting this scene, the kids are learning how to be defiant, to build their own mental shelter wherever they go, a safe passage through trauma.

The duet between real-life sisters, one seeking to know the other's heart and the other asking for reassurance after she sings, "I lost my mommy's hand," becomes especially alive with meaning during their real-life separation from their mother when she is threatened with deportation.

The character of Sarah's mommy, who replaces the original

Don Quixote's invented ladylove, Dulcinea, hugs Sarah throughout their scenes, to bring the girl peace at bedtime and comfort after a bully has knocked her to the ground. She also sings a popular Spanish folk song that the mothers of our group sing to their kids at times of intimate need, "Los pollitos dicen pío pío pío," or, in translation:

> The little chicks say pio pio pio
> When they are hungry, when they are cold
> The hen finds corn and wheat
> Gives them food and shelter
> Huddled under her two wings
> Until the next day.

The baby birds sing out their need for food and warmth and safety, and the mother bird responds by meeting those needs. By placing this familiar song in the story, a song from home, the kids remind themselves that they personally belong and are cared for wherever they go on our tour; that the story, like the song and like their mothers, is theirs. Hispanic audiences smile sweetly and laugh with the joy of recognition on hearing the song. Anglophone audiences, even if they don't understand the lyrics, recognize the comfort carried by the light and gentle tune.

The mothers of the Kid Quixotes have provided constant assistance, cooking food for the group—food typical of their homes, such as tamales, tacos, quesadillas, and empanadas—cleaning the classroom, assisting kids with memorizing their lines for the play, coaching them at home to sing their songs

out loud, and coming on trips as chaperones, helping me to care for more than twenty children as we travel all around New York City and beyond. They handle kid bathroom visits; correct kid behavior in public places; lead the kids in the tidying of every venue after every show, picking up our trash and lost toys and mittens; nurse kids through illnesses; watch out for dangers on the streets or the kids' tendency to stray from the group; and they notice details that elude me in the show, such as some children's habit of biting their nails onstage, for which the mothers paint the nails with nontoxic, nasty-tasting polish. They teach me to speak better Spanish, and their own example of practicing English raises a standard of bravery that their children follow with pride and admiration as they are practicing our play. The mothers' participation brings stability to the adventure, a wholesomeness of care that steadies everyone.

And within the group, our Hispanic teenagers—Joshua, Alex, Tabitha, Lily and Rebecca (who return on Saturdays when their parents are able to drive them south from their new home), and Ruth—have become expert bilingual tutors (all are stellar students in their public schools and brilliant authors and analysts of literature in our group) and friends, guardians, and loving parent surrogates for the little ones.

As we are writing the brief dialogue of the "Song of Basic Needs"—a process that will take only weeks to complete instead of months like the earlier songs—an opportunity arises for us to correspond by pencil and paper with a group of teen-

age refugee girls from Guatemala being kept in a detention center apart from their parents. Of course the Kid Quixotes want immediately to set the girls free, but after accepting the impossibility of this desire, they begin the process of setting free the refugees' stories.

Alex suggests that we ask the refugee girls to tell us what questions they would like us to ask them. Questioning someone can be an assertion of dominance, she says, restricting and deciding ahead of time what is meaningful about the other. Ours is a chance to let the incarcerated girls define themselves.

We receive a response from a refugee named Dolores who provides the one question that will guide all of these pencil and paper relationships, "What do you carry inside you?"

Before the exchange of letters begins, to illustrate the value of letter writing, I tell the Kid Quixotes that I have kept every handwritten letter my mom ever sent me after I left home thirty-five years ago. These hundreds of letters—on topics such as the weather, the garden and the yard, birds and the farmers' market—are especially precious now that my mom is shut inside a nursing home and barely able to write. Recently, after a gap of five years, Mom has suddenly written me a letter; the lines are a little wobbly, but the grace of her handwriting survives. Then I pull the letter from the pocket of my jacket and I read out loud:

"Thank you, Kiki, Zadie and your family for the special, colorful paper flowers you created for us! Have you ever heard the song, 'Paper Roses?' Whenever I've heard it I think of you and your thoughtfulness. I think of doing so many things

and realize what it means to complete even one special wish and then to put it in the mail, on the computer, or send it by phone. Winter weather comes day by day. We are supposed to receive a lot of snow and cold this week. You are probably getting some also. I put my hand on my belly and I remember what a gift it is to have a child. Love, Momo" (Momo is Zadie's name for my mom).

I point out that Mom is confusing the sequence of events, as if she were listening to the song "Paper Roses" and was reminded of the girls, when in fact the girls have reminded her of the song. She is also making a connection between herself and the girls via the weather, which she would always write about in the past, a reminder of our shared presence on the earth.

Corresponding, I tell the kids, who have no experience of writing letters, is in itself of value, both as an act of defiance against distance or the limits of incarceration and as a gesture of love between family, friends, or strangers.

Percy will write his message to a girl named Flor on paper folded into an origami frog. Flor will write back in the same way, and when I give that letter to Percy he will turn it over in his hands and open it slowly, with a very light touch, as if coaxing open the wings of a butterfly. The whole group will be entranced by this quiet spectacle.

"To hold in your hand a piece of paper that has been held in another person's hand," I tell everyone as I hold my mother's letter aloft, "is to touch and be touched by that other person. Before the words written on the paper even have been read, the message is understood; you, in your isolation, are not alone."

The girls in detention always write in Spanish and most of the Kid Quixotes respond in English. This means that translators are needed on both sides or, more accurately, the incarcerated girls, who speak no English, need bilingual help to understand most of the letters they receive, and most of the Kid Quixotes, all of whom are bilingual and speak Spanish in their homes but can't always read Spanish, need the help of our teenagers in order to understand the letters they receive.

A notable absence in our correspondence with the refugee girls is laughter; instead of jokes, corresponding pairs trade sympathy. They search for common ground, a chance to make contact across the distance between them. Many of the Kid Quixotes describe their own memories of suffering, reaching desperately deep inside for anything comparable to the pain of isolation.

Our Bernadette tells Lola that she broke both of her legs and both arms on a slide at an amusement park, when in fact, as her mother tells me when I ask after class, she only bruised her limbs. Lola writes back, "I am very sorry that you broke your legs and I want to tell you that I love you very much."

Tabitha, one of the Kid Quixote adolescents who is able to read and write Spanish, tells her partner Azalea, "One day I hit my head on the table and it hurt so much that I cried. But later my mom made cookies for me to make me feel better. I was sad and later I was happy as if nothing happened."

Almost every letter in the collected correspondence between the two groups includes a drawing of a flower, some in plain pencil and others dancing with color. A letter from our six-

year-old Cleo features thirteen large flower drawings, each one radiating all of the colors of the rainbow. The words are relatively few:

> "What I carry inside me is sadness because you are in a cave and I don't want you to be in a cave and I want to help you at the cave and I love you."

She has heard that the girls are being kept in a cage and her imagination changes *cage* into *cave*. This accidental translation makes me imagine that Cleo's colorful flowers have been painted on the interior walls of a dark rock temple to summon the blessing of real flowers, as our Stone Age ancestors appear to have summoned with their cave paintings the blessing of the real bison that kept their people alive.

As George Herbert's flower represented the return of God's love, these drawings appear to promise the return of love itself into lives bereft of their beloveds, a return to spring after the desolation of a long, dark winter of the heart. Almost every letter includes those words "I love you," and many close by stating that the correspondents are now best friends forever, or by asking simply, "Amigas?" Wendy, now aged ten, even offers her new friend a "Best Friends" necklace, "so that we can be connected." Ruth, Wendy's teenaged sister, offers in Spanish to make herself a sister to Gloria, her isolated friend:

> "It gives me great sorrow knowing that you don't have a family to give you a hug."

The topic of family comes up repeatedly in all of the letters. Separation from family is, after all, the hurt at the heart of these relationships. Our Talia, aged eight, who struggles mightily with reading and writing as if stuck in a giant spider's web, after opening her letter with, "I like puppies. Do you like puppies?" immediately moves on to:

> "My dad works in a place where people lose things and he sleeps in the morning and he works in the night like an owl so I never see him."

Justina replies to Talia:

> "My dad left me with my mom when I was two years old. I never knew my dad. My mom was pregnant with my little brother and my little brother was born. Today my little brother is fourteen years old. But we are not with our mom. My mom abandoned us. It has been three years since my mom abandoned us. For this reason I am here. I want to study."

Talia answers:

> "I like your name. I feel bad for you because your mom abandoned you. What do you carry inside you? I carry inside me happy. What makes me happy is I get to write to you. What do you like best about *Don Quixote*? I like the galley slaves because it reminds me of you. I love you."

Cleo, in her second letter, transcribed in Spanish by Alex, who does this service instead of writing her own letter, proposes to Maria:

> "If the food there is bad I will send you a tamal, because my grandma makes tamales at Christmas time. Once my grandma went to Mexico and I was left alone. At that moment I missed my family very much. I am six years old. When it is my birthday I will wish for God to set you free."

The very thought of Grandma's tamales is a cure for loneliness and loss. Cleo never hears from Maria again, just as Talia never hears again from Justina. The refugees come and go, a process that is beyond our control, despite Joseph's robust belief, at age nine, that—as he says to his correspondent, Venus— "We control our future."

Our Paulo, aged ten, tells his partner:

> "I once got lost in the shopping mall and I thought I was going to be lost forever. Gladly I wasn't because my Mom always found me so I felt very safe. I hope your parents come back for you. I have careness inside for you."

On the other side, the roles reversed, Amelia responds:

> "My mom is sick and I want to leave this program [the girls have been told they are not in jail but in a 'program'] to help my mom."

Amelia says "mi mami" ("my mom") a dozen times in two paragraphs. She closes her letter to Paulo by writing, in English, "I love you."

What does that mean, "I love you?" At Still Waters, we practice mutual listening, and that is what we offer to the refugee girls. Ruth, who said she would be a sister to Gloria, describes that role in her letter, in Spanish:

"Tell me your story. I am here to listen to you."

Despite her generalized and chronic anxiety, Ruth has a great capacity for containing other people's pain.

Joshua, writing in Spanish, after declaring his love for Belinda's name, says:

"If you wish, you can talk about your problems, insecurities, and sadnesses. I can't be with you physically, but with these letters I can listen to your problems and I can be your personal diary. That is, if you wish. If not, we can use this space just to have fun."

Both letters, from Ruth and Joshua, close with the words "No estas sola" ("You are not alone"). Neither receives a reply.

One glorious exception to the heartbreak is the correspondence between our six-year-old boy Rex and a teenage girl named Dahlia. Neither one speaks of sorrow, only of soccer. Rex describes his favorite match, between Spain and Portugal, with a breathless play-by-play account of who passed the ball

and who received it, of shots missed and goals scored. At the bottom of his second page—two pages by a boy who claims not to enjoy writing—he draws the field with facing goal nets and a group of stick-figure players and the large-writ caption, "LOOK!" Rex concludes his letter by writing that when Spain won the match he was, "Happy as a dog barking."

Dahlia, aged seventeen, responds in kind, describing her favorite match, between Barcelona and Real Madrid, complete with illustrations. Her response could be an act of kindness, an indulgence toward a little boy, or a relief, a grateful look away from the confines of detention.

For the past two years, Sarah has been exploring the confines of that experience, that great underground refrigerator, through her imagination drawing the narrative of her rescue mission in the margins of *Don Quixote*; now her correspondence with Dolores gives her a chance, verbally, to deliver the love she imagines, in real life.

"I am nine years old," she writes, "but I can be powerful. I like to be Don Quixote because I get to have a chance to be funny and brave and to save people. So you are locked up in a cage and I can help you by telling you a story."

The story speaks of the day she had to go to the hospital and get stitches in her leg—"It was BLOOD!!!!"—after having fallen against an iron gate while eating ice cream.

At the end of her opening letter to Dolores, after the story of her trip to the hospital, Sarah answers the question posed by Dolores: "I carry inside me my heart, destiny, love, family and memories. What memories I have is when I went to Central Park with my family and had a fun time by running in the grass."

The response by Dolores, adorned with elaborate drawings of roses, comes roaring back in Spanish, a hurricane of heartache and need:

> "Hello, dear Sarah. Thank you for the letter. I liked it
> a lot. I was very sad but then your letter arrived and
> what you told me made me happy. But sometimes I
> feel weak without strength, I feel that I can't go on.
> And now what I carry inside me is bitterness, sadness,
> and my soul is full of tears. I miss my family. And I
> need to be with them. And especially at Christmas
> I want to be close to them. And I want to leave this
> place soon. And to be with my grandma in the States.
> But I only ask that God help me. And each night I
> cry. And I ask God to give me patience. And I ask
> you, beautiful girl, to support me, to give me spirit by
> helping me by asking God. You are a great girl. Enjoy
> the moments that you are with your family with all
> your heart. I am waiting for your reply. Please send
> me a drawing of something beautiful to make me
> happy. I want to study English."

Dolores addresses the younger Sarah, the "great girl" who has the power to make her happy, with the respectful pronoun *usted* instead of the familiar *tu* used in everyone else's letters.

Sarah receives this answer in the midst of "The Problem" at home, two weeks before Christmas, a period when she is apart from her mother for the first time in her young life. Drowning in her own feelings of loss and fear, she seizes on her partner's sorrow like it's a broken board from the hull of a shipwreck:

"Dear Dolores, I hope you are okay. I love your letter and it was sad but I hope you have a wonderful Christmas even though you don't have your family. Well you and me can spend time together even if we're writing letters. Please don't leave me. I want to stay with you because you are my best friend that I ever had."

By the time we receive the next parcel of letters, Dolores is gone; none of us knows where she is.

The next step, after having received two rounds of hand-written letters in our correspondence, is to make room in our traveling show for the voices of the refugee girls. This has been the idea from the beginning of these relationships, that because the refugees have not only been incarcerated but also silenced, not allowed to communicate beyond the confines of their jail, the Kid Quixotes could raise awareness of their dire straits by sharing the girls' stories with our audiences.

The obvious opportunity in our script is the galley slaves scene, which we had chosen to dramatize in response to reports in the news about our ruler's policy of separating migrant families and locking up children. The silence of slave number four, and his need for another captive to speak on his behalf, attracted our attention because we saw this as our job, to speak for the voiceless, and when the old man became, in our version, a little girl called Cleo, her silence stood for the silence of all the unknown lost children, and the "Song of Basic Needs" was based on our imaginative guesses about what those children might yearn for.

Our group makes room for reality after the song's last

question, "What do I need to know to enter your fragile little heart?" The plan is to have the refugees' stories become the answers to that question, stories that can help us and our audiences to understand, and thereby care for, the girls. Our first answer in verse, before we receive the letters—"Hug me tight; tell me to close my eyes; tell me I'm safe and this is just a bad dream"—feels like universal truth, singing out loud every kid's desire for reassurance and safety.

The problem of what else to say or sing after that remains unresolved. The Kid Quixotes continue to debate the nature of the welcoming. Do we add verses to the "Song of Basic Needs" by restructuring the letters as song lyrics, as we did with Alex's essay in "Ruler of Myself?" If so, how would the audience know that those verses are real-life stories by specific girls? Does art disguise raw reality? Does the disguise actually focus the audience's attention on the reality, the way the colors and patterns of flowers lure necessary bees to the heart of the blossom?

There is also the problem of privacy. Dolores asks Sarah to speak for her, to be her advocate to God, as is Jesus in *Paradise Lost* or La Virgen de Guadalupe in Mexico. Does a private prayer belong in a public presentation? Sarah herself has traveled from shy to brave in the course of the *Traveling Adventures* project—and has been praised for this transformation by everyone who knows her—thanks to the power transferred to her by the attention of audiences, which includes the attention of strangers. Maybe these same strangers, via Sarah and her peers, can give their attention to Dolores and her peers, in their absence. This wider attention may never reach the refugees directly, but there is a chance that the compassion of strangers can radiate and

radiate and radiate outward from person to person and eventually bring warmth and light to the emotional cold and dark that surround these children in their isolation.

For the time being, our group has decided to stop each performance temporarily after Cleo's "Hug me tight" reply and address the audience directly, describing our correspondence in general, then announcing that we're about to read words written by a real refugee girl. What follows, read out loud, in Spanish and in English, is the above letter by Dolores. Audiences always cry, often throughout the reading, but always when Dolores says, "Enjoy every moment with your family."

There is an inherent power in an original object unshaped by artifice, placed in the setting of artistic storytelling. For example, most theater artists know that nothing they do can ever compete with the presence of a live animal onstage. I remember a production of Shakespeare's *As You Like It* in Central Park that placed a cage full of real chickens onstage; the actors, who were brilliant and spoke the beautiful verse the way a violin sings Bach, never had a chance at our full attention against the real-life strutting and clucking of the birds. The audience was hypnotized by pure, live truth.

But the letter by Dolores conveys more than its inherent power as a transmission of raw reality. Dolores lifts her sorrows up on rhetorical structure built by starting almost every sentence with "y" ("and") and by repeating and varying descriptions of her unhappiness, as "me siento muy debil sin fuerzas, siento que no puedo mas" ("I feel very weak, without strength, I feel I can't go on") and "lo que llevo dentro de mi es amargura, tristeza, y mi alma esta llena de lagrimas" ("what I carry inside me is bitterness, sadness, and my soul is full of

tears"). The rhythm and sounds of these compositions, the way they sing with growing urgency when read aloud, make a desperate heartbeat.

Dolores found gold, a bright bolt of pure feeling shot through the hard, dark rock of her distress, and with artistic skill she shaped a prayer. In our traveling play, our narrative sailing ship, we carry this treasure from shore to shore.

———

A refugee girl named Agnes writes to "una amiga"—"a friend"—whichever of the Kid Quixotes chooses to reply:

> "In my heart I carry the desire to achieve my dream,
> which is to serve God by serving the neediest, the
> poorest people."

Agnes could have articulated many other goals, such as being reunited with her family or living a prosperous life in this land of opportunity—where the people who owned the facility where she was kept were now prospering from her incarceration—but she chooses, or desires, to serve. If anyone is poor and in need it is Agnes, kept in isolation in a cage by the very country she came to while seeking asylum from the violence and poverty in Guatemala, her home country.

An important difference between the dreams of Quixote and Agnes is that Quixote seeks glory and dominion for his heroic actions. Every time he behaves like a hero from one of the adventure books that feed his delusions, he orders the vanquished or the saved—and grows swiftly enraged and dangerous if they do not obey—to report the accomplishment,

usually to Dulcinea, his fictional lady love, and he often intro-duces himself as "famous," which, inside the novel, he is not. He tries to dominate every situation he perceives to be a prob-lem. And Sancho is lured into accompanying his neighbor by the promise of an "ínsula" or "island"—a territory they will win in battle—for him to rule over as king.

Although their partnership becomes love and their desire to do good is genuine and abiding, they do also desire the reward of various kinds of power. Acted by children, the friends are as innocent (from the Latin for "harmless") in their ambition to be heroes as Sarah and Wendy would be in their real-life games of pretend adventures, and they are beaten down for their innocence. But the original ambition of the novel's he-roes remains, no matter how just or adorable these little girls are. They are not volunteering at a soup kitchen but going on adventures of violent conquest in a violent world. Agnes, by contrast, from her anonymous incarceration, asks only to be of use to those in need.

After a songwriting session for the galley slaves' "Song of Basic Needs," Sarah explains to me her next drawings; page after page in the margins of *Don Quixote* are full of pictures of chil-dren, the children she is rescuing; she hugs each kid, then asks each kid to believe her and to crawl through the hole in her drawing of the giant refrigerator and, one by one, they all do.

"How long does that take, to save them all?" I ask.

"Five years," she answers, and tells me the names she has given them. I recognize the names of the refugee girls in detention: our correspondents, Dolores, Agnes, Gloria.

After the last kid is gone, I ask Sarah where they are.

"They fell outside the jail and they landed on the tiger's back—"

"The same tiger who brought your mother to Brooklyn?"

"Yes, and the tiger spoke to each kid and said, 'Hug me tight and close your eyes; you're going to be safe.' The tiger walks and carries each kid and the kids can feel when the tiger is walking on soft ground, their eyes are closed but they know when the street becomes grass. The tiger says to open their eyes and the kids can see that they are in a field and they are standing just outside a gate and on the other side they can see their mommies standing in the grass with apple trees all around, standing and waving to their kids."

"How long have the mothers been waiting?"

"Forever," says Sarah. "They are always waiting."

After a pause, I ask, "What happens next?"

"The tiger crouches down and bows his head low to the ground and the gate opens."

"The gate opens by itself?"

"The tiger makes it open by bowing down."

"Couldn't he just jump over the gate?"

"It's way too high."

"Why does bowing down work?"

"He has to show respect and be humble. He can't scare the gate or it will stay closed."

"Then what happens?"

"The tiger goes inside and says, 'Welcome to Paradise,' and he lies down so the kid can get off his back and go to her mom, or his mom if it's a boy. Then the tiger goes back to the jail to get the next kid and everything repeats."

"Do the moms and their kids go out the gate?"

"No, because it's too dangerous outside."

———

In class we read the daily newspaper and talk about the constant hazards for refugees and immigrants in this country while noticing the relationship between those stories and the adventures of our Kid Quixote. There is a one-word headline we keep on the middle of our work table: "DESPERATION," it says, accompanied by a photo of many thousands of people crowding a bridge across the border from Mexico to us, people risking their lives by jumping into the river below and trying to swim across. Another headline always in our view on the table says simply "HELP" and shows a picture of the hands of a child grasping a chain-link fence. Then there is a front-page photo of a little girl crying at being separated from her mother at the border.

The kids are well informed about injustice by these and other stories in the news, by their parents, and by the ordinary details of their lives compared to glimpses they see of other people's lives on TV, or the gentrification of their neighborhood, or our friends who live in the private homes where we perform our show. To tell them that God is in Heaven and all is right with the world would be a lie, and they would know it. They are smart and they have eyes to see the unfairness that surrounds them.

As the galley slaves draw near, our Sancho tells Kid Quixote, "This is a chain of galley slaves, people forced by the king to go to the galleys."

"What do you mean, forced?" asks Kid Quixote. "Is it possible that the king forces anyone?"

"I'm not saying that," responds Sancho, "but these are people who, because of their crimes, have been condemned to serve the king in the galleys, by force."

"In short," replies Kid Quixote, "for whatever reason, these people are being taken by force and not of their own wanting."

"That's right," says Sancho.

"Well in that case," says Kid Quixote, "my path rises up to meet me. I come to the rescue of the wretched!"

After speaking with each slave, asking how each one came to be a slave, Kid Quixote summarizes, "From everything you have told me, dear brothers and sisters, I understand that although you are being punished for your faults, the punishments you are about to suffer are not to your liking, and you go to them without wanting because you don't have justice on your side."

Kid Quixote repeats that it is her job to help the oppressed, "because it is hard to enslave that which God and nature have made free." She goes on to ask the guards to release the slaves, arguing that the slaves "have done nothing wrong to you."

The logic is naïve and the assumption of the other's basic goodness is generous, in the way that children are generous: not in their ignorance of evil, because they are not ignorant, but in their readiness to believe another side of the story—"Justice was not on their side" and "They have done nothing wrong to you"—and to give a second chance, as they, too, appeal for second chances after doing wrong at home or at school. This is a matter of reciprocal justice, a moral dialogue, treating others as you ask them to treat you, rather than a case of being clueless.

The dialectical method of reasoning, part of Cervantes's ed-

ucation, is on display again in this scene, as Quixote and Sancho travel in dialogue:

Thesis: The slaves are being taken by force.
Antithesis: This taking is unfair.
Synthesis: The proper action is to release the slaves.

Early in our tour, the kids were so excited by the audience's adoration that their answers to after-show questions came out silly. "What's your favorite part of the story?" is a popular question, and the kids typically said their favorite part was the moment when the speaker received most of the attention, such as when he or she sang a solo or told a joke or beat up on a friend with pretend violence. They reminded me in these cases of the sparrows who gather at our birdfeeder on the fire escape at home, fluttering and chirping and pushing their way to the available seeds, a delirious response to food. I understand the need—attention as nourishment—but after two such episodes I asked the kids to stop and think.

"The audience," I told them, "is interested in your thoughts. Normally when a show is over the audience goes home, and maybe on the way home there's a conversation about what they saw and heard. But we present our show as a way of introducing ourselves, the beginning of a conversation that allows people, us and them, to get to know each other. If your answers are always saying, 'Look at me!' the conversation stops; there's nowhere else to go. Remember that this show is the result of everyone cooperating. It's okay to say, 'I really enjoy the

positive attention I'm getting,' but the truth is that you would not be getting that attention without your friends. Think about what happens *between* you. That's where the love is."

After this lesson, the kids began answering the audience by describing moments of cooperation, such as Cleo's blossoming. As the incarcerated refugee girl, Cleo initially sang so softly she couldn't be heard, even inside our one small room. Pushing her, insisting that she be brave and sing louder, didn't work. Then Kim offered a way forward, asking the rest of the kids to sing along with Cleo, but very quietly, to support her. She was no longer alone, and the volume of her voice rose steadily from show to show until one day Cleo announced that she no longer needed the other voices; she was ready for her solo. All of us stared in amazement as her voice filled the room at that moment in the show. After the show, Cleo now says to the audience that her favorite part of the play is her solo—not because she is awesome, although she is, but because everybody helped to make her brave.

Another answer to the question of favorite parts comes from Percy. Now ten years old, he has been with *The Traveling Adventures* from the beginning, when he had just turned seven. His restless mind always has had trouble with rehearsal as we practice many repetitions of every scene, so I allow him to read onstage for tranquility's sake, and to run around and play soccer with a paper ball before rehearsal and during breaks. These extracurricular soccer games, he used to tell the audience, were his favorite part of the project. If he had his way he would do nothing but read and run.

Over the years his outbursts in class, such as, "I'm bored!" and "What time is it?" have become less frequent as his aware-

ness of his surroundings and the needs of others has grown. He used to glare at me when I asked him to put his book away so we could run his scene, or yell, "Aw, come on!" when I told him his soccer match had to stop so we could begin class. "Aw, come on!" has even become a line in the play, in tribute to Percy, when Sarah orders the boys not to follow Marcela and they protest this restriction on their freedom.

Now he lets go peacefully, understanding that we are trading activities, all of which are worthwhile, and that we need him. Percy's post-show answer to, "What is your favorite part?" has become, "The part where we read the letters from the refugee girls, because they need us."

Sarah says she most enjoys acting her scenes with Sancho because she and Wendy are also best friends in real life. When she is praised for her acting, she looks down and says nothing.

———

Every year as spring begins to coax open blossoms even in the artificial, concrete depths of New York City, public school children grow sick. This is the season of statewide, standardized tests in all academic subjects. The testing goes on for weeks and the preparation, an endless repetition of practice testing, has been every day's job, all year long. Kids come to Still Waters with dark circles around their sleepless eyes, backs bent, their usual smiles and laughter absent. A number of them, as young as eight, have vomited or retreated to the couch, doubled over with nausea, stomach pain, or headache. I've lost count of the tears.

Five years ago, a story came to light about a drastic rise in suicide rates among elementary public school students in

New York City during test season. The Chancellor of the Department of Education publicized the numbers, but one day later she refused to speak on the subject. The story was quickly buried; government officials made no remarks and reporters abandoned the problem.

Having seen the distress of test-taking kids as they seek refuge at Still Waters or when I administered standardized tests at Bushwick High School, I believe that the main source of that distress is an absence of open dialogue. There are questions and answers, but there is no real person asking the questions, and the student has only one chance to say the right thing before the exchange is over. Days later, the student receives a grade—a number—as the only reply. There is no opportunity for the student to *learn* anything, to know what was right and what was wrong, or to ask questions in return with the goal of understanding the subject, because just as the student never meets the maker of the test, the grader of the test also is anonymous. They are not allowed to ask any questions of the proctor (the surrogate for the absent maker of the test), and, if a student does ask for help, the proctor is not allowed to answer. The fate of student and teacher rests on test scores, but they are prohibited from cooperating in their mutual best interest.

During a performance of *The Traveling Adventures*, if an actor forgets a line, he or she asks for help and someone in the group provides the answer; the story keeps going. People in the audience have said many times that they love this aspect of the show, the real-life cooperation. They also remark on the children's confidence and ease in a situation—a public spectacle—that many people would be afraid of. The kids are relaxed because they are not alone.

And because they are relaxed they are able to receive and respond to their own impulses. Just as Angelo can spin spontaneous street rhymes from a single word or phrase, Sarah's playfulness onstage has resulted in moments of divine goofiness, as when she pretends to fall asleep by instantaneously snoring on her mother's shoulder, or when her fingers walk across the floor to retrieve her beloved book, against her mother's rule. If she were strictly adhering to our plan, such details—the life of the show—would not see daylight.

———

During the days when Sarah is separated from her mother, Maggie asks if she can come to la escuelita as a safe place to meet Sarah and Cleo, and I agree. She also invites Monica, the bilingual volunteer who has become her only friend, because she wants me to understand completely what she has to say. Maggie and her daughters hug for a long time and wipe away each other's tears. Then Maggie, unsure of what is yet to come for her, tells the girls there is a story she wants them to know, and she wants me to tell it also in my book, as long as I change her name, which I have done. The girls and I sit and listen as Maggie speaks and Monica translates.

> When I was your age, Sarah, we had no shoes, but you can be happy in the country without shoes as long as you have food. The only food we had most days was two tortillas for each person in the family. We made the tortillas ourselves on a rock above a fire outside the house, and we were never sick. All day, every day,

we gathered corn and potatoes and whatever else we could find in the fields around our house. The house had only one room, with a dirt floor, and there were nine children and two parents sharing that room. There was no electricity.

One day a neighbor came by and said, "I can get you a job in Mexico City and you will have money for food for your family."

My parents approved, so my neighbor and I walked four hours and then rode a bus. I was carrying nothing because I had nothing.

"Don't worry," said my neighbor, "the lady I work for has granddaughters and she can give you their clothing."

When we arrived at the house of the rich lady, a very good woman, a white woman, she looked me up and down and said, "But she's a little girl!"

Then she asked my neighbor, "Did she come from the country or did you dig her out of the ground?" because my bare feet were dirty like potatoes.

That first day the lady told her husband, "She's only a girl; give her a week to see if she can learn."

She gave me soap and let me take a bath and then I wore her granddaughter's clean clothes and shoes and they fit perfectly. I was nervous to have these things because my parents always said, "Humility and respect above all. Never ever take anything. If you want something ask politely, saying 'Please,' but never just take. When you receive something, say 'Thank you.'"

I said "Thank you" to the lady.

For a week I made all the beds in the house and dusted the furniture and washed the floors and toilets.

One day I sat in the living room on the couch and my neighbor saw me and said, "We're not allowed to sit here."

"Why not?" I asked.

"Because we're poor."

"But we're all the same," I said. "We're all going to the same place and turning to dust."

After that week they were happy with my work so I stayed.

One day the man asked me to get him a Gatorade drink from the refrigerator. I couldn't read, so I guessed and I was wrong.

"You can't read?" he asked.

"No," I said.

"You need to learn," he said.

Then the lady taught me how to read. She was a professor at the university. First she gave me a pencil and showed me how to write my name and told me to copy what she had written. I was afraid because I didn't know how to hold a pencil. My mother once found a pencil in the village and gave it to me in secret, but my father did not allow me to go to school and when he found my pencil he took it away. I wanted very much to study but he said no, I had to work in the fields, digging. All of the girls had to dig, but the boys could go to school.

I copied my name.

After a month of working there I got the job of serving breakfast.

My neighbor said, "Your parents won't recognize you!" My skin was much lighter now that I lived indoors. In the fields we have no cream to block the sun and our skin burns and cracks and bleeds and turns very dark. But we had to gather food.

I copied all of the letters of the alphabet and spoke them out loud.

"We care about you," said the lady. "We could sell you for organs or prostitution; you're worth a lot of money, but we care about you. See that cupboard full of food? You may eat anything we eat—yogurt, chicken, bread. From now on the other girl will serve breakfast and you and I will study reading and writing."

After two months I could read and write.

"Now you're going to learn to cook in the kitchen," she said, "You're smart."

I told her I missed the country because there I could run and jump and see birds; I was happy like a beast. I could only think of getting food, so I didn't think of other things.

She answered, "But now you have food, so you are able to think of other things."

I stayed with that family for six years.

I cooked more and more and I started to experiment with rice, adding coconut, carrot, and chiles. The man said, "Who's changing my rice? I've had the same rice my whole life!" He was very happy.

When I would invent a new dish the lady would give me gifts such as jewelry and perfume.

My neighbor became jealous.

One day my neighbor told me, "Your father beat your mother and she's hiding in the fields; he drinks and he beats her. Go back home! Don't tell the lady! Just go!"

Then she stole the lady's fiftieth anniversary gold rings from her bedroom and hid them in my bedroom. I was the only person allowed to enter the lady's bedroom apart from her husband. When the lady asked my neighbor if she had seen the rings, my neighbor said, "No, but Maggie is the only person allowed on the second floor."

At that same time I was home to visit my family and to bring them money from my job. My mother used me as a shield from my father when he was drunk but he ripped us apart and threw rocks at her.

"This is my land!" he yelled.

The lady found her rings under my pillow and asked me why they were there. I told her I didn't know and that I always put things back where they belong. She believed me, and my neighbor left and never came back.

The first time I tried to cross the border to the United States my father forced me to go with him. I had no choice. He had borrowed money to pay the coyote. I thought maybe if I go with him he will change.

We met a large group, about sixty people, at the

Mexico City airport. I recognized a number of them from the village. Everyone was wearing dark clothes, long pants and tough, closed boots to hide in the desert at night and protect against snakes. The coyote told us to say, if anyone asked, that we were going to Tijuana for the grape harvest.

I was very excited to be in an airplane for the first time, riding above the clouds, and I forgot some of my sadness.

When the plane landed we had to walk. The coyote told us not to try to communicate with him, no eye contact, until he was two blocks ahead of us; then we could follow. "Don't talk to any strangers," he said. "They try to capture migrant girls and make them prostitutes."

We walked for more than one hour in the darkness until we came to a group of vans and got inside all piled up on each other. After a long drive through dark streets we arrived at an old house that was dark and run down. The coyote warned us to make no noise as we entered the house. At the back of the house we came out and saw that the house on this side was beautiful, with a swimming pool and a garden, but there was no furniture so we slept on the floor. Hundreds of people were there, sleeping. The coyote gave us instant soup and hotdogs to eat.

We woke up and got in the vans. At a place called Black Rocks the Mexican police told us to walk fast to catch the change of shift at the border at 5:00 a.m., just before sunrise. Gang members frisked us before

we crossed over; they even took money that was hidden in the vaginas of the women and girls. We had to take off our shoes, too, to show if there was money. The gangs knew the coyote. If you scream or run, they hit you.

Again we had to walk in the dark, across the desert, after crawling under the razor wire at the border, lifting it up slowly not to set off chain vibrations all along, vibrations that would be a clue that we were there. On the ground we saw the remains of border crossers and cattle, and we heard the sound of owls. Cactus spines got stuck in our hands. A few people turned back because they were afraid.

"Just ten more minutes of walking," the coyote said. "The vans are waiting."

When we arrived at the destination it turned out to be ICE agents in helicopters, cars and on motorcycles, with dogs. They arrested everyone. They cuffed us and chained us together and gave us water. Nobody would tell them the name of the coyote. "I don't know," we said. On the Mexican side of the border they put us in a big bus.

Back at the big empty house we saw the coyote again. This time he was dressed in fancy clothes and had his bleached blond hair styled for going out. The hair gave him his nickname, "El Rubio," "The Blond."

"You did well," he said, and told us that while we were being detained, drugs were crossing over.

Someone asked, "How do we know who works for you?"

He smiled and said, "They all work for me."

The next morning, again at 5:00, we made the same crossing, driving behind lookout vans, but the driver didn't get the warning on the walkie-talkie that ICE was coming because the batteries ran out of power. When he saw the helicopters he started to speed up, but he had to slow down right away because the vans in front had crashed.

The same agent greeted us. "You again?" someone asked.

He kept us in an outdoor cage that was very cold at that time of day. Then we got back in the bus and went across the border to Mexico.

"This time," said El Rubio the next night, "it's going to be harder." We were going to a tunnel, a passageway for drugs and weapons.

"Touch nothing, see nothing, say nothing," he said. "And use my name."

In a big cabin in the mountains, full of armed men, our hands were tied.

"We trust no one," explained the man in charge. "Now we will walk for three hours and for sure, this time, you will cross over safely."

They gave us burritos and chicken wings from Taco Bell, and even though we were starving we refused to eat that disgusting food.

After three hours of walking in the dark with our hands tied, and after walking through the giant

tunnel under the border, there was ICE, waiting for us.

"Are you scared?" asked the boss.

"No," we said.

"Are you El Rubio's people?"

"Yes."

"Don't run. You're safe."

This time we crossed. A van took fourteen of us to New York City, to Bushwick. Already my godfather and cousins were here.

My father got a job at a carwash on Knickerbocker and I worked cleaning houses for Jewish people. One of the women I worked for told me to get down on my hands and knees to scrub the floor.

"No," I said, "I'm worth a lot."

Then I got a job at the local tortilla factory. I learned how to work the machines and to grab the tortillas.

The woman who was the boss liked me. She sat down with me and gave me food and said, "Be here at 6:00 a.m. Make the coffee, sweep the whole factory."

I helped her daughter to carry groceries back from the store, and I took care of her little children who were playing at the factory. I always wanted to help.

"Keep learning!" said the boss.

I learned how to do everything, including how to bag the tortillas and cook and serve food in their little restaurant on the street.

For a week I did all of this every day and at the end

of the week the boss gave me a hat and an apron and said, "Welcome! You have a job! Keep working hard! I have faith in you!"

I thought I wasn't going to be paid yet but she did pay me. She said, "Stay out of trouble; no friends, no drinking or smoking or dancing; study; you're worth a lot."

I thought she was handing me twenty dollars, but she gave me 650 dollars.

My dad turned his back on me. He asked me, "Where did you go whoring around?"

Back in Mexico a man had come to our home to collect the first payment on the loan for the border crossing. I wired five hundred dollars to my mother in the village. The more I worked the more I paid our family's debt. But for a whole year my father wouldn't talk to me at all.

Then one day he told me, "We're going home." I wasn't ready to go home, but he said, "You don't talk. Silence." I surrendered.

The boss at the tortilla factory told me, "Come back! Stay the same! No drinking!"

My dad went right back to being angry and violent. He hit my mother and whipped me. This is why the scene in the Quixote play upsets me, the scene where the boss whips the girl and she has to forget it and keep going. I have lived this way. "Leave him," I told my mother, but she said nothing and stayed.

Maggie pauses her story. "Sarah, Cleo, my daughters, don't ever let anyone do this to you. Promise me."

Sarah and Cleo promise Maggie.

I started to think about Bushwick again.

"I'm going back, Mom," I said. "Don't cry."

Maggie cries.

The same process repeated on this journey, except my two brothers came with me instead of my dad. We walked in the dark, rode in vans and slept in a dry riverbed. Six times in one month we crossed, and six times ICE arrested us and sent us back. The coyote took us to different places each time so we would be disoriented and not able to identify the people we met. Once we saw ICE and the narcos—the drug gangs— hanging out at ease by the border, like friends.

Finally we got through when we stuck dynamite in a barrier made of pipes and scraps of metal and other trash and blew open a hole.

For two weeks we walked across the desert and we saw real coyotes eating human remains. Rattlesnakes ambushed us but missed biting us. Once we saw snakes eating a calf. We got water from cactus by using a flat, sharp rock as a knife. We only had three cans of tuna, a bottle of Pedialyte, beans, and a tin of sardines. When that ran out we were very hungry and so thirsty.

Our guide got lost. I have never felt such thirst before; all I could think about was water. We found some water at spots where migrants had been forced to abandon their bottles when getting into the vans, and kind volunteers left water along the way. But we had to be careful because ICE drops bottles of water as traps.

One day an American Indian man rode up to the group on a horse. He had long braids and a necklace of colorful beads.

He gave us pretzels and water, and he asked us, "Why are you coming here? You are Aztec. You have a beautiful land."

Then he told us how his people were ruined by the Europeans, by accepting blankets infected with smallpox. They trusted too much. And rats came over on the European ships, he said. "Before them, no rats lived here."

His hands were the color of tree bark but they were very soft. As he shook our hands one woman said that he was Jesus, our miracle in the desert.

"Remember your families," he said. "God bless you all."

On the long drive from Arizona to Bushwick I ate animal crackers and drank water. The woman who was driving was drinking tequila and bragging that in thirty years of smuggling people and drugs and weapons she had never been caught.

"You only have one life," she said, "so learn

everything you can; don't look back, don't live with the dead, go forward."

Maggie finishes her story. "Sarah, Cleo, promise me, please, if I am not here, you will teach your little sisters to read."

They promise.

About halfway through Maggie's story I stopped hearing Monica's English and switched to hearing only Maggie's Spanish. I knew what she was saying without translation, either by Monica or by my own struggling thoughts—a sudden, blessed revelation that being alive is much wider than I had known.

———

"What happens to you?" I ask Sarah the day after her mother's story. "After all the refugees are gone?"

There are no drawings this time.

"The tiger comes back for me," she says, staring off in a daze. "I jump into my drawing through the hole and I land on his back and he tells me to close my eyes and hug him tight."

"So you go to the place of the soft ground, too?"

"No, I ask him to take me home. My mom is at home."

"In Brooklyn?"

"Yes. I need to go back home."

"Do you pray to go there, the way you prayed to reach the refrigerator?"

"No, because the tiger wants to go to the Bronx Zoo first, to visit his cousins. And I want to see what there is along the way."

"What is there along the way?"

"I don't know. I've never been there. Probably there are mountains and rivers and other cities; and bears."

"What happens at the Bronx Zoo?"

"The tiger has to go invisible so they don't catch him and put him in the cage. He tries to talk with his cousins but they all start crying, and they can't stop crying. So we go home."

"Does he stay invisible?"

"Yes, because he's afraid of Animal Control and the police might shoot him."

"Does he go inside your home?"

"Yes, he stays with us to protect us."

"Does he go outside?"

"Yes, I take him for a walk every day. Nobody believes me because they can't see him; but I feel safe."

— 5 —

El Show

In April of 2019, halfway through the projected five years of the *Don Quixote* translation project and at the close of the opening tour, we put on a show in la escuelita for the families of the Kid Quixotes. The parents call the play "El Show," adopting and adapting the English word with its Spanish definite article.

Homemade food of all kinds, prepared by the mothers, has been placed on tables by the window in large foil trays, including tacos, tamales, empanadas, pasta, chicken, rice and beans, pernil (roast pork), salad, and fresh fruit. The parents begin to serve the food right away so that everyone in the room is well fed before the performance begins.

After eating, the kids gather around the piano to warm up their voices as Kim plays chords to guide them up and down the scales. Their favorite warm-up is to sing "Mee—ee—ee—ee—ow" in rising and falling arpeggios and then meow like

cats. They do it before every show and every time they do it they laugh.

After the vocal exercise I pull the kids close to me and ask them what their job is.

"To tell our story," says Sarah. She began this process nearly three years ago, when she was barely seven years old and silent.

"To speak loud and clear," says Paulo, whose work with puppets has helped him find strength in the act of articulation.

"To listen to each other," says Percy, who, at the beginning of the project, was chronically distracted and rude. Now he is a patient gentleman.

"To be brave," says Cleo. This middle child, in her singing, has found a way to be heard for good reasons, a departure from her rebellious behavior at home and refusal to cooperate at day school.

"To have fun," says Joshua. Thank goodness adolescence has not knocked out his playfulness. I remember eight years ago on a class trip to Central Park when Joshua was seven, he found the empty shell of a cicada, held it up to the sun, and said, "The stylish cicada prefers see-through outfits."

"Yes," I say. "All of the above."

"I'm scared," says Talia, who now, at eight years old, believes that girls, too, can be angry, and angry can be good.

"Why?" I ask.

"Because my mom is watching."

"But she has seen you do this, right?"

"Yes, but this is different."

"Different how?"

"She's going to be looking right at me."

"And listening to me!" says Talia's little sister Roxana.

Many of the parents have seen this phase of *The Traveling Serialized Adventures of Kid Quixote* already on its tour—some multiple times—sitting or standing always on the periphery of the crowd, often holding babies and toddlers. They have accompanied their children as they traveled on buses and trains beyond the block, beyond the neighborhood, beyond the city, for over two years. Like the novel and our play, this tour has been a story of adventures along a road. The kids have been praised by strangers at every stop, and their parents have witnessed that praise.

Today our coming home is only for the families.

The kids assemble and define the perimeter of the playing area with their bodies, then their parents sit on three sides of that area with nobody between them and their children, except in cases where younger siblings of the actors are sitting on their mothers' laps.

The kids are not pretending to be anyone else; they are who they are while telling a story, their own story. They are not trained actors, singers, or dancers; they are real kids who happen to be acting, singing, and dancing. There are no masks or costumes, theatrical lighting or scenery, nothing to distract from the pure truth of the kids. When Maggie sees Sarah acting, she doesn't see a girl pretending to be an old man in Spain in the 1600s, she sees her daughter, her Sarah, nine years old now, being brave and resourceful and devoted to making a better world. Wendy's parents see their daughter being steady and loyal, a good friend. Percy's mother witnesses her son becoming patient and attentive to other people. After the show,

Paulo's mother will kneel and hug him with tears in her eyes because she watched him speak out on behalf of his defenseless neighbor.

When everyone is in place and ready there is no empty space on the floor except for the playing area, about eight square feet. The classroom is absolutely full of families. I step between and over kids to the middle of the room and I thank the parents.

"Es un honor trabajar con sus niños y niñas"—"It is an honor to work with your boys and girls"—"Muchas gracias."

That's all I say. The rest is up to the kids.

The show begins.

Sarah sits cross-legged in the middle of the playing area. The book *Don Quixote de la Mancha* is open on the floor in front of her. The room is quiet. Even the toddlers and babies are hushed, waiting.

Sarah turns a page.

She turns a second page.

She turns a third page.

Her mother, played by Tabitha, enters and says, "Sarah, hora de dormir" ("Sarah, it's time to sleep").

Tabitha has replaced Sarah's beloved Lily, who created the role and worked with the younger girl in a patient, steadfast way. When they were onstage together, the love on display was genuine. When Tabitha first stepped into the role of Mommy, the relationship between her and Sarah was awkward; they seemed remote to each other. Tabitha spoke quickly and was barely audible. In rehearsal I asked her to slow down, to say every word, showing by speaking slowly that she, as a mother, is patient. She relaxed as she spoke this way and took time with her daughter. Sarah, in turn, relaxed. Their travels have made

them close and Tabitha's exquisite tenderness has won Sarah's trust. Today, when Tabitha arrived at rehearsal, Sarah ran to her and hugged her, and now when they are acting together, the little girl leans into the big girl's embrace. This, too, is real love.

As Tabitha and Sarah sing the familiar bedtime song "Los pollitos dicen pío pío pío," the mothers all smile. The closeness they know at home is being reflected to them here. Their children are telling them that these moments matter.

The little girl pretends to fall asleep, and after Mommy leaves, Sarah pulls out a flashlight and clicks it on. She continues reading by its light until Percy makes the sound of a rooster at dawn.

In class we have spoken about *devoción*—a religious passion—and here it is.

Sarah carries her copy of *Don Quixote* throughout the play. It's a big, heavy book for such a tiny girl, and she uses it as a shield, a weapon, and a pillow. As her mother readies her for school, braiding her hair, putting on her school uniform, putting on her backpack, Sarah struggles to keep reading. This devotion to reading is what the parents want for their kids.

Up to this point, all of the dialogue has been expressed in Spanish and in gesture, so the parents are fully engaged.

Next, when Sarah is alone and has discarded her school skirt in favor of pants, the play becomes bilingual. The kids, who are more at ease when they speak English, have been careful about including Spanish for this very day, for their parents. The goal is that everyone can understand the story.

"Yo soy Don Quixote!" declares Sarah, holding the giant book above her head. This announcement tells everyone in

the room that what follows is a story of self-determination. The parents are watching their children make choices about who they are.

Some lines repeat their content in both English and Spanish, such as Sarah's "Hay alguien que necesita mi ayuda? Hello? Is anybody in distress?" In class, the kids wanted to make sure that this crucial moment early in the play, when Sarah blazes her own trail, was clear to everyone, the idea that our hero is right now becoming a hero, someone who is looking for opportunities to help other people. At the same time, the kids were able to justify the character's use of both languages in this scene by saying that she is pleading to anyone, in any language, who might need rescuing, as the shepherd boy calls out to anyone who might come to the rescue, "Help! Auxilio!"

—

When Mommy reads from the book to soothe Kid Quixote after she has been attacked by bullies, reading the very same passage the audience has just witnessed and the story of the present moment of rescue, the girl repeats her assertion of self-definition, saying, "That's me, Mami!" and "Yo soy Don Quixote!" When her mother gently objects and tells her, "No digas esas ridiculeces. Eres mi hija. Eres Sarah"—"Don't say such ridiculous things. You are my daughter. You are Sarah"—the struggle continues. She insists, switching to English for her most defiant statement, "Yo sé quién soy, Mami. I know who I am, and I know who I can be."

But at the end of the scene, when it appears that Sarah is sleeping, Mommy says, "Dulces sueños, Don Quixote"—"Sweet dreams, Don Quixote"—with great kindness in her

voice, as she strokes her daughter's head. She needs to keep Sarah on a sensible path, but she also honors the child's imagination. This is true of all the mothers in the room.

Anglophone audiences can see the closeness of mother and daughter, hear the English disruption and experience this as a glimpse into the bilingual, private life of the other, whereas the parents at Still Waters know this bond and separation as their own.

Both Mommy's reading aloud of the very passage of the novel that is being acted out as she reads and the stopping of the action to read a letter by a real refugee girl enact the same basic meta-fictional conceit of the novel. The reader is explicitly reminded that the characters are living in a story. Quixote refers to the author who is writing his exploits as a godlike person making decisions about the hero's fate along the way, and the narrator encounters multiple other narrators. This multiplicity asks the reader, and the audience at our show, to think about what is real and whose story this really is. Being aware of characters as constructs also invites awareness that the kids in the show, as authors and as actors of their own story, are constructing and revising their selves.

The next and scariest step in Alex's journey is to sing "Ruler of Myself," her song of herself, in front of her parents.

The only dialogue between Alex and her parents about her identity has happened weeks before today, when her mother noticed Alex spending a lot of time with one girl and asked if they were a couple. Alex answered, "Yes," and that was the end of the dialogue.

Alex arrived late today because she and Ruth were perfecting their makeup and hair and rehearsing the song at Ruth's home. Alex is quiet and still; it seems like she is looking straight through the walls of the classroom. She sits and waits, her ukulele on her lap.

When her time to sing arrives, with Ruth singing privately by her side, I watch Alex's parents react. This is the first time they have seen the show. When Alex sings the lyric "Un jardín de flores de todos los amores"—"A garden of flowers of all kinds of loves"—her mother cries.

After the end of the show, her father, who I have barely heard speak in the last eight years, hugs Alex and says, "I'm proud of you," in English, very much his second language, and her mother says, "Gracias." She is thanking her daughter, she says, for allowing her to understand. Alex has worked hard in the bilingual writing process and in rehearsal and on tour, over two years in total, from age fourteen to sixteen, to make sure that her parents can understand this show and her anthem, her coming out and her growing up. Her dialogue with an ancient novel has advanced her dialogue with her parents.

Nearing the end of the show we reach Cleo, who stands for refugee children separated from their families and locked in jail, those who are forbidden to hug. Sarah's musical dialogue with her sister has only one line in Spanish, when Cleo responds to Sarah's question, "Who is your family?" with "El aroma de los tamales que mama me hizo para mi"—"The aroma of the tamales that Mommy made me just for me." Mothers in

the room begin to cry when they hear this line, a line that has been lost on Anglophone audiences. Two of the mothers have made tamales for the feast today.

They cry again when Cleo sings, "I lost my mommy's hand"—*mommy* and the Spanish *mami* sound the same.

Sarah and Cleo's mother, Maggie, safe here, holds her two toddlers close on her lap.

———

Sarah and Wendy have decided in rehearsal to continue their stage game of pretend beyond the events of the novel, the game that has crossed over from imagination to painful, bruising reality—they have been beaten down yet again—by having Kid Quixote teach Sancho to read, adding a closing scene that doesn't happen in Cervantes. Ruth suggested this, saying that our play came from what we have read so far, or from what Sarah reads in the play, and now it's time for new adventures. If Sancho, played by Ruth's little sister Wendy, is going to help in the search, she needs to know how to read.

"Remember?" says Sarah, in the scene, in the show, lying flat on her back. "In the book Sancho doesn't know how to read."

Wendy, as Sancho, despite complaining of pain all over her body, agrees from the ground, "Okay, okay, I'll do it."

"Yay!" says Sarah, sitting up, bouncing back yet again. "Repeat after me."

Kid Quixote then teaches Sancho the ABC song. Nadia, Percy's three-year old sister, sings out, too, and as she sings she steps from the audience onto the playing area and sits on the

floor next to Sarah, who says, "Hi, Nadia," then carries on with the ABCs. The song is in English, but everyone knows what it means.

"Congratulations, Sancho!" says Sarah immediately after the song is over. "Now you can read!"

This joke receives laughter from the whole room. Literacy in English is a basic need in this country, for parents and children alike, and the parents, for whom the second language is a struggle, and who will do anything they can to assure that their children learn to read English very well, find Sarah's instantaneous blessing very funny.

———

Taking a bow with the group is Felicity, absent from the whole tour. Today, she has been a member of the Chorus and she has sung all of the choral parts of the songs. Her mother, Dorothy, watched her and smiled throughout, a soft, adoring smile. Dorothy tells me later that on the next tour, Felicity has her permission to go.

———

Right after the show we have a conversation with the audience, as always. I rely on the kids to translate for their parents. It's the first time on our tour that I, as an Anglophone, have been in the linguistic minority.

I say what I always say, repeating myself from my introductory words before the performance started, "Es un honor trabajar con sus niñas y niños."

Maggie, who has attended about half of the performances but

often has been distracted by her two littlest girls, raises her hand and says, in Spanish, translated by Monica, "The show has moved me, because when they beat the girl, well, it's something that I've experienced, when they beat her and she has to forget it and just keep going. Forgive me"—she is crying—"forgive me. Sarah feels safe here, and every time she gets back from school, when the bus arrives late, she tells me 'I'm not going to eat, I want to go to Still Waters.' And every day she comes here thrilled and full of hope. I tell her 'Let's go home so you can eat something,' and she says 'No,' and she comes to the little school."

As she cries, mothers nearby put their arms around her. Sarah, sitting on the floor, looks downward and covers her face with her hand.

The parents and their kids don't know, unless they guess, that they have pulled me up from the abyss, day after day. They have given me belonging and surrounded me with love.

"Somos familia," I say.

"Somos familia," they say.

We are family.

———

Days after the closing of our tour, I discover that one of our writer friends has written about Still Waters in her new book. She says that visiting here has changed her relationship with her own kids. Now she sees them as "intellectual equals" to her, and "life partners in conversation." I read the passage to the Kid Quixotes and I ask them what they think.

"Yes," says Alex. "We are partners here."

"What does 'partners' mean to you?" I ask.

"That we listen to each other and we love each other," she answers.

"Anything else?"

"That we make things together," says Percy.

"Anything else?"

Sarah raises her hand.

"Yes, Sarah?"

"That we lift each other up after we fall."

Acknowledgments

I have been lucky beyond all right. I was born into middle-class prosperity in a corner of the world untouched by public violence, and I grew up privately in peace. Now I have access to medications that have saved my sanity and saved my life in the ongoing war against bipolar depression. My diploma from Yale casts a spell on all who hear that name, a spell that produces renewed opportunity after every downfall. I'm able to swim every morning to sustain my physical health and peace of mind. My family has an apartment we can afford to live in; we never run completely out of food, unlike some of the families I've worked with who have lived on coffee, toast, and ketchup. And I have time—to sleep, read, think, play with my kids, apply for grants, organize fundraising events and write this book—and the opportunity to write this book came about because Valeria Luiselli wrote about the Kid Quixotes in the *New York Times*. Thank you, Valeria, for that and everything else you've done.

Every chance I've ever had for happiness has come from other people's generosity.

There are thousands of people to thank: Real People Theater, our devoted Still Waters in a Storm volunteers, our benefactors and our hosts at every venue on our tour, and the many writers, scholars, and artists who have given of themselves to the kids in Bushwick.

Gracias to the great translator Edith Grossman for her example and her blessing.

Thanks to George Walker for introducing me to the "Articulate Poor."

The 52nd Street Project gave me a chance to work with kids, a chance that would change everything.

Without you, Amber Sibley, the show would be bereft of puppets.

Marc Cantone, by documenting the group, you made yourself a mirror that showed us we were interesting, day after day for three years. As did you, Peter Gordon; rest in peace.

Dan Halpern, gracias for the copies of Edith Grossman's translation of *Don Quixote*. They are life-long treasures for the kids.

John Lawhead, thank you for the Bushwick history lesson, and Victor Mikheev for educating the Kid Quixote company about windmills and wind turbines.

Amanda Palmer and Rosanne Cash lent their grace and genius to our songwriting process.

Southlands Foundation introduced us to horses and the earth.

Thanks to Professor Diana Conchado of Hunter College, Professor William Egginton of Johns Hopkins University, and

Professor Rogelio Miñana of Drexel University for providing their expertise on Cervantes not only to the kids but also to the writing of this book, and extra thanks to Diana for interpreting Spanish and English during my spoken interviews with parents of the Kid Quixotes.

Thanks also to Jeremy Tinker of New York University for contributing his knowledge of physics to our class.

Our friends at The Paideia Institute, led by Jason Pedicone, especially Elizabeth Butterworth and Nicole Andranovich, have illuminated the lives of my students by reaching back into antiquity and retrieving wisdom for today, and they have provided invaluable guidance on the Latin passages I've cited here.

Rick Martin has been our window onto the world from the very beginning.

Jeremy Ratchford, Kathryn Morris, and Peter Carey, Quixotes all, believed in the promise of what they saw and took action.

Sara Goodman gave us our first artistic home away from home.

Thanks to my brother, Kevin, for talking about things he didn't want to talk about, just for me.

Thanks to my boyhood friends whose forgiveness spared me isolation.

Kim Sherman is not only a brilliant composer, she is also a brilliant collaborator who demonstrates utmost respect for the genius of kids.

Thanks to Teresa Toro for organizing the chaos.

This book would not exist without the active belief and powerful wisdom of Johanna Castillo, my agent at Writers

House, whose love for the Still Waters community is strong and constant, and her brilliant, calming assistant Wendolyne Sabrozo. They have taken good care of me.

Elaine Colchie, also known as My Godsend, gave her wisdom and encouragement through multiple readings and revisions of the manuscript and persuaded me that I could do this, after all.

Tom Schneider rescued my computer when I believed all was lost.

Everyone at HarperOne, thank you. Juan Mila, my editor, has a very helpful way of being simultaneously strict and enthusiastic. He and his insightful assistant, Alice Min, dared me to make this book far better than what I first imagined. Noël Chrisman was both copyeditor and writing teacher. And Judith Curr, a thousand thanks for hearing me and Sarah and saying yes in response.

Deep thanks to Anne Sikora and Joan Caruana, my New York therapist and psychiatric nurse practitioner, pro bono keepers of my sanity.

To the families of Still Waters in a Storm, thank you always for the honor of working with you and your children.

I would not be alive now were it not for my parents, who have given birth to me twice.

To my children, thank you for being patient with Daddy. I love you.

Not long after I fell in love with Tina, my wife, there was something I needed to say. Her children were asleep in their beds and she and I were sitting on the couch.

"I have a serious mental illness. I have bipolar depression."

All she did by way of response was to smile.

"I'm properly medicated and I'm in therapy, but there are struggles."

Again she smiled and said nothing.

"I'm kind of boring; I need to sleep eight hours a night and go to bed at the same time every night and get up at the same time every morning."

"Yes," she answered.

"And the medications make my thinking slow."

"Is that all?"

"Once I tried to kill myself."

She reached out and took my hand in hers and said, "I love you."

Every day I strive to be worthy of her love, and to let her example guide me.

If you enjoyed *Kid Quixotes* by Stephen Haff,
check out the young readers' companion book:

Becoming Kid Quixote by Sarah Sierra

A True Story of Belonging in America

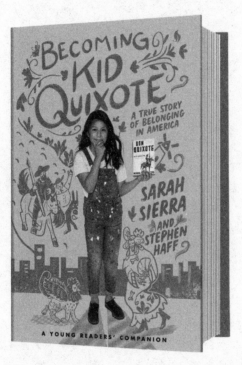

In this inspirational middle-grade memoir, nine-year-old
Mexican-American Sarah Sierra finds her voice through the power
of words and imagination while standing up for the
immigrant community she calls home.

HARPER
An Imprint of HarperCollins*Publishers*